The Somali Diaspora

Hi Will,
I have heard such
great things about you.
Thanks for your
support!
[signature]

To my big brother Will,
Thank you for all your help.
[signature]
09/13/08

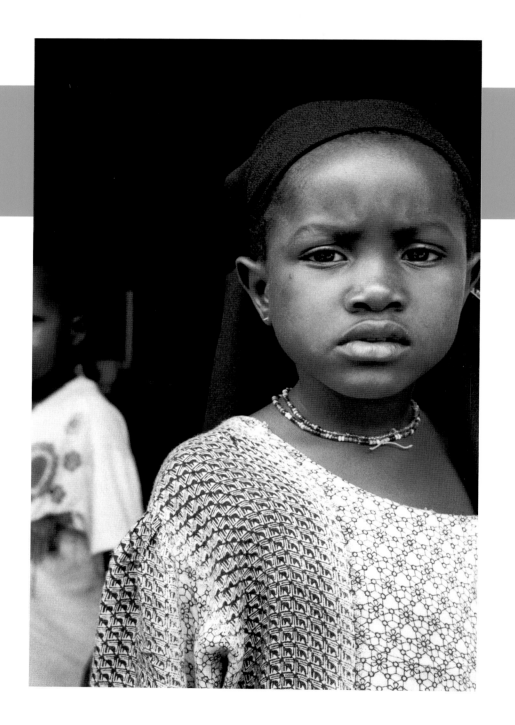

The Somali Diaspora

A Journey Away

Photographs by Abdi Roble

Essays by Doug Rutledge

University of Minnesota Press
Minneapolis
London

For more information about the Somali Documentary Project, see www.somaliproject.org.

Photographs copyright 2008 by Abdi Roble

Copyright 2008 by the Somali Documentary Project

Published by the University of Minnesota Press
111 Third Avenue South, Suite 290
Minneapolis, MN 55401-2520
http://www.upress.umn.edu

Library of Congress Cataloging-in-Publication Data

Roble, Abdi, 1964–
 The Somali diaspora : a journey away / photographs by Abdi Roble ; essays by Doug Rutledge.
 p. cm.
 Includes bibliographical references.
 ISBN 978-0-8166-5457-4 (pb : alk. paper)
1. Somali Americans—Pictorial works. 2. Refugees—United States—Pictorial works. 3. Somalis—Kenya—Pictorial works. 4. Refugees—Kenya—Pictorial works. 5. Somali Americans—Biography. 6. Refugees—United States—Biography. 7. Somali Americans—Social conditions. 8. Community life—United States. 9. Somalis—Kenya—Social conditions. 10. Somalis—Migrations. I. Rutledge, Douglas F., 1951– II. Title.
 E184.S67R63 2008
 967.730049'354--dc22

 2008024508

Printed in Canada on acid-free paper

The University of Minnesota is an equal-opportunity educator and employer.

15 14 13 12 11 10 09 08 10 9 8 7 6 5 4 3 2 1

Contents

The Somali Documentary Project: How It All Began

Abdi Roble, the son of a veterinarian, was born in Mogadishu, Somalia, in 1964. Abdi grew up to become a professional soccer player in Somalia. In fact, as we trek around the world together, I am constantly amazed at how many people remember him from his soccer days. Before we get around to asking people if we can document their lives, we often stop while Abdi and his former fans recall specific plays from important games, games that themselves recall a Somalia of happier days.

At the height of his career, Abdi decided to leave soccer and Somalia altogether. After a stint as a migrant laborer in Saudi Arabia, he came to the United States in 1989. When he first arrived, Abdi endured poorly paid jobs, as immigrants often do, while he struggled to learn English. However, one day he happened into a flea market, where he saw his first camera. He had to borrow the price of the camera from a reluctant friend, who thought the idea was silly and impractical. But from that moment on, Abdi was determined to become a professional photographer. He tells a story about being in an ESL (English as a Second Language)

class and passing out photographs. Abdi would say to his classmates, "I want to be a freelance photographer, so here's a free photograph." Abdi's adviser, Margaret Hawkins, quickly pulled him aside and explained the importance of a good dictionary.

In spite of his initial difficulties, Abdi went on to be a freelance photographer for newspapers such as the *Columbus Dispatch* and the *Columbus Post*. He also became quite an artistic photographer. Many people would argue that Leica makes the best cameras in the world, so you can imagine how honored Abdi was when Leica offered to sponsor his shows One Month in Europe with Leica (2000), A Leica Portrait of Cuba (2002), and Japan: A Leica Perspective (2004).

Clearly, Abdi had made the incredible transformation from being a soccer star in Somalia to being an important photographer in the United States. But in 1991, his life underwent another significant transformation when civil war broke out in Somalia. Imagine sitting in front of a television in the heartland of the United States and watching pictures of your hometown exploding with gunfire and bombs.

Ironically enough, the television on which Abdi watched Mogadishu's torment was in Columbus, Ohio. Abdi had come to Columbus simply because he had met a friend whose home was there when Abdi was living in Washington, D.C. When Abdi arrived, there were only two Somali families in Columbus. Once war refugees were resettled in the United States, however, Columbus became a place to which Somalis decided to move. Abdi watched as the city underwent profound change. Fifty Somalis arrived one day, a hundred the next. Soon there were tens of thousands of people from Abdi's homeland living in Columbus. Sometimes people were greeted with friendly gestures, but often they were not. Suddenly Abdi found himself faced with the question that other voluntary migrants had to ask themselves: How can I use my talents to help the Somali people? Abdi wasn't a social worker, and he wasn't a doctor or a lawyer; he was a photographer. How could he use photography to ease the plight of the Somali people who were fleeing the civil war? It was in answer to this question that the Somali Documentary Project (SDP) was born.

My own history is significantly different from Abdi's. I was born in Michigan, the son of a factory worker. My father finished only the eighth grade, but he respected education. Nevertheless, he was surprised when his son received a Ph.D. from the University of Chicago. My published work applies the theory of cultural an-thropology to literary texts. My knowledge of cultural anthropology and my ability to write made me a pretty good candidate for Abdi to approach about being the writer for the Somali Documentary Project.

I had always thought that teaching was a way of doing good for people, so when Abdi described the mission of his project I could hardly refuse. The mission of SDP, as Abdi described it then, was to record the history of the Somali Diaspora through photography and writing, to educate hosting communities, and to bring international attention to the plight of the Somali people. I have always admired the fact that this mission has never changed.

Abdi and I had met a few months earlier because I had decided to purchase a camera and reignite a former love of photography. He helped me choose a camera, and we instantly became friends. Mind you, everyone who meets Abdi loves him immediately. Nevertheless, the friendship meant a lot to both of us. We knew that we trusted each other, that we could work together, and that we had the same goals.

Gradually, I began to go out into the Somali community with Abdi, where I quickly met new people and learned about a culture in ways that expanded my imagination. Abdi believes that documentary photography is an extension of the relationship you already have with a person. So we never simply went out and started taking pictures and doing interviews. Instead, we would go and sit in an ESL class for weeks, we

would have meals with families, and we would attend meetings. My point is that documenting Somali people always begins with making new friends.

It would be wrong to present myself as an outsider. Somali folks don't really process information about other people through racial paradigms. Instead, they simply respect anyone who treats them with respect. Once Somali people trust you, you belong within their family and within their community.

That sense of belonging has always been very important to both Abdi and me, but it has not always been easy to earn. When we first started documenting the Somali community in Columbus, folks did not trust us. Many people were fresh from the refugee camps. Their lives had been as close to intolerable as human life can get, and many people whom the refugees should have been able to trust had turned against them, so they were understandably wary.

Ironically, it was an increase in this kind of tension that offered us a significant entrance into the community. At one point, a fight broke out between recent Somali refugees and their African American neighbors. The conflict may well have stemmed from a misunderstanding, but the Somali families felt under attack by people living in their apartment complex, so they had to be moved. When Abdi and I heard about the situation, we went over to start helping people put things into trucks. We didn't bring a camera or a notebook. We brought only our strong backs and

our good spirits. By the end of the first evening people offered us food and friendship. They were calling us brothers. But we still had not overcome their fears. We maintained our hope, though; this was a three-day move that took place over the Fourth of July weekend. And wouldn't you know it, on the last day, just as we started to drive away, one of the elders called out to us, "When are you going to take our pictures?" Because elders are so influential in the Somali community, we knew that we would be accepted by many members of the community and that the Somali Documentary Project could begin.

The reticence to be documented did not simply disappear, however. It exists partially because people who have been abused are distrustful, but it also exists because of the Islamic injunction against creating images. An interesting example occurred when we attended an ESL class in Columbus. We went every Tuesday for six weeks. We met people, talked with them, and helped them with their homework. The elders even spoke for us and told the students what a great thing this documentary project would be for the history of the Somali people. In Somalia people were losing their history, but here they could build one. In spite of all that, when Abdi got his camera out, women huddled together and waved him away. No documenting would ever occur in this class.

When we went to Dadaab, in northeastern Kenya, we were really afraid that people would not let us

photograph them and record their stories. All aspects of traveling to the refugee camp forged a life-changing experience. When our show was on display in the Riffe Gallery in 2005, we described some residents of Columbus as having recently been resettled from Dadaab. As a consequence, people kept asking Abdi and me what life was like in the camp. That is when we knew we had to go. A few months later, Abdi gave a presentation of the work we had done in Columbus to students at the Twin Cities International School in Minneapolis. Once again the topic of Dadaab came up, but this time no one was asking what the camp was like, because many of the children had firsthand knowledge of it. When Abdi explained that we wanted to go to Dadaab so that the history of that difficult place wouldn't be lost in the sand, the children got excited. It was those kids, the children of Dadaab from the Twin Cities International School and its sister middle and high schools, who were responsible for sending us to Dadaab. And when we came back and showed them the pictures, those children also helped us raise money to relieve the suffering in the camp. Perhaps it would be more honest to say that we helped them, because without those kids most of what this project has become would never have been possible.

Flying into Dadaab was incredibly meaningful to me. We took a small plane from Nairobi that flew low over the ground. As one experiences Nairobi from the air, one can see why it is a population center. The river that flows through the city makes the surrounding area green and lush. One can see the outlines of neatly drawn farms that stretch for many miles. Gradually, however, as the plane makes its way north, the river grows thinner and the amount of fertile land diminishes. When I realized that we were drawing near the refugee camp, I thought, My God, no one would want to live here! Indeed, it was absolutely desolate. It is disturbingly ironic that people from a country with one of the longest coastlines in the world are forced to exist in a dry, inhospitable spot, where water comes only with hard labor.

Thankfully, we were wrong to worry that the inhabitants of Dadaab would not want their stories told. Everyone there was aware that what he or she had been through was unjust, and they had some hope that telling their story might put things right. They complained that no one ever talked to them. Journalists, they said, would drive by in a Jeep with representatives of the United Nations High Commission for Refugees (UNHCR). They would stop in the compound and speak to people whom the organization selected, but no one walked through the streets, sat in the huts, and actually talked with the folks who had to do the hard work of making one day lead to the next in this godforsaken place. People would gather in crowds to tell us what they had been through, and if anyone started to use the first-person pronoun, someone else would say, "What do you mean 'I'? It's the same for all of us. This is everyone's story."

I know that human existence in Dadaab is not as hard as it is in many places in Somalia right now—or in many other places in Africa, for that matter. Still, witnessing the suffering that occurs in the refugee camp changes a person and makes him smaller, I think. To walk through the clinics where malnourished women struggle to give birth to children who have little chance of survival is agonizing. Just seeing the amount of dirt in the clinics is stunning.

It is even worse to walk beyond the camp, where thousands of people beg to enter Dadaab. Each of them has a story, no doubt true, of the horrors that he or she has endured. Many get the stories drawn up into letters that they thrust toward any UNHCR employee they see walking by. You must imagine hundreds and hundreds of people waiting at each entrance of the camp, and every morning the employees must turn their heads away from the hordes of sufferers because trying to help all those people would be overwhelming. It must be—indeed, I know it is—excruciating to walk away from a malnourished woman whose life would seem luxurious to her if she had just half of what would seem little to me.

As a matter of fact, simply eating lunch in Dadaab is emotionally trying. The UNHCR allowed us to be in the camp for a limited time every day. We had to go out with their trucks in the morning and return with them in the afternoon. We would meet in the breakfast room, where piles of food were laid out—eggs, pan-cakes, meat, toast, yogurt, cereals, and jellies. When we came back for lunch, we would again have all we could possibly eat available to us. Don't get me wrong: in the United States, this would seem like an inexpensive buffet, and I certainly do not begrudge the staff members of the nongovernmental organizations (NGOs) their nourishment. Nevertheless, the ethical dilemma of human existence is seldom put in such stark terms. Eating itself became like a meal of malnutrition; sand-wiched in between my eating heartily, I had to ob-serve people who got barely enough food to survive. Just a few calories less and they could easily perish. And yet, when I walked through the streets of Dadaab, it was they who offered me food, not I who brought them part of my all-you-can-eat lunch. Dadaab is a humbling place. I shall never recover from the shock-ing way the experience of being there measures out the meaning of human life.

Following Abdisalam, his wife, and their children, the refugee family we met in Dadaab and visited in Ana-heim, was a different kind of challenge. The difference between the subject of a documentary and a friend is something that seems clear enough, but the ethics of journalism and that of human relations often come into conflict. If a friend or relative had come to the United States from Dadaab, we could easily have said, "Come stay with us. We will help you. Live with us while you are learning the language and looking for a job." That would have been the Somali thing to do, but such an

intervention would have prevented us from telling this very important story. In small ways we did help Abdisalam. We bought the kids coats when he couldn't afford them, and we helped him negotiate the prescriptions he needed for his family, but we never interfered enough to change the story. If the story helps the Somali people, then that was the right thing to do. There were times, however, when we just wanted to put the whole family in the car and take them to Columbus, where we could introduce them to the people who could have made their lives so much easier. We hurt with their hurt, and we celebrated their successes. Still, sometimes it pained us when they insisted on feeding us but we could not wrap the warm blanket of our friendship around them and help them through their trying times.

Minneapolis was like dessert somehow, the sweet after a challenging holiday meal. It was like hanging out with friends. Amina Dualle let us live in her basement, heaven knows why, but it was so much fun. One day, Abdi stayed home because he had a headache. Amina's children, Fuad and Ismahan, pretended to have locked themselves out of the house. They sent a friend in through the basement window to let them in. Meanwhile Abdi woke up to hear a noise and see these legs coming in through the window. He picked up one of my big boots and heaved it at the legs. Then he could hear Ismahan and Fuad laughing. That was what life was like in Minneapolis: we were part of the family, and we had a lovely time.

It is true that we spent as much time talking people into letting us document them as we did actually taking photographs and recording stories, but as we got to know folks, they brought us into the family. We were brothers to everyone. We could hang out in factories and coffee shops and talk about African politics or about local friends. We were up every day at 6:00 a.m. and awake until two the following morning, but we loved every minute of it. It was easier to gain the trust of people in Minneapolis, both because by then people could see that the results of our work were positive and also because there were more voluntary migrants there, whereas in Columbus the percentage of people fleeing the war was higher. People who have been shot at recently are simply much more likely to be nervous than those who came to the United States before the war began.

Speaking of being part of the family, when we arrived in the Twin Cities we asked folks to tell us of a family we could document. Everyone insisted that the Warsame family would be ideal, and of course they were. The Warsame family lived in the suburbs, had a son who had been in the American armed forces, and now had five kids in college. They also had one child in high school and one in middle school. Mr. Warsame explained to me that the name of his youngest daughter, Zamzam, refers to the holy water of Mecca that one drinks on the hadj or pilgrimage to the holy city. We were with the family during Ramadan. This meant that

during the day the family was fasting, but after sunset they would have a large meal. We had the privilege of being travelers, so we were not required to fast. Nevertheless we were treated to those wonderful meals in the evening just as if we had.

Kadra, the mother of the family, explained that she particularly missed being home at such times. She told me that there were stories her mother had passed down to her that she would share with her daughters if they were in Somalia, but she would not reveal them in America. I wondered what mysterious part of their heritage the Warsame girls were missing by being in Minnesota. Then, when we showed her the photographs of Columbus and Dadaab, Kadra said, "I don't care what they teach my kids in school; this is the real history. This is what I want my children to know!"

At that moment I knew how important the work we were doing was to the Somali Diaspora. Abdi had told me about Ali Said, the Somali photographer whose studio was raided at the outbreak of the civil war. When Ali got back, he found strings of his negatives being used as clothesline. The documentary history of an entire people was lost with the destruction of one man's work. Ali had been the only documentary photographer in Somalia, and I knew of his tragedy. Nevertheless, when Kadra told us that we were preserving the only history that mattered to her I knew our work had to be made available to everyone in the Diaspora. I realized that she was speaking for tens of thousands,

or more accurately hundreds of thousands, of mothers who wanted their children to look back at a Somali past while working toward a future in America.

Years before this moment, Diriyos, a friend who is an artist living in Columbus, had given us a similar explanation of the value of the project. Just as we were beginning our work, we asked Diriyos what he thought about our plans, and he replied, "In Somalia, when you are lost, we say look back. . . . For people my age, this work will give us something to look back at and remember. For young people, though, when they look back, they must also look forward. This project will be an opportunity to look back toward a history and forward to a future."

I think when Diriyos talked about the project as a way of organizing the lives of people in the Diaspora, I knew it would be a book. However, it was not until Hashi Abdi, of the Somali Action Alliance, explained the stages of Somali existence in America that I knew what the structure of the book would be. This structure seems particularly fitting to me. Diriyos, the artist and poet, gave us the metaphorical meaning of the work; Hashi Abdi, the politician, gave us its logical structure; and Kadra, the mother, gave us the audience. With three beautiful people like these guiding us, how could we fail?

In addition, hundreds of mainstream Americans have asked us thousands of questions at our presentations around the country. It was important that this

book answer those questions, for in this way our work would fulfill two important aspects of its mission: it would provide a history of the Somali Diaspora and it would educate members of the host communities.

On a personal level, though, the Somali Documentary Project has always meant making new friends whom I respect and admire. For that reason alone, I will always be thankful to Abdi for inviting me to become part of the project, and as we make those presentations at schools, churches, and governmental organizations, I am constantly given the opportunity to share with people what I most appreciate about my new friends, friends who have taught me a special kind of humility and who have taught me to be a better person than I could have ever been without the grace that comes with their acquaintance.

The Somali Diaspora in America

Somalis are the new neighbors of Americans. When people come from different backgrounds, it is often difficult for them to introduce themselves to each other. We would like to make those initial introductions through the words and photographs of this book, but as we begin this journey to meet new friends from distant lands, we should make ourselves aware of a few caveats.

As Aristotle once pointed out, a person who lives outside of society "must either be a beast or a god."[1] To be human is to express identity inside a cultural context. To change that context is no easy task. Americans should try to keep this fact in mind as they introduce themselves to their new Somali neighbors.

Another thing Americans should understand is that they have a considerable amount in common with Somalis. For example, Somalis have a profound work ethic. They believe that with hard work, they can accomplish nearly anything, and the truth is that Somalis have to work very hard. They have large families in America, and odds are they have had to leave some relatives back home. So when the typical Somali holds down two or even three jobs, he or she is often trying to support seven or eight people in the United States and even more folks in East Africa.

Like Americans, Somalis are also entrepreneurs. Somalis have always lived in an area rife with trade. Their homeland on the Horn of Africa juts out into the Indian Ocean and is just below the Gulf of Aden, which makes it ideal for trade with India, Asia, the Arabian Peninsula, and the rest of Africa. Consequently, when Americans see Somalis starting businesses, this is not a skill that they are simply picking up from their new environment. It is an ancient aspect of their cultural tradition.

Like Americans, Somalis believe in family. In the U.S. cities where Somalis have settled, they move to the suburbs as soon as they can, because they want to remove their children from the crime associated with urban schools, and they want their kids to get a good education.

If the location of Somalia accounts for some of the similarities between Somalis and mainstream Americans, it also accounts for many of the differences. The

proximity of Somalia to the Arabian Peninsula helps explain why more than 99 percent of Somalis are Sunni Muslims. Somalis are devout Muslims who believe in the five pillars of Islam, which require belief in Allah and Muhammad as his prophet, prayer, charity, fasting during Ramadan, and, finally, a responsibility to make the pilgrimage to Mecca at least once in one's life if one can afford the journey.

Being devout Muslim does not mean, however, that Somalis believe themselves to be at odds with Christian Americans. Somalis distinguish between regional and Islamic disputes. They express concern that the war on terror is a war on Islam in general, and this idea frightens them. Nevertheless, they believe that many conflicts in the Middle East are economic and regional and do not actually concern them. Moreover, Islam teaches that we should all greet each other with a smile on our faces. It also includes the responsibility to be charitable. One's first act of charity should be to one's neighbor. If a Muslim's immediate neighbor is Christian and that neighbor is in need, the Muslim is committing a sin if he or she does not offer charity to the neighbor.[2] Somalis are in a foreign country, which may make them shy, but if given even a slight opportunity, they will become very friendly. If given a larger opportunity, they will transform an American friend into a member of the family.

Aside from faith, geography accounts for many of the other traditional virtues of Somalis, such as generos-ity and hospitality. Historically, Somalis are a nomadic people. Oddly enough, the British were only interested in Somali ports, so they did not develop the infrastructure. Even today, most of the roads in Somalia are unpaved, and unlike most other former British colonies, there is not one foot of railroad in this small country. This lack of infrastructure has kept the nomadic tradition alive well into the modern era. Somali nomads are strong, noble people, who walk tremendous distances with their camels and goats to find water. The danger involved in traveling so far on foot through the desert and scrubland in equatorial Africa means that Somalis have to be able to depend on each other in moments of stress. When nomads make camp in the desert, they keep a fire burning to signal their brethren that they can expect food and water in that spot.

No matter where they migrate today, Somalis maintain that tradition of hospitality and great respect for the traveler. If a Somali living in Texas were to decide to move to Minneapolis, for example, he or she could arrive and meet someone at a Somali restaurant, for instance. Simply as a result of this first meeting, the family of the person in Minneapolis would not merely give the Texas Somali a place to stay, they would even give the traveler their own bed. They would then tell the person from Texas to rest for the first few weeks of his or her stay. After this period, they would help the person find a job and an apartment. In the meantime, they would quite graciously and happily support

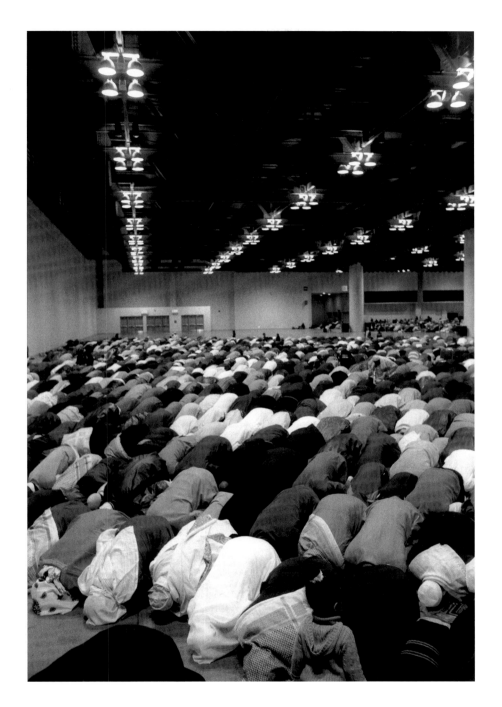

Eid ul-Fitr prayer at the Minneapolis
Convention Center, October 2006.

the traveler for several months. This is the nomadic tradition.

This Somali notion of helping each other through difficult times extends to business as well. Like Americans, Somalis believe in business; unlike Americans, the notion of competition is not a prominent part of their culture. If a newcomer were to come to a successful Somali entrepreneur in the United States, say a clothing retailer, and ask for help starting a business, the retailer might well lend the new entrepreneur the money he needs interest free with no determined date of return. "Just pay me back when you can" would be the exhortation. Or the established business owner might simply give the newcomer half his stock. Perhaps he would even split the retail space, turn half over to the newcomer, and then introduce his customers to the new business.

Another way Somalis help each other start businesses involves the tradition of *sholongo*. Because Islam prohibits Somalis from paying interest, they sometimes face difficulties raising the capital required to start a new enterprise. One way to overcome this barrier is for several people to put money in a pot. For example, imagine that a cabdriver wants to open a phone card shop, knowing how badly his fellow Somalis want to call home. He can manage the rent for the store, but the original investment in stock is beyond him, so he and each of nine friends put $500 in a pool twice a month. This would mean that every two weeks one of the ten people would be given $5,000. The first time our cabdriver received the pot, he would pay the deposit on his new business; the second time, he would invest it in stock, so that within a year, his new phone card business would be up and running. If the other members of the sholongo believed in our cabdriver, they might even let him take the first two pots and then either repay the money or forgo his next two turns. If our cabdriver were to remain in the sholongo, he would be part owner of several businesses within a few years.

The answer to the question of how Somalis get their money is that they earn it just like everyone else, but they also have creative ways of supporting each other, so when Americans see a Somali driving a car shortly after arriving in this country, they should not think that the government is in the habit of giving away automobiles to East Africans; instead, they should try to understand that ten people went in on the purchase of the vehicle, which takes five people to work during the day and another five to work in the evening. Similarly, when Americans see Somalis opening businesses before they have even learned English, rather than imagining some mythical interest-free loan available only to recent immigrants, they should realize that Somalis simply help each other start businesses in ways of which Americans are largely unaware. However, once Americans begin to observe these methods of raising capital, without the often-crippling cost of

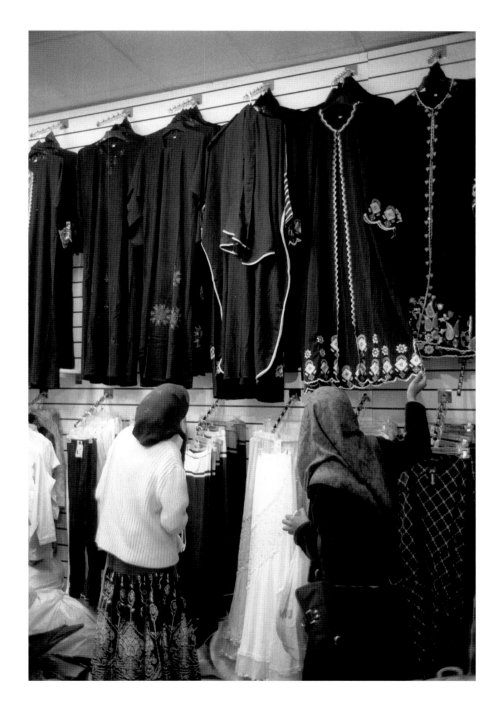

Somali women shopping in Karmel
Mall, Minneapolis, October 2006.

interest, perhaps they might just begin to adopt Somali business strategies.

Finally, Americans should try to be sensitive to the fact that while some Somalis have come to the United States because the land of the free is where they want to be, this is not universally true. Voluntary exiles left their homeland to get an education, to start a business, or just to enjoy the culture and opportunity that America represents. Many of these people are dentists, doctors, teachers, and entrepreneurs. They left Somalia before the civil war broke out in 1991, so they came to America intentionally, and this is usually where they want to live. However, Somalis who fled the civil war were forced to leave their country. Those folks often still consider Somalia their home. It is where they would prefer to live and raise their children. These forced migrants can be teachers, entrepreneurs, and community leaders, too, but they still do not feel at home in America.[3] This is not to say that recent Somali immigrants resent or dislike Americans. Indeed, when asked how they feel about Americans, Somalis will almost to a person say things like "America is our father," and "Americans are good people." They may dislike specific politicians, policies, or even cultural practices (they disapprove of casual sex and the availability of alcohol, for example), but we have never heard a Somali say that he or she dislikes America or Americans.

Nevertheless, it is important to realize that some Somalis, especially those who arrived before 1991, feel as if the United States is their home and are more likely to accept American policies without challenge. However, the Somalis who came after 1991 did not come here willingly and usually do not feel they belong here. They would much prefer to be in America than in their own war-torn country or in a refugee camp, of course, and they appreciate that they have been given a safe place to live by Americans. As an act of friendly consideration, however, Americans should probably keep in mind that many of their new neighbors still feel like exiles; they feel as if home is a country where everyone is Muslim and speaks Somali; it is a place where if they travel, someone will take them in; it's a place where their children call all their adult neighbors uncle or aunt, and like a family member, these honorary guardians are part of raising their kids; home is a place where, when they grow old, they will be honored for their experience and be an integral part of running their community, not segregated from life by walls that treat them as old and tell them that everything important is young; home is a place where, when it's time for their son or daughter to get married, they will be an important part of finding a respectable spouse who will bring them well-behaved grandchildren, and there will be nothing at home to tell their children or grandchildren that casual sex or a life punctuated with alcohol is a good thing. Their physical home may have been blown up in an unnecessary spate of apparently unending violence, but the home of their memories,

the home of their ideals, is a place where they belong. It may not exist in Somalia, but it does not exist in America either, and as good neighbors, Americans should be sensitive to the fact that these hardworking, God-fearing, family-loving people have to live every day feeling as if they belong in a world to which they simply cannot return. Many of your neighbors from Somalia are truly people who cannot go home.

The truth is that in many urban centers, like Columbus, Ohio, and Minneapolis, Minnesota, Americans are trying to understand and relate to their Somali neighbors. However, they have many questions about the new people who have just moved into their neighborhood. At first, they wonder why Somalis seem so foreign. Somalis often dress differently than Americans, and they always worship differently. Moreover, this difference in religion often frightens Americans. For example, in 2006, a group of Somali Imams, or holy men, were praying at the Minneapolis–St. Paul airport as they waited to board a plane.[4] A fellow passenger complained that their prayer made her feel uncomfortable, so the Imams were not allowed to catch their flights. Often, Americans must go through a period of adjustment before they begin to realize that in many ways, they have things in common with their new Somali neighbors, but that in many other ways, there are distinct cultural differences between them and recent Somali immigrants. Once they acknowledge the similarities and the differences, many Americans wonder when the differences are going to go away.

About recent immigrants from the Horn of Africa, Americans often ask, "When are the Somalis going to assimilate?" whereas the Somalis inevitably wonder, "How can we maintain our culture?" A certain amount of tension seems to exist between members of the dominant culture, who want to know when the Somalis are going to become like them, and the Somalis themselves, who want to know how they can enjoy the safe haven that is the United States without adopting the often crass and all too often violent aspects of American culture with which they are confronted.

One therefore has to be careful with the question of assimilation, because it is often signals misunderstanding. The people who ask it don't always realize the variety of Somali immigrant experiences in this country or the breadth of experience people had in their native land. When a Somali ESL teacher recently asked his students if we could document them, he explained why a Somali documentary history might be valuable by saying, "When you think about it, many of our kids today don't even know how to milk a camel." The ESL teacher meant to say, of course, that if Somali cultural traditions were not recorded, many of them would be lost from memory. Yet for many Americans the unintended message might be that all the Somalis they meet come directly from the nomadic experience, but this is very far from the truth. Many, many Somalis who lived in Mogadishu or other large cities were educated in Italy, Germany, and other European countries. Members

of this professional class speak several languages and often immigrated to the United States before the civil war began. Thus, the Somali experience in America can range from that of a gentleman who was born a nomad but now runs a coffee shop in a bustling American city to the former ambassador or even the former prime minister. Such people are citizens of the world, and like others with international experience, they are well educated and sophisticated. Any question of how Somalis are going to intersect with American culture must begin with the realization that people from Somalia have brought with them a range of experiences. It is true that they all speak Somali and are Sunni Muslims, but within that cultural framework, they had a wide variety of economic, educational, and even religious experiences.

Most people also remind us that the United States is a nation of immigrants, and they suggest that all immigration experiences are alike. However, descendants of earlier immigrants often trace their roots to Europe, and few previous influxes of immigrants have had to endure the horrible holding tanks of the refugee camps for decade upon decade before they came to America. Then there are the African Americans, whose ancestors were brought here as slaves, but those noble and long-suffering people are separated from their heritage by five centuries of oppression, violence, and frustration. The institution of slavery separated African Americans from their original culture so thoroughly

that it left them primarily with the culture that enslaved them. As a result, they are more American than they are African, and, although this fact often surprises both European and African Americans, African Americans usually have little in common with recent Somali immigrants. So the question about this specific group of immigrants must remain: How do members of an African culture who have been invited here by the U.S. government manage to intersect with a culture infused with European traditions? How do members of a Muslim culture decide to coexist with a culture that is nominally Christian?

Americans seem to expect Somalis to assimilate, but what does it mean to assimilate? The answer has to do with questions like what it means to be human, and how one shares that humanness with one's children. After that it has to do with questions of how one defines one's religion, how one educates one's children, how one dresses, and how and with whom one eats. The distance between *sambusa* and hot dogs is a space we travel with the word "assimilation."[5] Most Americans now think that they should be able to draw the road map of assimilation, but many Somalis have decided that they want to draw the map for themselves. Actually, most Somalis avoid the word assimilation. Abdirashid Warsame explained his difficulty with the concept by saying, "America may be a melting pot, but I don't want to melt." Somalis seem to prefer the concept of participation, the notion that they can

participate in U.S. culture without letting America define the meaning of their lives.[6]

The U.S. government thinks of human beings as individuals, a concept of humanity that developed during the Protestant Reformation and was filtered through philosophers like John Locke, John Stuart Mill, and Thomas Jefferson. "All men are created equal," the founding fathers inform us, but after that each of us must pursue life, liberty, and happiness individually, in competition with others, which theoretically produces the greatest good for all. For Somalis, whose cultural traditions were not filtered through the Reformation, the individual is always subservient to the family and to the larger community of Somalis. Therefore, even though the U.S. State Department resettles them individually, these nomadic people travel until they find themselves together.[7]

Various local communities, most notably Lewiston, Maine, but also Columbus, Ohio, and many others throughout the country, have been confused by and have struggled to resist this secondary migration on the part of Somalis. Most Americans are not prepared to relate to Somali people on their own terms, people they themselves invited into their country. It is important to bear in mind that Somalis are legal immigrants to the United States, who are here because the American government, under the provisions of the Geneva convention, granted them permission to live within its borders. If they are going to move a second time within the United States, why do Somalis choose northern cities, like Columbus, Minneapolis, and Lewiston? Why don't they settle in the South, where the climate may be more like that of their homeland? Somalis are asked these questions with a rhythmic consistency, but attempting to discover an honest answer must inevitably lead to deep philosophical and cultural questions. Somalis are often initially resettled in warmer places such as Anaheim, California, Atlanta, Georgia, and Tucson, Arizona, but they leave for various reasons that are immediately obvious to refugees themselves but that are not often considered by mainstream Americans. For example, they leave Anaheim because it is far too expensive for a family of recent refugees. The initial federal grant for refugees only pays the rent for the first month or two, and the social assistance that follows usually will not pay the rent and utilities required for large Somali families. Atlanta also is too expensive. Moreover, the housing Somalis were given there tended to be in parts of town where they didn't want to live. Indeed, it seems ironic that Americans somehow expect Somalis to settle in southern cities, but they don't appear to spend much time reflecting on how difficult three centuries of racial tension have made life for the African Americans who already live there. Why should newcomers walk straight into problems Americans have yet to solve? Somalis don't worry about racism much, and they don't filter life through racial paradigms the way Americans do, but why

would they voluntarily live in impoverished neighborhoods, or why should they voluntarily inhabit the impoverished spirits that racism has created?

One afternoon, we were speaking with Sadio, a young Somali mother whom we followed from Dadaab to Anaheim, California. The family realized that Anaheim was too expensive and that they would soon have to move. At that moment, Sadio asked her cousins with whom she had been resettled, "Why do Somalis live in all the cold places?" The first answer to her question has to do with the economic and class structure of America. Anaheim, the home of Disneyland, is, like all of Southern California, an extremely expensive place to live; a Somali family who doesn't speak the language and whose survival skills were developed in a refugee camp could not afford to remain there long. Nearby San Diego has a Somali community of 10,000 or so folks, but they are mostly voluntary migrants who came to the United States for an education and who have lived here long enough to command professional salaries. Recent refugees must find a Somali community where the cost of living is tolerable and where middle-class life is affordable enough that they can raise their children in a safe environment with good schools. To achieve this middle-class goal, while simultaneously sending money home, Somalis are willing to work three jobs, go to school, and start a business, but they want those three jobs to let them live where they can separate their many children from the violence and sexual exploitation that vibrate throughout most American inner cities and where they can give their kids a good education. The truth is that most Somalis find these goals easier to accomplish in many northern American states than they do in warmer climates.

We spoke to Abdulkadir Hashi, president of the Somali Business Association of North America and the owner of a thriving trucking company, who moved to Minneapolis from North Carolina. That move in itself contradicts the expectations of most Americans, but it becomes even more ironic when one considers his declaration that "when I first came to Minneapolis, I saw a woman wearing a hijab and I felt like I was home." This was the Minneapolis of a decade ago, before the Somali community was so large. Abdulkadir asked the Somali lady if there were a Somali restaurant nearby, and he discovered that there was. In addition to relating this experience, Abdulkadir adds a qualification that helps answer the question of most Americans, for he holds to the principle "Where I make my living is where I make my home." By this simple declaration, Abdulkadir explains how much easier it is for Somali families to make a living in Minneapolis than it is in many other parts of the country.

Can the goal of Somali Muslims actually be to achieve what most Americans think of as assimilation? Consider for a moment the way Somalis celebrate Eid ul-Fitr in Minneapolis. Traditionally, Somali families treat their children in a special fashion to observe the end

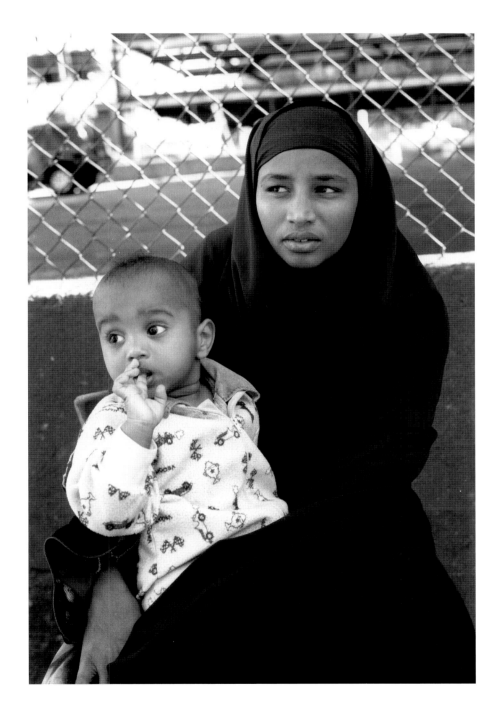

Sadio and her son Abdiaziz,
Portland, Maine, October 2006.

of Ramadan. In Somalia, parents send their kids out to the neighbors with bags, and the children come back with candy and money. In Minneapolis, when the fast is broken on the last evening of Ramadan, the children are taken to the Somali malls, where they are allowed to select one present. On Eid itself, however, which begins the day after Ramadan, the youngsters are taken to the Mall of America. There were approximately 30,000 Somalis in the Mall of America during the Eid celebration of 2006. They came immediately after the service at the mosque, around noon, and stayed until the mall closed at 11:00 p.m. As many Americans know, the Mall of America has a large amusement park at its center, but this state fair atmosphere becomes an image of Eid Wanaagsan (Happy Eid) for Somali children. They share with other Muslim kids the joy of the frog-jump, the log ride, or bumper cars as a way of enjoying the end of the fast and of celebrating their renewed testimony of the power of Islam. The image these children have of a happy Eid will forever be associated with the Mall of America. The symbol of middle-class commercialism, the largest mall in the United States, for one day becomes in the Mogadishu of North America the physical celebration of a Muslim holiday.

In one sense, the celebration of Eid in the Mall of America should mean that the Somalis in Minneapolis have assimilated. Somalis have not simply adapted to this symbol of American commercialism, however; they have taken it over and made it their own. After interviewing a substantial number of the shop owners that day, and the very few customers who were not Somali, we came to understand that they were confused and troubled by the Eid celebration. They felt as if the space did not belong to them on that day, and they did not understand the values of the people who had taken it over. The Victoria's Secret mannequin may remain in a ridiculous state of public undress and the Christmas tree may remain boldly lit,[8] but those symbols of American culture have no meaning in the Mall of America on Eid, for on that day young women in hijabs and little boys wearing the *Qamiis iyo Cigaal*[9] celebrate their successful negotiations of the trials of Ramadan. For an entire month, children thirteen and over have had to survive the daylight hours with nothing to eat or drink, and their younger siblings have been experimenting with the fast and bragging about their strength of character. It is important to realize that fasting means the avoidance of all pleasures, even affection, and for the last week of Ramadan it often means forgoing sleep. During Ramadan, Somali children have been making themselves strong enough and holy enough to be worthy of the blessings of Islam. During Eid, they are given permission to have treats and to enjoy these simple rides in celebration of the strength of character that they have discovered and developed the month before.

Not only are they celebrating Islam, but unlike individualistic Americans, who dread shopping at a

crowded mall, the Somalis are also celebrating each other. They are happy that the building is full of other Somalis. For one day, the Mall of America becomes a Somali space. Somali moms in their beautiful holiday headdresses chatter with each other in every small shop, while their children giggle with the thrill of being lifted to the heavens on a ride. Somali dads fill the coffee shops, talking about whether any practice or institution could possibly pull together the small country on the Horn of Africa long enough for them to visit their relatives one last time before they die. For one day, the Mall of America has become a celebration of Islam not Christianity, community not individualism, modesty not exhibitionism, sacrifice not indulgence.

Is this assimilation, or is it a way of temporarily redefining a foreign environment and making it one's own? The establishment of a group of charter schools in Minneapolis and the movement of Somalis to the suburbs represent the same phenomenon of a people creating its own way of relating to the dominant culture. Somalis have had several problems with conventional public schools since they arrived in America, and in fact they have tried to work with the school systems to resolve those problems. The larger issues involve such things as children being placed according to age rather than intellectual ability. For children who grow up in the brain-stealing environment of a refugee camp, this can be a severe impediment. Other problems involve the presence of gangs and the exposure to

a culture of violence and sex that all our children must endure in public schools. Often non-Muslim children do not understand why hijabed girls are not available for dating, so they hit the girls in frustration or pull off their hijabs. Somali boys then protect their sisters and fights start. Issues that seem smaller to Americans but not to Somalis involve such things as a requirement to have an art class. As many Muslim people observe a religious injunction to avoid creating human faces, having their children study art in conventional American schools makes many Somali parents uncomfortable.

In response, Somalis all over the country create after-school programs to bring Somali children up to grade level. Moreover, in Minneapolis, Abdirashid Warsame developed a group of charter schools called collectively the Twin Cities International School, which allows the Somali community to educate its children in a way that will maintain their culture. Twin Cities International teaches the fundamentals, as any other school would, but time is set aside for prayer, and when a child gets into trouble, he or she is taken to a group of Somali elders for discipline. Only in severe cases are discipline problems referred to the principal. Moreover, the school is aware of the ravages of the refugee camps on Somali kids, so it has built a support system to help children achieve grade level. Teachers know which children have suffered from what trauma and treat them accordingly. One young boy named Mohammed is very smart but challenges discipline in

every class. His teacher, Dr. Ali Jama, explained to us that the boy has an anger management problem because of his experiences in the refugee camp. For that reason, teachers are tolerant of his sometimes disturbing behavior and continue to encourage him to develop his intellectual skills. In a public school, Mohammed would be lost.

The Twin Cities International School speaks to the issue of participation. Hashi Abdi, the director of the Somali Action Alliance, a political organization in Minneapolis, holds that Somali refugees experience three stages of life in the United States: dependence, preparation, and participation. When Somalis first come to America, they are not ready to work and are dependent on social services. The economic assistance they receive does not last long, and it is never sufficient to cover all of their bills. This stage usually ends soon, though, because the aid agencies and the NGOs across the country quickly begin teaching people how to survive in a first-world country.[10] During the preparation stage, Somali refugees develop language and job skills and adjust to American culture, which they once thought would solve all their problems but which they soon learn would only help with some of their troubles, though it introduces them to many others.

Finally, there is participation. Participation is a concept that is different from assimilation in that it suggests that Somalis are able to take part in those aspects of American culture that suit their definition of self but not those that violate their dedication to their family or their religion. In this way, women who participate in a union rally wear purple hijabs, purple being the color of the union. In the eyes of most Americans, the hijab is a symbol of the powerlessness of Somali women, but for these ladies it becomes a symbol of their power. In this way also, the Warsame family can move to the suburbs so that their children are removed from the tensions of violence and sexuality of inner-city schools and receive the good education that is typical of suburban schools, but the family can still send its kids to Qur'an school and teach them the value of a Muslim life.

The issue of assimilation versus participation is perhaps best illustrated by Somali cabdrivers in Minneapolis. Muslims (primarily Somalis) make up roughly 70 percent of the cabdrivers in the city, and many reject riders who carry alcohol. According to the cabdrivers, only about 6 percent of the fares from the airport carry alcohol, but when a driver refuses a fare, he is sent to the back of the line, which takes on average six hours to work through. Moreover, the driver risks losing his job and even his license by refusing to transport a person carrying alcohol. Hassan Mohamud, along with the Metropolitan Airports Commission and other leaders, worked out a perfectly feasible solution, which was to have a certain color of light or sticker on taxis, signaling which drivers would not transport alcohol. The dispatcher would then observe people carrying

alcohol and take them to the drivers who were not concerned with the issue. Unfortunately, that compromise was attacked in the press.

The cabdriver issue has been covered with a degree of excitement in the Twin Cities that has made finding an equitable solution difficult. The late professor Edward W. Said of Columbia University has analyzed the relationship between the press and Muslim culture. In *Covering Islam,* Said makes several points that are worth considering here. "In no really significant way," he argues, "is there a direct correspondence between the 'Islam' in common western usage and the enormously varied life that goes on within the world of Islam, with its more than 800,000,000 people, its millions of square miles of territory, principally in Africa and Asia, its dozens of societies, states, histories, geographies, cultures."[11] Said goes on to say that when covering Muslim communities, most reporters are confronted with a group of people whom they don't understand, and whose language they don't know, so they come to depend on ready-made phrases:

> There is an unquestioned assumption that
> Islam can be characterized limitlessly by means
> of a handful of recklessly general and repeat-
> edly deployed clichés . . . [N]ot knowing the
> language is only part of a much greater igno-
> rance, for often enough the reporter is sent
> to a strange country with no preparation or

experience, just because he or she is canny at picking up things quickly or happens to be in the general vicinity of where front page news is happening. So instead of trying to find out more about the country the reporter takes hold of what is nearest at hand, usually a cliché or some bit of journalistic wisdom that readers at home are unlikely to challenge. (xi–xii)

We would have to substitute the word "culture" for "country" to apply the preceding passage to the relationship between the press in the Twin Cities and the Somali community. Nevertheless, from Said's perspective it would seem that many journalists in Minneapolis and St. Paul were quick to apply the clichés from the war on terror, so abundant in the evening news, to the Somali cabdrivers. For example, Katherine Kersten wrote an opinion piece for the *Minneapolis Star Tribune* that associated the cabdrivers with terrorists by calling them Islamic fundamentalists (Katherine Kersten, October 16, 2007), and Fox News stirred up emotions by suggesting that the cabdrivers might be associated with Sharia law and America's enemies in the war on terror (John Gibson, March 1, 2007). The cabdrivers obviously have no intention of hurting anyone, but the inability of many Americans to understand these Muslim people translates into fear, fear that it is easy for the press to play upon and exaggerate.

Arousing fear or misunderstanding should not be the

goal of anyone whose job it is to communicate between cultures in the United States. Indeed, if one believes in a pluralistic society and is willing to think about other cultures according to the principles involved in that concept, then the point of a comparative exercise should not be to prove that one culture is superior to another, but rather to try to understand that other people might live according to different values. This does not mean that human beings should not be capable of learning from one another across time and space, but it should mean that we can respect each other's differences without insisting that we all become the same or encouraging us to fear each other's differences.

Moreover, there is a larger concept in which human beings confronted with diversity attempt to understand that people from other cultures might define themselves by principles different from those of mainstream Americans. The issue involved in the cabdriver dispute seems to be one of self-definition, or ontology, and suggests why assimilation is perhaps not achievable and may not even be desirable on the part of some Americans. First of all, consider that the cabdrivers are being as purely good as they know how to be by refusing to be associated with the *Haram* (the sin) of alcohol, and according to Hassan Mohamud who is a Sheik, a scholar of Islam, and a practicing lawyer, they are forbidden by the Qur'an to be associated even with the act of carrying it. Nevertheless, it is the cabdrivers who are associated with evil by the news media and the alcohol drinkers with good. Given the myriad of cultural contexts in which alcohol can be linked with a lack of restraint and even with religious evil in America, this seems on the face of it to be a bizarre inversion. Indeed, we all know that a cabdriver would be arrested if he were to carry open bottles of alcohol, so it seems a bit odd to hear people suggesting that because a driver would rather not make a distinction between an open and a closed bottle, he is somehow trying to undermine the American way of life. The fact remains that Americans do not understand why Somali Muslims cannot transport alcohol even though they don't believe in drinking it, and they are unable to understand because of the profoundly different ways in which Somalis and Americans define themselves.

Americans define themselves as free to act, but for many, the freedom to act is not tied to a philosophy of being. For Muslims, every act must be based on their most intense and intimate definition of self, but for Americans, one's actions can be separated from the nature or essence of one's being. The separation of the spiritual from the acting self is not something Somalis have experienced. They believe quite simply that bad people do bad things and are associated with evil. Transport a man who will drink the alcohol you help him carry, and part of the guilt that should derive if he beats his wife will be yours. Of course, the more important issue is that the cabdriver will have violated his own sense of purity.

As we have seen, the manner in which mainstream Americans define themselves must be distinguished from that of Somalis. Nevertheless, the ethical goals of Americans and Somalis are not always as estranged as they might at first appear. Indeed, when you listen to Somali parents worrying about their children, they sound remarkably similar to American parents, so perhaps the moral structure of Islam should not be as frightening as the press often makes it seem. Consider, for example, the fact that Americans have been troubled by the young age at which their children are initiated into sexuality. Should they not be grateful for a group of parents who refuse to allow their children even to dress in a sexually suggestive fashion? For decades, Americans have also decried the way the media promote the abuse of alcohol by young people. Yet semitrucks deliver beer to college campuses to help American teenagers celebrate football games. Should parents not at least hope that instead of befriending someone who does shooters after class, their kids might actually get to know someone for whom alcohol is forbidden?

Christians and many secular Americans often express an anxiety to restrain the license of postmodern America. Most would prefer to do so without limiting the freedoms that make the United States what it is, but of course, Somalis do not want to limit that freedom either. Indeed, from their point of view, the disagreement over the cabdriver issue involves the fundamental American freedom to practice one's religion. Moreover, freedom and pluralism are among the principles that allow Somalis to be in the United States and to practice their own culture. Somali Muslims are thriving in American culture, so they have no wish to undermine it. And since Somali Muslim parents want many of the same things for their children that American parents desire for their kids, it is hard to believe that the ethical paradigms that make both sets of parents wish to care for their children in a similar fashion make them as irreconcilable as the headlines would have us believe.

As we noted previously, Hashi Abdi's three phases of Somali immigrant life—dependence, preparation, and participation—represent the Somali experience in America. Add to these phases the initial stage of being a refugee and you have the outline for this book. Our story begins in a refugee camp where Somalis fled when the civil war broke out in 1991. From there we move on to document the family of Abdisalam, whom we met in Dadaab refugee camp in Kenya and then followed to Anaheim, California, and finally to Portland, Maine. When the family of Abdisalam arrives and begins to cope with life in America, its members are dependent on the social services available to them. This fact is frustrating to Abdisalam, but his frustration is one of the new challenges he must face.

Next we document Somali life in Columbus, Ohio. Most Somalis who live in Columbus came from southern

Somalia. They were nomads and subsistence farmers, many of whom were not well educated before they arrived. As we mentioned earlier, the Somali population in Columbus includes members of the professional class, but their numbers are few in comparison with those in Minneapolis, Minnesota, so in many ways, in spite of the numerous businesses there, Somalis in Columbus are still preparing to participate in American life. People there are flocking to ESL classes, learning job skills, and working for minimum wages under difficult conditions.

However, one only has to spend a little time in the Somali community in Minneapolis, the Mogadishu of North America, to realize that while most people in Columbus are still preparing, the Somali community in the cold, northern city on the banks of the Mississippi is fully participating in American life. Here Somalis not only influence elections, they win them; they are not simply victims of the media, they challenge it. Here, the Somalis do not simply complain about the public schools, they create their own. In Minneapolis, Somalis are not just studying to be doctors, they perform operations.

One major theme of our work is that the people in these photographs are the neighbors of Americans, and it is important that neighbors should understand one another. One way to accomplish this goal is for Americans to comprehend what Somalis have been through. Moreover, in order to understand the Somali Diaspora,

both Americans and Somalis themselves must come to recognize and appreciate this full range of Somali experience in the United States. That is why we begin on the dirt roads of Dadaab and end in the active and well-lit streets of Minneapolis.

NOTES

1. Aristotle, *The Politics,* trans. Benjamin Jowett (New York: Colonial Press, 1900), 1.2.7.

2. *Al-Qur'an: A Contemporary Translation,* by Ahmed Ali (Princeton, N.J.: Princeton University Press, 1993). See, for example, Surah 4, Ayah 36, p. 79. (Surah and Ayah in the Qu'ran are equivalent to chapter and verse in the Bible.)

3. See Nicholas Van Hear, *New Diasporas: The Mass Exodus, Dispersal and Regrouping of Migrant Communities* (Seattle: University of Washington Press, 1998): "Forced migration refers to individuals or communities compelled, obliged or induced to move when otherwise they would choose to stay put; the force involved may be direct, overt and focused or indirect, covert and diffuse" (10).

4. Bob Von Sternberg and Pamela Miller, *Minneapolis Star Tribune,* November 26, 2006.

5. *Sambusas* are triangular Somali pastries filled with meat, lentils, and vegetables that are fried in oil. They seem to be related to the samosas eaten in India. Of course, most hot dogs contain pork, which Somalis do not eat because of the Muslim prohibition against it.

6. Actually, many cultural anthropologists and sociologists now avoid the word "assimilation." For example, George De Vos, a cultural anthropologist at the University of California

at Berkeley uses the concept of "adaptation" instead, which is similar to Hashi Abdi's concept of "participation," discussed later in this chapter. See George A. De Vos, *Ethnic Identity* (Chicago: University of Chicago Press, 1982).

7. Current research argues that refugees need the support of others who speak the same language to survive in a new cultural environment. Unfortunately, current government policy is based on research from the 1950s; see Donna R. Gabaccia, *Immigration and American Diversity: A Social and Cultural History* (Oxford: Blackwell, 2002), 200–263.

8. We spoke to the public relations manager at the Mall of America on Eid about the Christmas tree, and he tried to explain that this symbol was devoid of religious significance by describing it as a "holiday tree."

9. The *Qamiis iyo Cigaal* is a long head covering secured with an ornamental rope worn by Muslim men on formal occasions.

10. See David Peterson, "African Immigrants Set Pace to Get Off Welfare," StarTribune.com (December 27, 2006). Peterson points out that "research by state officials shows that, although African immigrants received more welfare assistance than U.S.-born blacks at the beginning of this decade, they now receive less." Peterson goes on to quote Ruth Krueger, director of employment and economic assistance for Dakota County: "On the state's so-called 'self-support index'—based either on working at least 30 hours a week or departing from welfare altogether—Somalis in Dakota County are earning a rating of 80 percent vs. 72 percent for whites . . . Statewide, the figures are 78 percent for whites, 75 percent for Somalis, 76 percent for other African immigrants and 58 percent for U.S.-born blacks and American Indians."

11. Edward W. Said, *Covering Islam: How the Media and the Experts Determine How We See the Rest of the World* (New York: Pantheon Books, 1981), x.

Dadaab: That Dry, Hungry Place

Dadaab refugee camp in northeastern Kenya is home to more than 150,000 refugees who fled the violence that stemmed from the civil war in Somalia.[1] When President Mohamed Siad Barre was overthrown in 1991, violence became endemic in this small country on the Horn of Africa. The cold war and the Ogaden conflict with Ethiopia left the country rife with weapons.[2] Consequently, when the central government in Somalia crumbled, people easily fell prey to competing warlords and ordinary bandits. Somalis have a saying: "When elephants fight, the grass dies." Most Somali people were like the grass in the conflict that swept through their country. Mohammad, for example, recalled how nice life once was in Mogadishu. He would take his children swimming many an evening in the nearby Indian Ocean. One day bandits came to Mohammad's home and demanded money. He explained that he didn't have any, but that he would write these armed men a check if they would only leave. "I think you know the banks are closed," the thieves responded, and they shot him. As they raised their guns, Mohammad's brother tried to intervene, so they shot him too, his body falling on top of Mohammad. While this horror was unfolding, Mohammad's son tried to run to the neighbor's home for help, but he was gunned down for his efforts. When the carnage ended and the thieves had left, Mohammad's wife ran her fingers over his lips to discover that her husband was still alive. During those few tragic moments, Mohammad lost his son, his brother, his country, and the meaning of his life. Still he had to find the strength of character to let his wife drag him to the refugee camp, which was hundreds of miles away.

To understand the magnitude of the violence that swept through Somalia, one must comprehend that most people have a story similar to Mohammad's. After being threatened by random gunfire, educators, subsistence farmers, small business people, and nomads had to flee through 80 kilometers (roughly 50 miles) of desert to reach Dadaab, assuming they survived long enough to reach the border. When the gunmen came, people had no time to gather supplies. They just had to run. We have spoken to people who report drinking water from the few mud puddles they could find and living off mangoes, the only food they could find, for more than

a month, as they struggled to reach the refugee camp. Many were wounded by roving bands of thieves, so loved ones would have to carry or drag them in this crippled state to the camp. We even spoke to one woman who was pregnant when the bandits came to her village. When she started running with the others from her village, the movement stimulated her contractions. She had to stop, deliver her child, and then pick up the baby and start running again. Abdisalam, the father of the family we followed from the camp, was shot in the arm as he was leaving the mosque in Sakow. At that moment, he joined the exodus to Dadaab, making his way through the desert while he was still bleeding. Multiply these events thousands of times. Take them from large cities and small villages. Picture hordes of people running, taking buses, driving cars, and sailing boats to flee gunmen, and you start to envision the massive human flood that the UNHCR had to find a way to house when it created Ifo, Hagadera, and Dagahaley, the three camps at Dadaab.

Dadaab was already a small village in Kenya, a place many Somali nomads would pass through, when the UN built its compound. There refugees live in stick-and-mud huts, walk miles for water, live on little food, and are educated under the most primitive of conditions.

Immediately after the 1991 war started, the UNHCR had to work quickly to help displaced Somalis, but the process has sadly slowed.[3] Because of continuing conflicts in the country, an additional 50,000 people made their way to the camp in 2006, but unfortunately it will take some time for those people to be absorbed into Dadaab. Currently, a refugee struggles across 80 kilometers of desert after he reaches the Somalia–Kenya border only to be told that he cannot enter Dadaab. However, he is perfectly welcome to fill out a form. The new refugee is interviewed. He answers the questions in the hope that when he finishes this confusing conversation, he will be granted entrance to the protective environs of the camp. Legally, it should take no longer than three months to be processed into Dadaab. The refugee could never comprehend, however, that processing this form will in fact take three years on average, three years during which the refugee will have no legal right to food or to the protection of the camp.

During this long period, the UNHCR is trying to decide whether the applicant is a political or an economic refugee. Political refugees are granted status under the Geneva convention and so are perfectly welcome to the meager food and shelter the camp provides. Economic refugees, on the other hand, must continue to make their own way in the often treacherous no-man's-land that surrounds Dadaab. To the people who have fled the violence, this distinction makes no sense. To give the UNHCR credit, the organization has few resources and must apply them according to the mandate they are given by the donor countries, but to the people themselves, the difference between economic and political refugees appears nonexistent. If you left

when the bandits were shooting up your village, and specifically shooting at you, then you would be a political refugee. Unfortunately, if you were to wait long enough to discover that you could not possibly support yourself in a village from which the thieves have taken everything and have chased everyone else out, then you would become an economic refugee. No matter how you frame the discourse, it would be difficult to explain this distinction to someone who is hungry. We spoke to one woman who had survived outside the camp for eight years. She felt she could not return to Somalia for fear of being shot, and she knew that if she ventured farther into Kenya, she would be arrested. So she continues to wait outside the camp. She told us that she has been raped more times than she can remember, and she said, "I am starving out here! I am starving!"

So how do those people survive who wait for years outside the camp without food? They are supported by friends, relatives, and those Somalis who have been granted the much-sought-after privilege of entering the camp. And yet, no one inside Dadaab gets enough to eat.[4] People are given 6.6 kilos of ground maize that has sat in storage for years. This 14.5 pounds of cornmeal has to last an entire family fifteen days. Unless a family is lucky enough to have a relative outside the camp who provides money for such things, or unless a member of the family is fortunate enough to work for the UNHCR or another nonprofit organization, there

will be no meat, no fruit, and no vegetables in the family's diet, only the stale maize and a little bit of cooking oil. This diet often causes refugees to contract diarrhea, but the odds of the clinic having medicine for this disease are not good. Diarrhea can kill people, especially children, because of dehydration, but that is just one more struggle that must be faced by the residents of Dadaab.

Even though no one in the camp has enough to eat, Somalis are so generous that they share what little food they have with refugees who wait outside with nothing to eat but charity. In fact, Somalis are so hospitable that when we walked down the dirt lanes of the camp, refugees invited us in for tea and cakes. One of life's great ironies is that people who themselves are starving insist on being generous, but if donor countries were equally as giving, those folks would not be nearly as hungry.

Schools operate in the camp, but the students have no notebooks, almost no books, and very few pencils. Another of the great ironies of Dadaab is that students are taught to read and write, but once they learn, they have nothing to read, nothing to write on, and nothing to write with. The student-teacher ratio is nearly sixty students per teacher, and many of the teachers have learned what they know inside the camp. There are also no screens on the school windows to keep out the mosquitoes. When we visited the clinic, we were told that it was working at 110 percent capacity, but

it would be at 170 percent once the malaria season started. One wants to ask if mosquito screens can really be so much more expensive than trying to treat children with malaria.

Many people were in the clinics when we visited, but no one wants to go there. The doctor explained to us that mothers resist coming to the clinic until it is too late. Frankly, one can understand why. The clinics are dirty, small, and inadequate. They are understaffed and underequipped. Many mothers die when they come to give birth because they are badly malnourished, and most of the babies perish as well. There are no X-ray machines here. Dadaab can afford to fly seven people a month to Nairobi for X-rays, but after that limit is reached the next person in line cannot have an X-ray that month and may never get one. We spoke with one man who, along with his son, had fallen off his donkey cart. Both men broke bones, but only one space was left in line for the X-ray machine that month, so the father asked that his son be treated.

Unfortunately, Dad will be paralyzed from the hips down for the rest of his life, because his opportunity of having his broken hip treated has passed. Family and friends must carry him around on a litter. That is the only mode of transportation left to him now that his legs have stopped working. Another of Dadaab's great ironies is that there is an X-ray machine in a clinic that is well staffed with doctors and nurses and in which other equipment and medicines are available.

That clinic, however, is reserved for the people who are about to be resettled in the United States, a country that insists that no diseases be brought to its shores. This clinic is not for people who are actually ill.

So if it takes three years to get into Dadaab, how long does it take to get out? The stark reality is that most people will never leave the camps until the UNHCR determines that Somalia is a safe place for the refugees to return. At one time, Canada, Australia, and the United States were taking refugees from Dadaab. However, those numbers significantly diminished after the terrorist attacks of September 11, 2001.[5] Now, only the United States is accepting Somali refugees from the camps and then only a few hundred a year. Family reunification programs also allow a few hundred Somalis to leave the camps annually. Moreover, the policy in 2005–6 was only to resettle victims of violence or torture. Because there is no seniority system, these plans for resettling whatever group the current director and the State Department see as most vulnerable seem unfair to many of the inhabitants. Most people who live in Dadaab have been there since 1991, when the civil war in Somalia broke out, and most residents of the camp will be there until peace is restored to their homeland. Recently, we spoke to a Somali refugee who had been both in Kakuma and Dadaab (Kakuma is another refugee camp in Kenya that houses a large Somali population). When asked which camp was better, he exclaimed, "Kakuma, because if you are in Kakuma,

there is some hope you will get out, but in Dadaab, God help you." One hundred and fifty thousand people are stuck in a place where there is almost nothing to do; where if you are hungry, there is little to eat; if you are sick, there is little medicine; and if you hunger for knowledge, there is little education.

There is at least one plane of existence on which the residents of Dadaab thrive, however, and that is the spiritual plane. We saw only one mosque while in the camp and that was only half built because of a lack of funds, but everyone there is a firm believer, and it is clear that their faith gives the residents of Dadaab the strength they need to survive. When we attended the graduation ceremony in Dadaab, the Imam adjured the students and their parents, saying, "You cannot think about the life surrounding you. You have to think about something higher." I believe that everyone in the camp was able to take his advice, for in this place where life is perhaps as harsh as life gets, everyone's looks and everyone's spirits were high. People in Dadaab look noble, and they act nobly. Walk down the paved, indeed, the gilded streets of the busiest towns in America, and people try to extort money from you in all the forms available to them, from merchandise to begging, but walk down the dusty avenues of Dadaab and no one asks you for money. Instead, they invite you in for tea and *anjeero* (a kind of Somali bread comparable to a pancake). They have nearly nothing, but whatever distance they experience between nearly

and nothing represents something they are more than willing to share with old friends or friends they have just met, and share it they will, with a happy and an optimistic spirit, even though it means they will go hungry later. These are spiritual people, who inhabit a desolate land.

NOTES

1. The population of Dadaab was 150,000 when we were there in 2005. Since then, the flooding in Somalia and the invasion of that country by Ethiopia have dramatically increased the number of refugees in this part of East Africa. Consequently, the population of Dadaab has grown as well. See CARE International, Kenya: "Humanitarian Conditions Worsen in Dadaab Refugee Camps: CARE Warns of 'Time Bomb' if Funding Continues to Decrease," August 23, 2006 (http://www.care.org/newsroom/articles/2006/08/20060823_kenya_refugees.asp): "Since January of 2006, more than 20,000 new arrivals have come to the Dadaab refugee camps. U.N. agencies estimate that under a best-case scenario, there could be up to 50,000 new arrivals by the end of 2006. This means that we may be planning for an additional 30,000 people to arrive in the camps by the end of the year, a situation that will make it extremely challenging for agencies to meet the basic needs of those seeking refuge." In 2007, Kenya closed its borders with Somalia, making it impossible for new refugees to come to Dadaab.

2. Robert D. Grey, "The Soviet Presence in Africa: An Analysis of Goals," *Journal of African Studies* 22, 3 (1984): 511–27. Grey makes the point that "while the Soviet Union

massively accelerated its supply of arms throughout the world in the last half of the 1970s, the increase to Africa was especially dramatic: in the decade 1967–1976, the average annual value of such transfers was $2,200 million, whereas during the half-decade 1976–1980 the comparable figure was $7,700 million, a multiple of 3.5." The Ogaden Peninsula is a region within the political boundaries of Ethiopia that is inhabited by Somali-speaking people and that was given to Ethiopia by the colonial powers when African borders were formalized in 1954.

3. It is important to note, however, that even at the outset of the civil war in Somalia, the UNHCR had a difficult time placing refugees. For example, "In 1991–1992 the UNHCR sought to resettle over 125,000 refugees and found places for only 54,000, truly a drop in the bucket." Carl Kaysen, "Refugees: Concepts, Norms, Realities, and What the United States Can and Should Do," in *Threatened Peoples, Threatened Borders: World Migration and U.S. Policy,* ed. Michael S. Teitelbaum and Myron Weiner (New York: W.W. Norton, 1995), 249. If the UNHCR had such little success in placing all refugees in 1991, the year the Somali civil war broke out, then imagine the difficulties after 9/11/ of placing these Muslim refugees in first-world countries.

4. UNHCR Briefing Notes, "Kenya: Malnutrition Levels in Refugee Camps Cause Alarm," July 2007 (http://www.unhcr.org/news/NEWS/468a3e3e6.html). Here, the UNHCR explains: "A survey mid-2006 showed that despite WFP providing 95 percent of general food distribution ration for the last two years, the acute malnutrition rate was 22.2 percent in the Dadaab camps and 15.9 percent in Kakuma camp, well above the World Health Organisation's emergency threshold of 15 percent."

5. See Franklin Goza, "The Somali Presence in the United States," in *From Mogadishu to Dixon: The Somali Diaspora in a Global Context,* ed. Abdi Kusow and Stephanie Bjork (Trenton, N.J.: Red Sea Press, 2007), 255–74. Goza presents immigration rates of Somali people into the United States. Of course, his numbers include all Somali immigrants, not simply those from Dadaab.

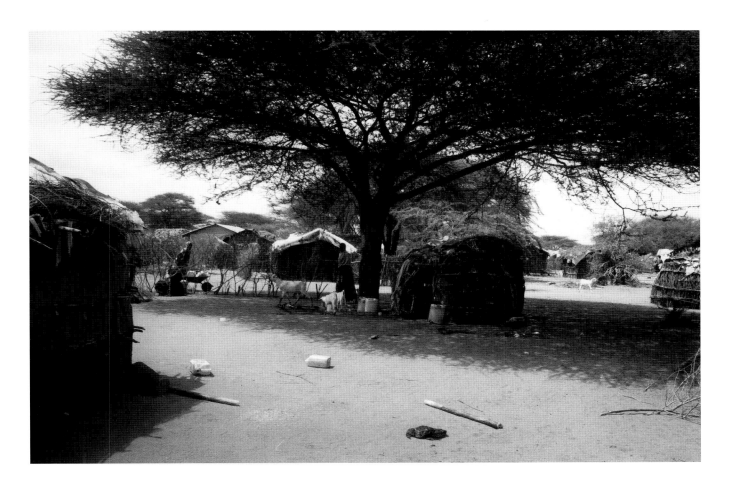

The Avenue, Dadaab, November 2005. In Dadaab, people are assigned a small plot of land on which to build their mud-and-stick homes. Between the blocks these boulevards develop, which create a maze that only the initiated can navigate.

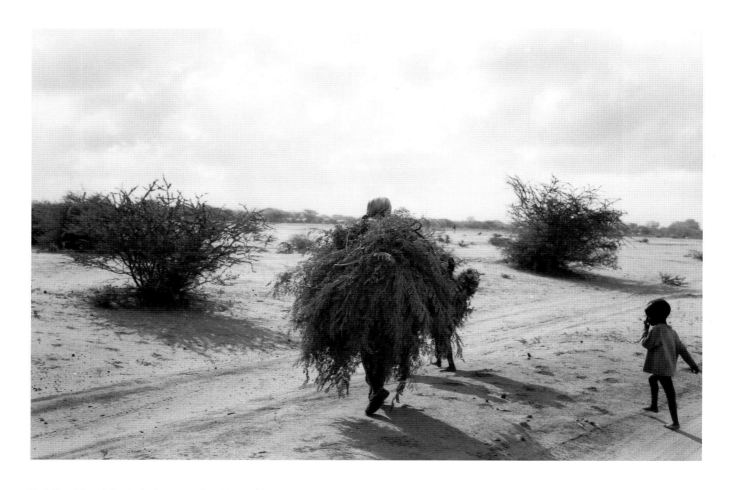

Building Materials, Dadaab, November 2005. This woman carries thatch that she will use to repair the roof of her home. It will take her the better part of a day to gather it, and she will have walked several miles to find places where plant life is sufficient for the roofing material she requires.

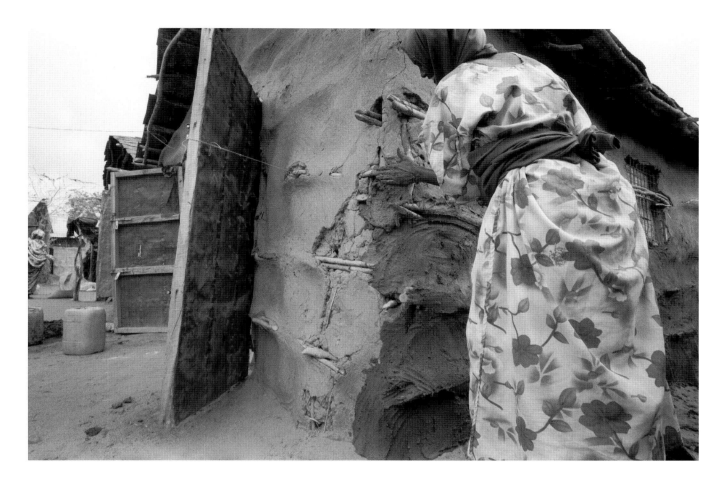

Fixing Up the House, Dadaab, December 2005. Homes in Dadaab are always in need of repair; the occasional rain and the intense heat can be tough on mud huts. A combination of clay and dung is used for repairs.

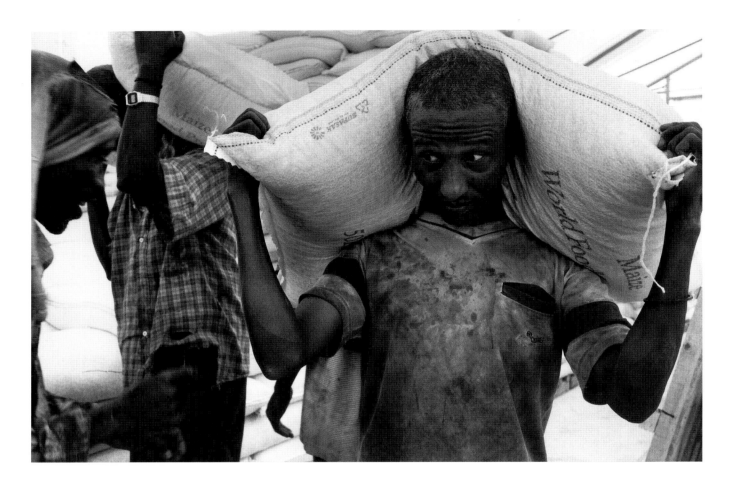

Unloading Grain 1, Dadaab, November 2005. These men must
unload nearly a ton of grain each day to earn eighty cents.
With the few pennies they make, they will buy their children
a vegetable or piece of meat. These luxuries might protect the
children from diarrhea or severe malnourishment.

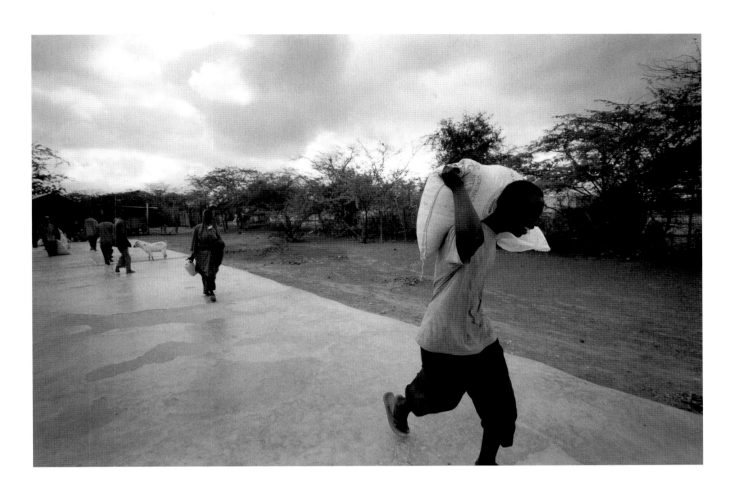

The Unending Load, Dadaab, November 2005. The men who
unloaded grain had come to think of themselves as slaves. They
earned so little, and as they watched other people come to the
camp after them and be resettled before them, they began to
think that the UNHCR was keeping them because they were so
good at unloading grain. The truth is that these men, like most
people in the camp, will never leave until the UNHCR believes
that Somalia is stable enough for repatriation.

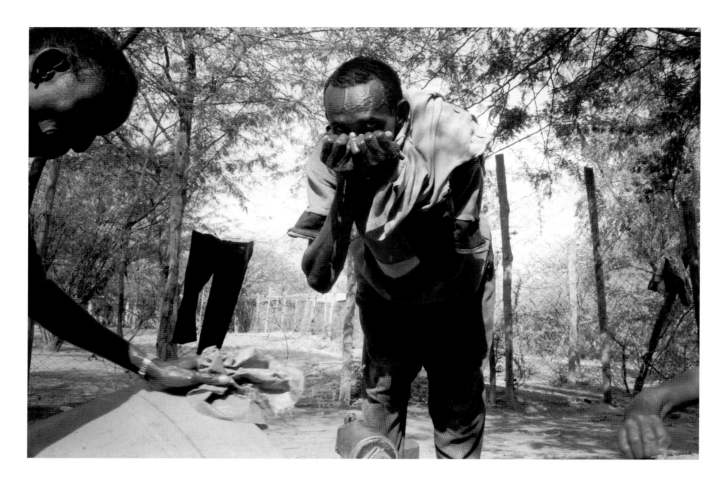

Taking a Break, Dadaab, November 2005. When the men unloading
grain stopped to take a drink, they said to us, "When a man's
house is on fire, you don't ask how the fire started, you put it out.
The international community has to understand that our house is
on fire now."

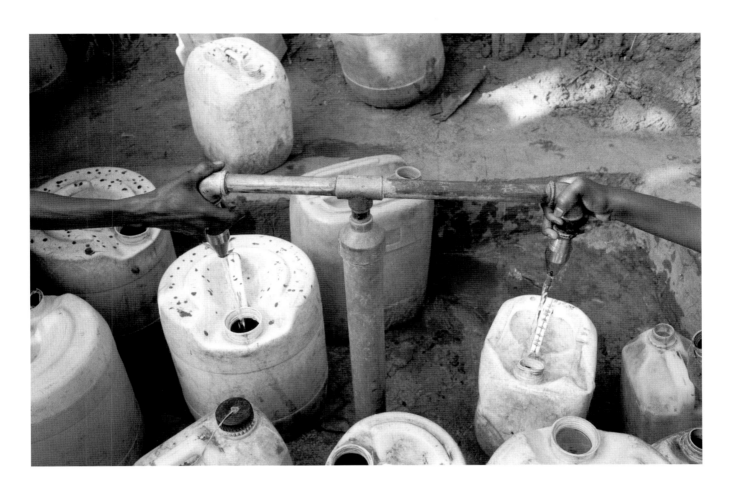

Water, Dadaab, November 2005. Often women must walk long distances for the water needed by their families. Millions of insects and omnipresent dirt make the conditions at the faucets less than sanitary.

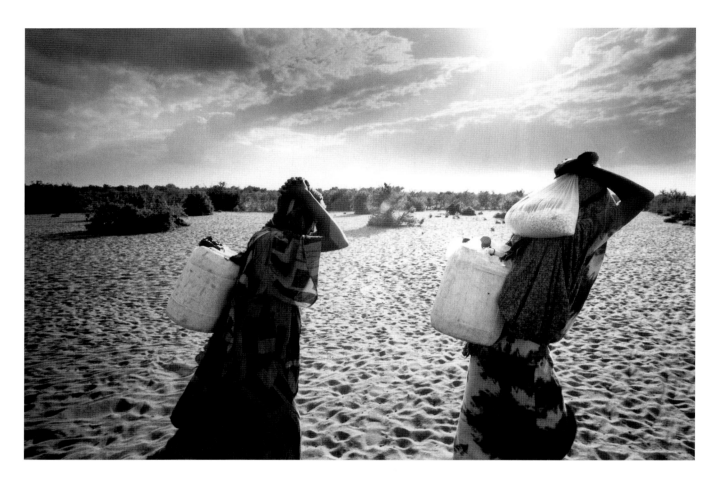

Walking, Dadaab, December 2005. After gathering grain, cooking
oil, and water supplied by CARE International, this mother and
daughter must carry their supplies back to their hut through the
desert.

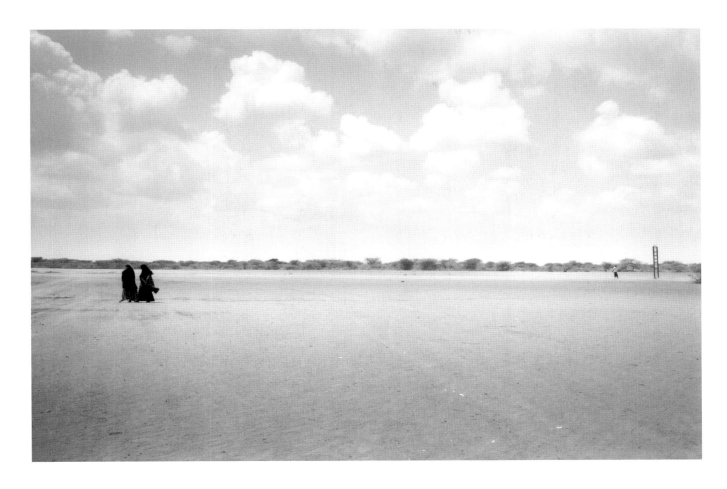

Veiled Women Walking 1, Dadaab, December 2005. The three
camps of Dadaab are home to more than 150,000 people. The
distance between camps ranges from eight to ten miles, a very
long way for people to travel to visit friends or garner supplies.

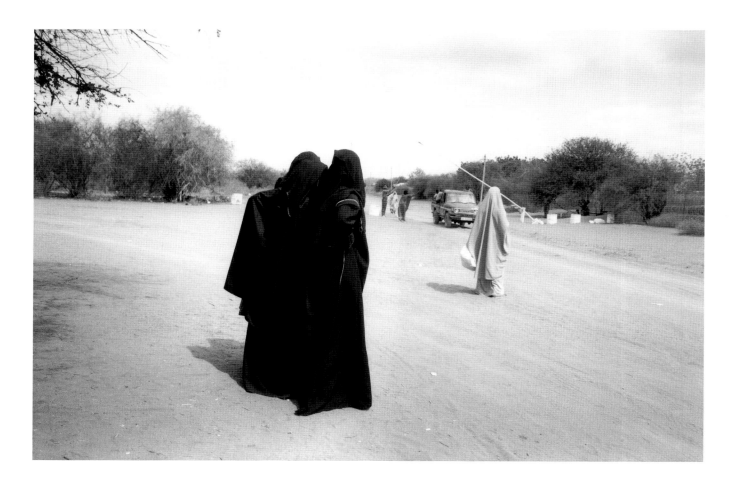

Veiled Women Walking 2, Dadaab, December 2005. Refugees must
walk many miles between Hagadera, Ifo, and Dagahaley if they
wish to visit family and friends. Members of the UNHCR and
other NGOs negotiate the distance in armed vehicles.

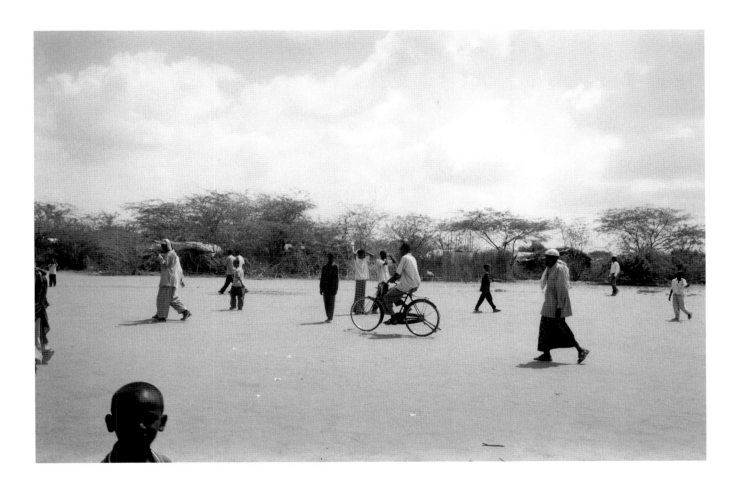

Space with Bicycle, Dadaab, December 2005. A few lucky people
travel between camps and neighborhoods on bicycles. Everyone
else must walk.

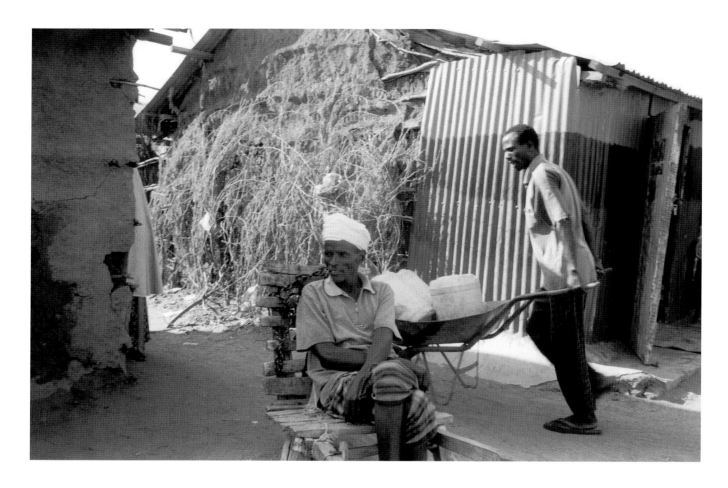

Wheelbarrows, Dadaab, November 2005. These men make a few
extra pennies by helping people move their belongings or by
carrying their supplies.

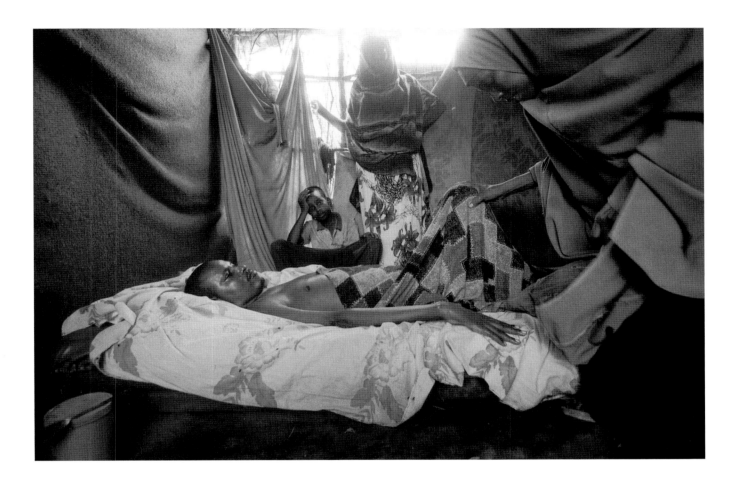

Sheik Ahmed, Dadaab, November 2005. Sheik Ahmed was shot
once in the upper and once in the lower part of his spine as he
was leaving a mosque in Sakow. His wife then had to transport
her paralyzed husband to the refugee camp, where he has lain for
more than six years. He receives no medical treatment, not even
pain relief, and has never had an X-ray to see if the bullets could
be removed.

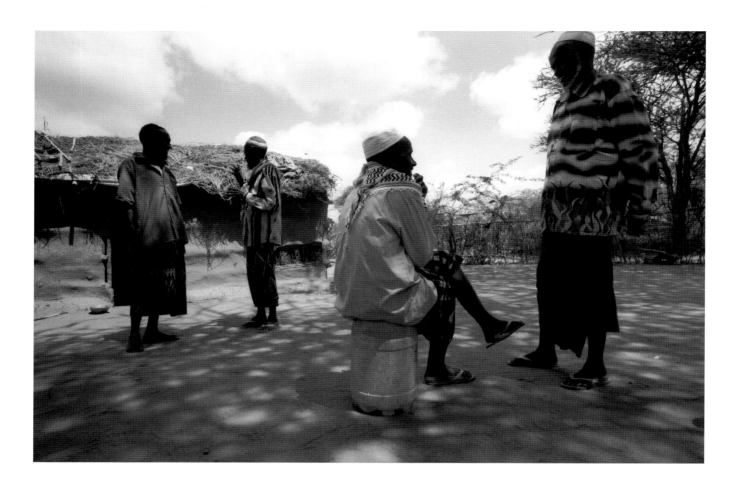

Elders, Dadaab, December 2005. The intricately sewn hats *(koofi)*
these men wear indicate that they are elders, a respected position
within Somali culture. Traditionally, people come to elders for
advice and for the settlement of disputes. Somalia is an oral
culture, and wisdom is passed from one generation to another;
Somali was not a written language until 1972. It has been said
that when a Somali elder dies, an entire library dies with him
because many of the culture's stories are lost with his passing.

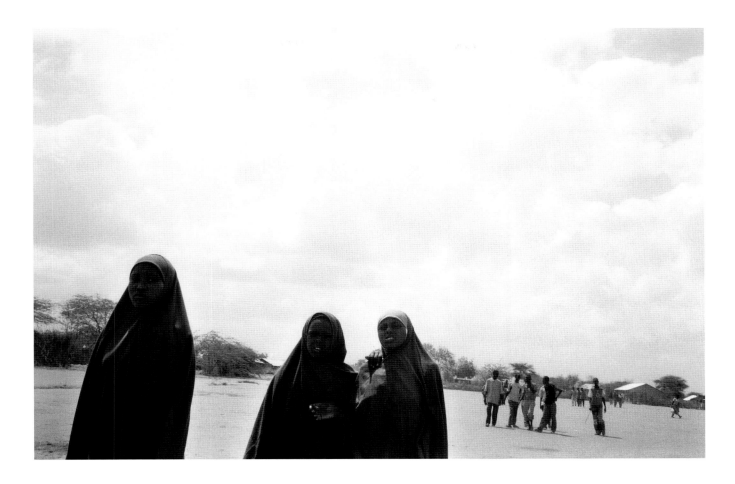

Children Going to School, Dadaab, November 2005. These girls are on their way to Friends International School in Ifo. Children have to walk from a few blocks to a few miles to get there. Friends International School is a blessing to the people of Ifo. When we visited, the school served 1,600 students, 634 of whom were girls. There were twenty-eight teachers, for a teacher-to-student ratio of 57:1. Children have few supplies, and the teachers are volunteers who have often learned what they know inside the camp. School is taught according to the Kenyan system, which imitates the British educational system with its series of examinations. The school teaches subjects such as Arabic, Somali, science, mathematics, geography, religion, and education. Younger students may be placed in front of the class so that they can receive more attention.

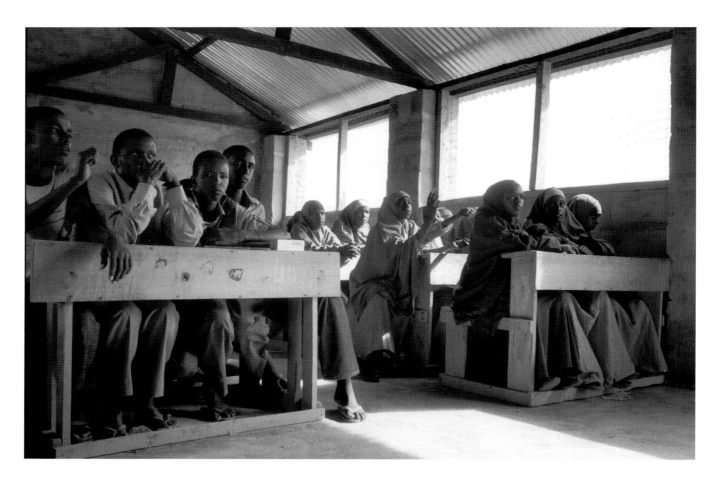

Listening, Dadaab, November 2005. Students listen intently—
as they must, having nothing to write with or on. What they
hear from their teacher is the grand total of their instruction.

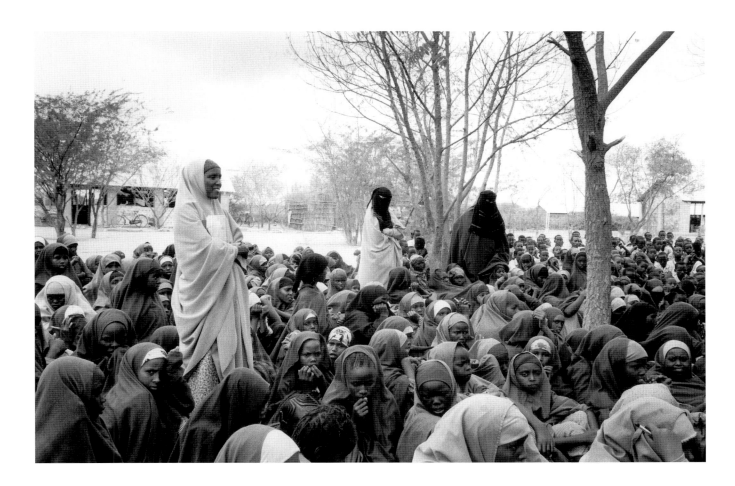

Graduation Ceremony, Dadaab, November 2005. These children
sit on the ground, waiting for their teachers and parents to finish
delivering speeches. Then they should receive rewards for being
good scholars. Many students were praised for exemplary grades,
but when the time came to get their prizes, the children were told
that the school could not afford even very modest rewards like
pencils or paper for their hard work. The prizes would come at
some unspecified time in the future.

School Kitchen, Dadaab, November 2005. In a dark, unhygienic kitchen an elder makes porridge of stale cornmeal for the school-children. He has nothing to work with but a primitive fire, a huge pot, and the cornmeal that families donated so that their children could have a noon meal.

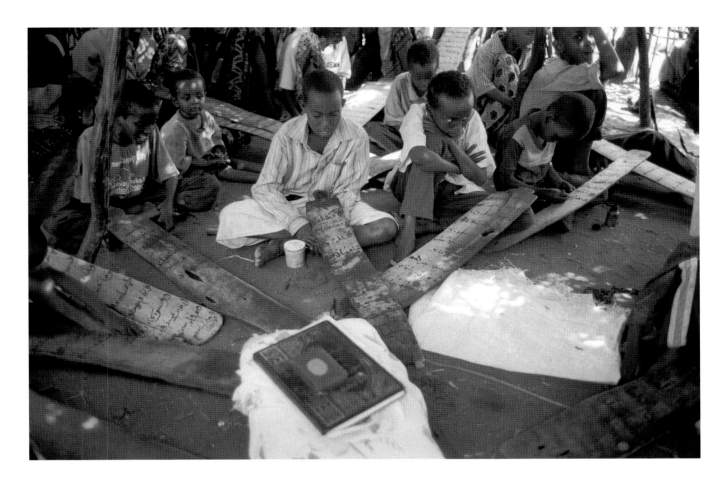

Qur'an School, Dadaab, November 2005. These children are
memorizing the Qur'an. They write a verse on one side of this
board *(loox)* and hold it away from themselves but toward their
teachers as they recite the verse aloud. When the Sheik is satisfied
that the children know the verse by heart, he will allow them to
erase it, and the process will begin again with the next verse.

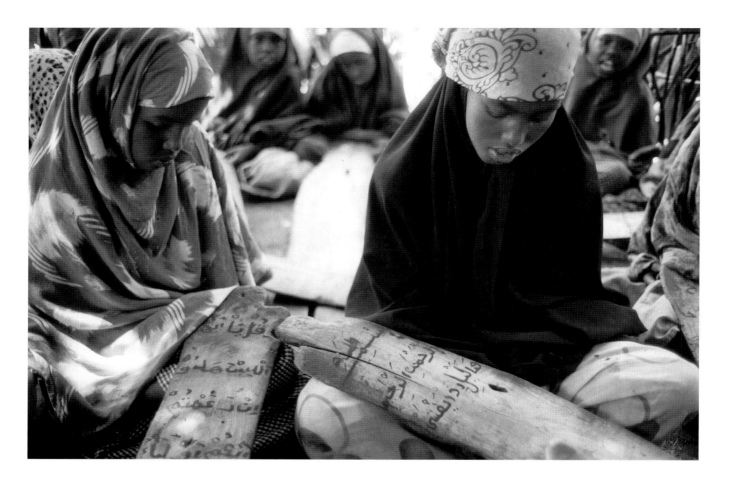

Girls at Qur'an School, Dadaab, November 2005. Girls also
memorize the Qur'an, but they are separated from the boys.
Traditionally, the children would write the holy verses on their
wooden boards with charcoal. Unfortunately, even charcoal is at
a premium in the camp, so all too often youngsters find discarded
batteries, break them, and use the acid to write their verses.

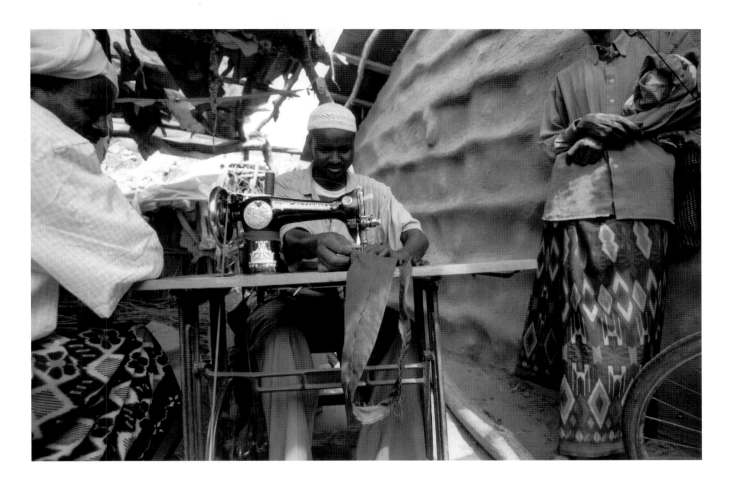

Sewing Machine, Dadaab, December 2005. Everything must be reused or repaired in Dadaab, including clothes. A tailor lucky enough to have a sewing machine can make a little money in the camp so long as he can keep pedaling.

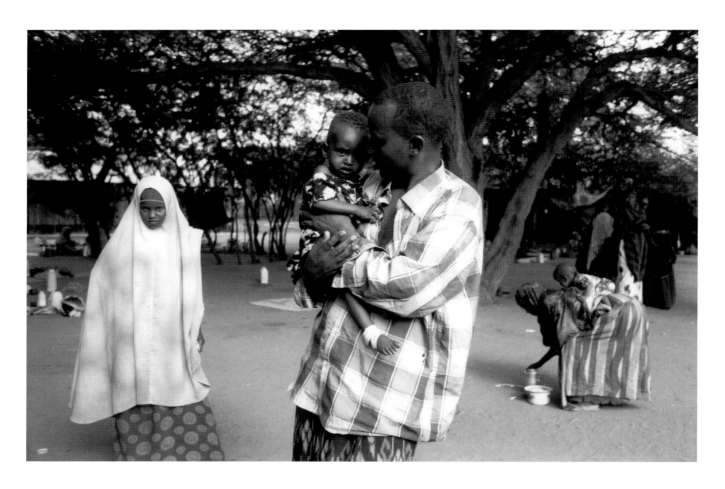

Wounded Foot, Dadaab, November 2005. A father wearing
macawis, traditional Somali garb for men from the waist down,
comforts his child, who has come to the clinic to have his foot
bandaged.

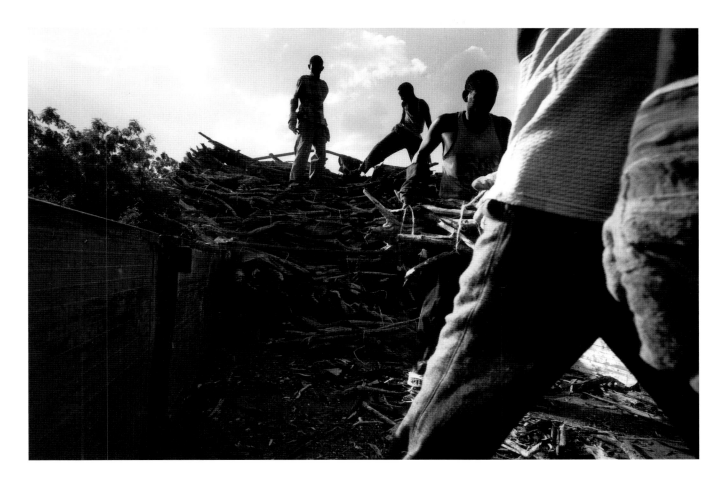

Unloading Wood, Dadaab, November 2005. Women must use wood to prepare food, but they are often raped by masked men when they leave the camp to gather it. The German NGO Gesellschaft für Technische Zusammenarbeit initiated a program to furnish 25 percent of the firewood the women need; this has helped considerably, but women are still vulnerable to rape. People earn the equivalent of about thirty U.S. cents a day for this backbreaking work, and they are paid every three months. One woman broke open a bundle of wood to show us the scorpion nesting in it. These are not the kind of scorpions whose sting kills, but a sting will make a person sick for several days, which means at least three days without earning thirty cents.

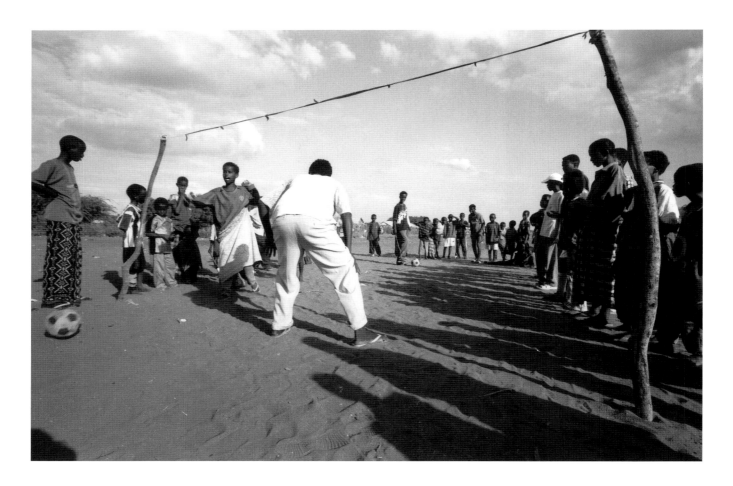

Soccer, Dadaab, November 2005. Somalis were colonized by
the French, the Italians, and the British—three countries who
brought this beloved European pastime to Somalia. Somalis love
the sport so much that they will make a net and even the balls in
order to play.

Guitar Player, Dadaab, November 2005. Somalis have a long
tradition of music and poetry, and these people entertain groups
of onlookers during the long desert days. We were speaking with
the guitar player when an older woman whose mental faculties
were diminished (perhaps because of the stress in the camp) said
to the musicians, "I wrote all these songs. You know I did, but
you never pay me anything."

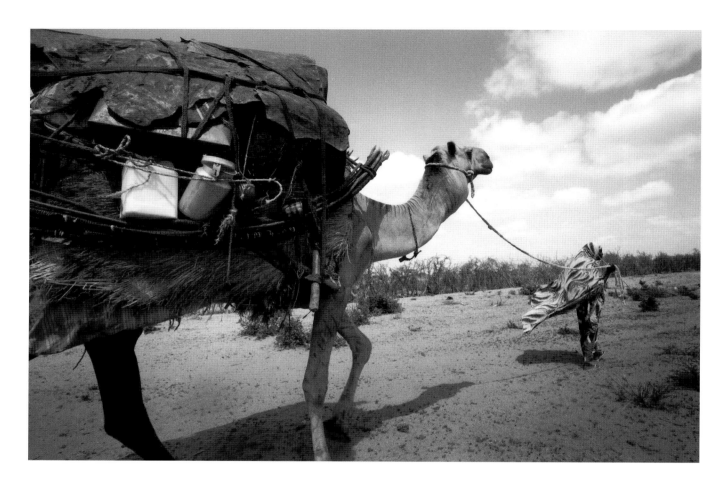

Camel, Dadaab, December 2005. Nomads in this part of Kenya
are Somalis. They travel from one watering hole to another to
keep herds of goats and camels alive. Somalis are proud of their
camels and of their ability to drink camel milk, which they believe
brings health. Many people think that the word *Somalia* derives
from the phrase "So mal," which means "milk the camel." As this
command is uttered when guests arrive, it is taken as a symbol of
Somali hospitality.

From Refugee to Dependent: The Family of Abdisalam

While we were in Dadaab, we met and became friends with a family that was soon to be resettled to the United States. Most people in Dadaab feel trapped, but when we first met them, the family of Abdisalam believed that they would soon be going to a better world. Unfortunately, Abdisalam was to learn that the process of resettlement and adjusting to a new culture would not be as easy as he had been led to believe. The story of Abdisalam and his family begins as the story of people who are running from war. Moreover, as they are resettled from Dadaab in Kenya to Southern California, their story becomes an epic journey, involving travel from one continent to another and then moving across one of the largest countries in the world. Moving through time, space, and culture without understanding either the technology or the language of most of the people who were helping them was the challenge that the family of Abdisalam had to face to survive the war in their country and the confusion presented by their newfound land.

Before fleeing the civil war, Abdisalam lived near the small southern Somali town of Sakow. Abdisalam is a Sheik or a holy man.[1] Indeed, Abdisalam was continuing his religious studies while he lived in Sakow. He also had a small farm. Abdisalam, whose name means servant of peace, fled Somalia in 1998 after a gunman shot him in the arm as he was leaving the mosque. While wounded, Abdisalam had to walk fifteen days through the desert, living off mangoes and the very little water he could find, to reach Dadaab.

When Abdisalam was shot, bandits were attacking the entire village of Sakow and chasing everyone out. The thieves planned to exploit the livestock and the few valuables people left behind as they ran. When people fled, they had no time to check on the well-being of relatives; they just ran. Abdisalam is lucky in that he was able to reunite with his mother and sister. Many of his friends were never able to reunite with their relatives once they reached Dadaab.

Life in the Jubba River valley would have been difficult. Abdisalam would have lived in a simple stick hut, much as he did in Dadaab. However, he would have had more food available to him than the 6.6 kilos (14.5 pounds) of stale cornmeal and the few ounces of

cooking oil that had to last the entire family fifteen days in the camp. He would have also had the freedom to pursue other resources.

When Dadaab was first established, it could be a dangerous place. People say that during the first few years, robbery was common. Abdisalam was robbed twice by bandits in the camp and lost what little he had there. Thieves stole things like cooking pans, mementos, and, of course, food. They took anything that might be of value. In the last few years, there has been little to eat in the camp, according to Abdisalam, but it has been a relatively safe place to live.

Life in Dadaab may have been a struggle for the family, but the UNHCR's policy at the time of only re-settling victims of violence and torture became a bless-ing for them. They were given a way out that most residents of the camp will never know.

When he is resettled, Abdisalam said while still in the camp, he would like to return to school. He would like to learn to help people. Ideally, he would like to be a doctor. With medical skills, Abdisalam believes, he would be able to travel to refugee camps all over the world to help people in need.

Once Abdisalam and his family were ready to be resettled, they were placed under the care of the Inter-national Organization for Migration (IOM). The IOM has the resources to put refugees on a plane, but those funds come from previous refugees having paid for their flights. The IOM is willing to wait three years,

but it expects every refugee to repay the organization $950 per flight. Abdisalam could not speak English and because he had spent eight years in Dadaab, his job skills were minimal. Nevertheless, before he and his family even ate their first meal on American soil, they were already in debt for nearly $5,000.

Abdisalam thought that immigrating to the United States would solve all of his problems. He soon real-ized, however, that social assistance would barely cover the rent, let alone the food and utilities that his grow-ing family would need. He had to adjust to the real-ity that leaving the problems of Dadaab behind only meant that he would have to face new problems in an unfamiliar world. Abdisalam found it depressing to be dependent on social services. According to Hashi Abdi, the director of Minnesota-based Somali Action Alliance, this period of dependence should not last longer than two years, but for Abdisalam, it would be an emotionally difficult time.

The U.S. State Department has a policy of reset-tling refugees to areas in which only a few people of that ethnic group already live. So, instead of land-ing in places like Columbus, Ohio, or Minneapolis, Minnesota, where thousands of Somalis would have welcomed them, the family found themselves in an expensive tourist town in Southern California, where there were few people from their native land to lend them a hand.

Like all new refugees accepted into the United

States, Abdisalam and each member of his family were given $425 by the State Department to get them settled into this country. For the immediate family of five and the two cousins, Farhiya and Sadio, and Sadio's son Abdiaziz, this came to $3,400. The rent for their apartment in Anaheim was $1,700 a month. The landlord agreed to forgo the security deposit. Moreover, Orange County pays the rent for refugees for the first thirty days. This means that the federal grant would nearly pay the next two months' rent, so for the first three months, the family was secure. After this, a family of four would receive $864 in cash assistance every month and another $400 in food stamps. Abdisalam's family is a little larger; indeed, once we include the cousins, it becomes a family of eight. Therefore, if we double the amount for a family of four, it becomes $1,728. As the rent for the family was $1,700, the family has only $28 left to pay the electricity, phone, and water bills, as well as the costs of transportation and clothing. Clearly, after the first three months, the money from social services was never going to be enough.

Because the resettlement agency anticipated the economic exigencies, the family of Abdisalam was able to settle in, enjoy their new home, and learn about America for a few weeks, before their economic needs became real to them. The IOM had been responsible for giving the family some cultural training before they left. Abdisalam explained that "for example, they told us it is illegal to bribe someone. They told us that you can't drive without a driver's license. You can't leave the children home alone, and you have to use seat belts. Also, you can't smoke in public places." It was obvious that the family had much more to learn than these few hours of cultural training could offer them. Not only did they have to figure out how to use a gas stove, a vacuum cleaner, and an ATM, they also had to start adjusting to a culture whose values were often very different from their own.

In spite of its difficulties, resettlement helped the family in profound ways. For example, when we first met Ijabo, Abdisalam's wife, in Dadaab, her head was completely covered, but when we saw her in Anaheim, she wore the style of hijab that revealed her face. We were horrified to see that this twenty-five-year-old woman looked three times her age. We learned that she had been feeding much of her share of the cornmeal to the goats so that her children could have milk. She was so malnourished that she was weak. Indeed, it seemed as if her spirit had left her. It took nearly a year in this country, a year of eating well and taking medicine for malnutrition, before Ijabo's personality returned. Finally, she began to lift her head, to laugh, and to enjoy her three daughters: Shukri, two; Hamdi, three; and Hofsa, the eldest, who was six when the family came to America. In spite of everything she had been through, Ijabo was pregnant when she entered this country, so, if her body could tolerate the struggle, she would soon have another child.

Being resettled in Anaheim was difficult for the family, but they were happy to be there. The resettlement agency in charge of helping Abdisalam and his family through their initial period of dependence was the East African Community of Orange Country, under the direction of Ibrahim Sheikh Hussein. This agency helped the family find an apartment that would waive the security deposit and concerns about creditworthiness, so their initial federal allotment would actually cover two months' rent. The issue of creditworthiness is ironic for recent refugees, for how can a person be worthy of credit if he does not have a work history, and how can he have a work history if he has spent the past eight years in a refugee camp? The East African Community of Orange County had also sought out furniture and other supplies through charity, so their home was furnished when the family arrived. This gave them a very positive start.

As we saw, however, once the first three months had passed, even when federal aid was combined with state and local assistance, it was not sufficient to cover the rent, the utilities, and the food that the family would require. In time, Abdisalam found a part-time minimum-wage job at a package delivery company, but his salary was not enough to cover the shortfall between the family's bills and the support that social services provided. The family found ways to cope during the short term. For example, they took in other Somali families as lodgers. These families were in the process of secondary migration themselves; that is, they had been resettled in one city but were moving to another. In this way, the family of Abdisalam could afford their rent, and they could make their allotment last longer. However, this survival method clearly broke the lease restrictions, which required that a limited number of people live in the apartment. Moreover, since most Somali families are looking for a way out of Anaheim because it is far too expensive, this could at best be a short-term method of coping with an impossible situation. As he came to understand the difficult economic challenges that faced his family, Abdisalam began to feel a great deal of pressure.

Of course, the process of resettlement was not only hard on Abdisalam. His cousins Sadio and Farhiya were also resettled with the family. Sadio had to make a terrible choice before leaving the camp, yet her plight is typical of refugees. In order to be resettled with Abdisalam, Sadio had to leave her husband behind. Sadio's husband had arrived in Dadaab later than she and was not eligible for resettlement. Therefore, Sadio was put in a dreadful predicament. She had to choose between being resettled with her cousin or remaining behind with her husband. Being resettled would mean adequate food, shelter, and education for their son, Abdiaziz. However, leaving her husband would mean years of loneliness and a son who in all likelihood will be a teenager before he is reunited with his father.

Both Abdisalam and Ijabo had to leave family

members behind as well. They both had to leave their mothers in Dadaab, and like Sadio, it will take them years of filling out forms before either grandmother can rejoin the family. We have spoken with many people inside and outside the camp since that time to discover that all too many people have to endure broken families in order to escape the hardships of the refugee camp.

Aside from economic difficulties, the family will have to endure the confusion of living in a foreign culture. On their first day in America, the family had an experience that typifies the cultural conflict they will experience. While they were waiting in line at the social service office, the resettlement agents brought the family lunch, which they were enjoying in the parking lot. Just at that moment, a young man drove up in a rather new Volvo. He explained that he had recently been employed as a computer technician, but that he had given up that well-paying job because he aspired to become a stand-up comic. Unfortunately, his aspirations were not paying off, so he was coming to the social services office to collect welfare. While the young man was explaining all this, the family shared their lunch with him. To appreciate the full irony of this moment, you have to consider that only two days before these people had been in a refugee camp, where they were starving. It took them a full day to fly to California, and they could not have eaten very well on the plane, either. But during their first full day in the United States, the family was generous enough to feed a Volvo-driving, out-of-work comedian. Only in America!

This desire to share is both part of Somali culture and part of what it means to be Muslim. When he had only been in America for a few weeks, Abdisalam found himself in line at the grocery store behind a Vietnamese man who was digging in his pockets and flipping through his wallet. Abdisalam soon realized that the man could not afford to pay his grocery bill, so without hesitation, Abdisalam paid the bill for both his family and that of the Vietnamese man in front of him, even though Abdisalam knew that in a few weeks he would be struggling to pay his own bills. When asked how or why he could be so generous, in spite of the fact that his family had been on the verge of starvation only a few weeks before, Abdisalam responded by saying, "Islam teaches us that when you give, you will receive twice as much in return." Abdisalam would face complex challenges in the coming months, challenges he could neither anticipate nor understand, but as Somalis continually observe, it is their ability to help each other, their profound ethical responsibility to be generous, that helps them through the grave difficulties of the Diaspora.

Abdisalam and his family enjoyed their new home in Anaheim and were making new friends. Sadio and Abdisalam started ESL classes, and Abdisalam found a part-time job. Nevertheless, their economic situation remained untenable. The only reasonable response was

to move. The question always was, "move where?" Because he was a Sheik, Abdisalam used the refugee network to get in touch with mosques in various communities around the country. After a few months, he discovered that a position was available in a Qur'an school in Portland, Maine, so he borrowed some money from his new friends, loaded his family on the plane, and moved east.

The process of secondary migration as exemplified by Abdisalam's move from California to Maine is not unusual. Somali nomads have a tradition of scouting to find a suitable climate for their livestock. In the same way, Somalis of the Diaspora will send people out to discover the right place for the community to thrive, or they will make phone calls all over the country to discover what area will fit their needs. Mariam Mohamed, the wife of Ali Khalif Galaydh, the former prime minister of Somalia, tells a funny story about her mother-in-law coming to visit while her husband was teaching at Syracuse University. One morning, the mother looked out the window to discover that the ground was covered with snow. She then turned to her daughter-in-law and asked sternly, "Who scouted Syracuse?"

Some cities like Columbus, Ohio, and Lewiston, Maine, were scouted in such a way, and their significant Somali populations are the result of secondary migration. As we mentioned earlier, when Somali people were resettled in Atlanta, Georgia, they were very uncomfortable there because they had been placed in the middle of impoverished and run-down neighborhoods, so they moved to Portland, Maine, and Columbus, Ohio.

When Mohamed Awale, the president of the African Culture and Learning Center, realized that he was having a hard time finding apartments for large Somali families in Portland, but that in Lewiston, there existed such an excess of housing stock that owners were actually demolishing apartment blocks, he asked a landlord if he could send a family to Lewiston. That worked fine, so many others followed, but tension soon developed, tension so severe that in 2002, the mayor of Lewiston, Larry Raymond, asked the Somali people to leave his city. Before the Somalis came, the population of Maine was almost 100 percent white, and, unfortunately, some amount of resentment formed toward the Somalis. Nevertheless, the Somalis in this northeastern community have continued to build businesses and make their lives in Maine, and in the process they have struggled to overcome prejudice.

The Somalis in Maine are fond of recounting one story that describes how most mainstream Americans in that state have come to appreciate their Somali neighbors. Apparently, a strip mall found itself home to both a bank and a Somali coffee shop. The managers of the bank did not appreciate the way Somali people lingered outside the coffee shop to talk about their lives in Maine and about politics back home. Consequently, the owners of the bank found themselves constantly going

to the coffee shop and asking the owners to keep their customers inside the shop and out of the parking lot. On one very eventful day, however, two men went into the bank with guns and came out with bags of cash. The Somali men in the parking lot witnessed this, so they simply refused to let the robbers drive away. They blocked the exits with their cars, and they swarmed the escape vehicle. By the time the police arrived, the Somalis had the situation completely under control. After that, the bank manager went to the owner of the coffee shop and asked if he needed a loan. The bank manager also offered to provide benches for the Somalis in the parking lot. The racial tensions in Maine have eased substantially since the Lewiston incident, and, as the bank story indicates, there is hope that as Mainers get to know their Somali neighbors, they will begin to appreciate their virtues.

In the meantime, Abdisalam and his family faced more difficulties in Maine than they had endured in Anaheim. Somalis may be a nomadic people, but moving from one end of America to the other nevertheless presents a daunting challenge. Abdisalam's spirits were high when he first walked into the mosque at Portland, but when the Imam told him that the funds for the position had failed to materialize, though he would be more than welcome to volunteer if he wanted, Abdisalam's heart dropped. Because Abdisalam is a Sheik, he was very tempted by the job as teacher at a Qur'an school, but he could not have known that this deci-sion would mean that he was moving from one tourist town to another. So life in Portland would be just as expensive as it had been in Anaheim. To make a bad situation worse, social services in Maine would not help Abdisalam, because he had left a paying job in California. It would care for his wife and daughters, but with no income for Abdisalam, not even welfare, the family's situation had become much more trying. Now, they found themselves in a homeless shelter with no furniture and inadequate support. In Dadaab and in Anaheim, Abdisalam had remained sure that with per-severance, life for his family would improve. Suddenly, one could see doubt in his face.

Abdisalam could have turned to the Somali community in Maine for assistance. The African Culture and Learning Center helps people learn the language, apply for social services, and search for employment. Moreover, if Abdisalam had come to them, they would have helped the family with food and furniture. But Abdisalam felt ashamed and depressed. He wanted to meet other people in a mode of success, so it was hard for him to ask others for help.

Difficult matters were made even more challenging during this period because Ijabo was getting very close to delivering her baby. Of course, the federal Refugee Medical Assistance program paid most of her medical bills. However, negotiating the world of doctors and insurance is problematic enough for those of us who speak the language and have some idea of what care

we need and what benefits we are offered. But imagine having a baby when you do not understand much of what the doctor is saying and nothing about what the pharmacy or the government insurance program is telling you. Moreover, the pregnancy was weakening this already fragile woman. With the help of nutritional supplements and Western medicine, however, Ijabo was able to survive the ordeal of bearing a child. In spite of the frustration, Najmo was born on October 1, 2006, a healthy and happy baby girl.

This event represents perhaps the most profound benefit the family received by being resettled to America. For Ijabo was so malnourished that if she had remained in Dadaab and delivered her baby there, the odds are that neither mother nor daughter would have survived.

Although she misses the many friends she left behind, the process of being resettled has been good for Ijabo, at least by the simple measurement that she is healthier, but it has proved much harder on Abdisalam. He was very happy when he first arrived in this country, but as time went on, he became depressed. Traditional Somali gender roles are distinct but require hard work of all members of the family. During his many years in the refugee camp, Abdisalam could do little to support his family. He did work the occasional odd job to bring in money. This would have assuaged his guilt and occasionally given his children a little more to eat than the grain that was ordinarily available to them, but it would not have been equivalent to fulfilling the traditional Somali male role in the way that he would have experienced in Sakow. Moreover, when he came to the United States, the bills seemed overwhelming and employment was very hard to find. As we saw, he found a job packing boxes for a delivery company in Anaheim, but this was inadequate for his family's needs. In Portland, he thought he had a job lined up, but when it fell through, he had to accept the fact that he was not supporting his family. Ijabo could go on fulfilling her role in the refugee camp and in America, but for Abdisalam, there was little to do except learn. The fact that he could not fulfill his traditional role as provider was depressing for him. Unfortunately, this outcome is not unusual. We have spoken with people who regularly treat mental illness in recent Somali immigrants, and we are told that depression is typical for male Somali newcomers and that it can last for years.

The truth is that as Ijabo stayed longer in the United States, she became happier, but Abdisalam became sadder. When Abdisalam first came to this country, he was driven past a man in the streets who was addressing passers-by. When he asked what the man was doing, he was told that this person was begging for money. "What, in America?" Abdisalam asked with shock. "Why doesn't he work?" Abdisalam will never beg, but before he immigrated, he believed that people could accomplish anything here with hard work. Abdisalam

could not have understood that he would have to spend years learning English and developing job skills before he could support his family at the level of his expectations. In the meantime, as he acquires these skills, he will have to endure several low-wage jobs, often working two or three jobs at once so that he and his family can survive in this land of opportunity.

Sheik Abdisalam may be depressed as he struggles to support his family, but he has reason to say *"Alhamdulilah"* (thank God). In time, he will develop the language and job skills he requires to survive, and he will regain his happy and open heart. In the meantime, he will face many cultural conflicts. When presented with the prospects of these difficulties, Abdisalam nonetheless continually declares that he is glad to be in America.

He is struggling, but he can see that his wife is happy and that his oldest daughter, Hofsa, is going to school and is quickly learning English. In the eyes of all the women in his family, Abdisalam can see hope.

NOTE

1. According to *Webster's New International Dictionary,* 2nd ed. (Springfield, Mass.: G. C. Merriam, 1960), the word "sheik" means literally "old man," but a better translation might be "elder." We are most familiar with its use as an honorific for a political or tribal leader, but students of Islam who teach the people in their towns and villages also are known as sheiks. In fact, some of the people on whom this title has been conferred have been women.

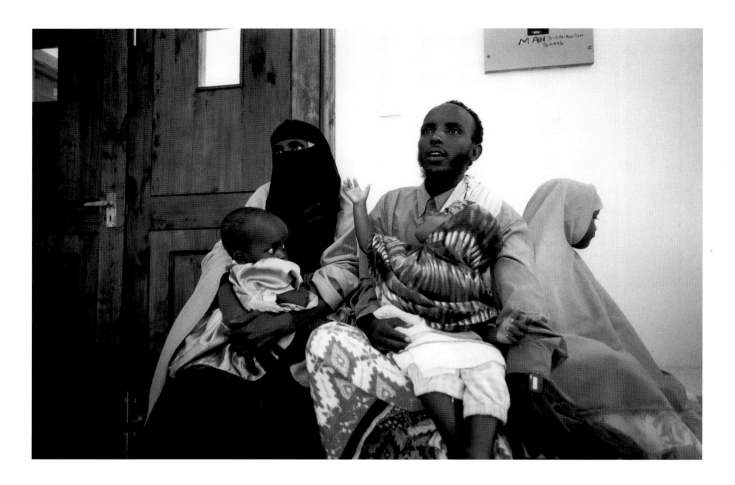

The Family of Abdisalam, Dadaab, December 2005. Abdisalam
Abdirahman Hassan, age 32, and his family are being examined to
make sure they meet American health standards for resettlement
and do not carry any diseases to America. This clinic is clean
and has modern equipment, such as an X-ray machine. The
clinics of Dadaab, which care for people who are ill, are much
more primitive.

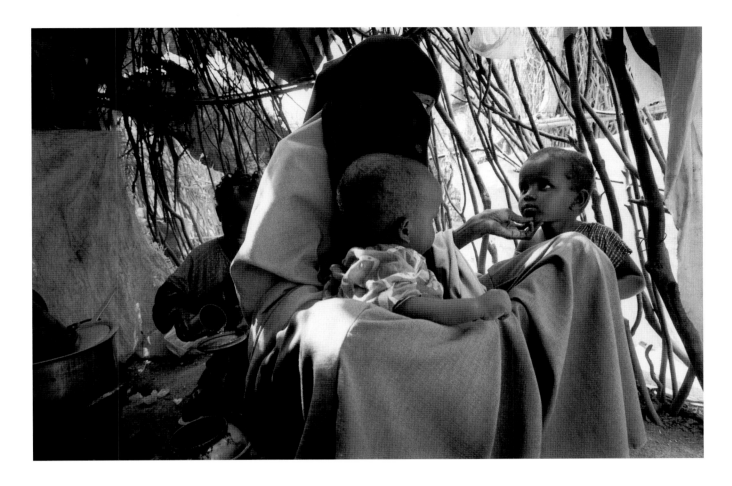

Ijabo and Her Daughters, Dadaab, December 2005. Ijabo, age
twenty-four, tickles Hamdi's chin, while Shukri (whose name
means "thank you" in Arabic) snuggles in her lap. Hofsa
entertains herself behind her mother. The women of the family
are hanging out in the kitchen.

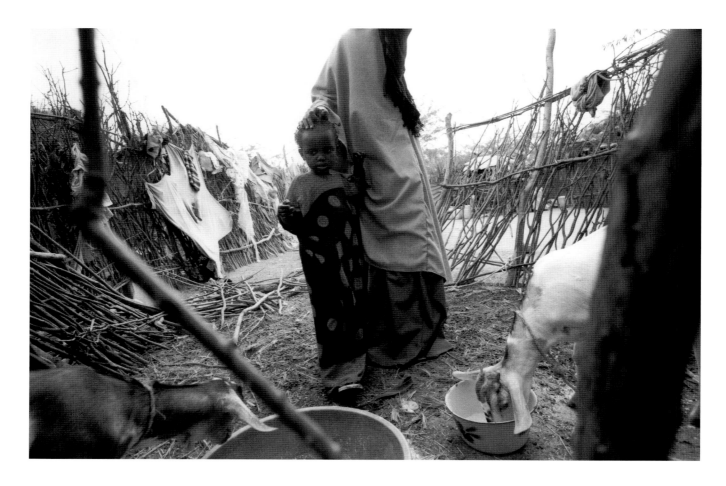

Feeding the Goats, Dadaab, December 2005. Notice how thin Ijabo looks as she feeds the family goats. We were horrified to learn that she was feeding the goats her share of the cornmeal so that her daughters could have milk. Ijabo was terribly malnourished, and she became pregnant before they left the camp. If the family had not been resettled, she might well have died.

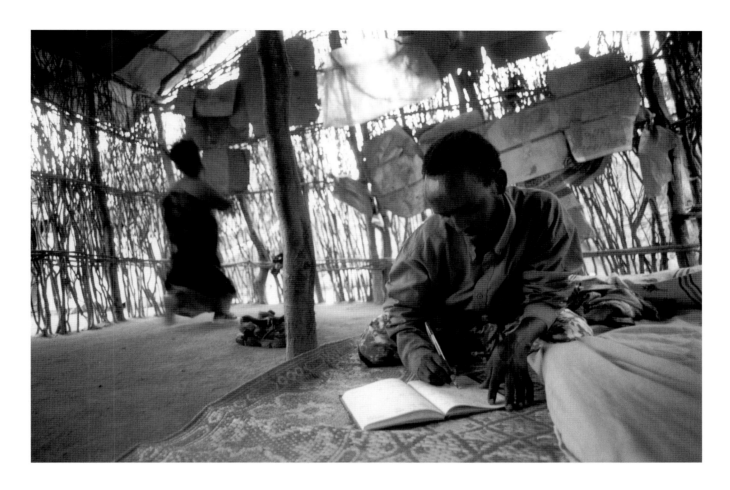

Journaling, Dadaab, December 2005. Abdisalam takes a few
moments to record his thoughts while the children play outside.
He is respected as a Sheik because of his intelligence and
dedication to study.

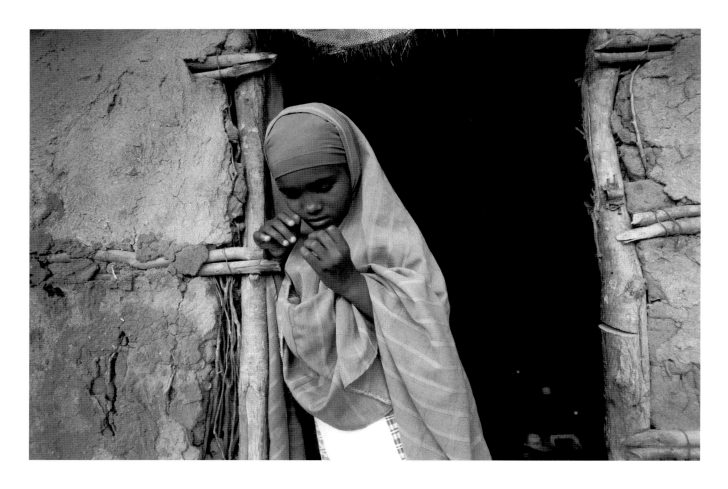

Farhiya in the Doorway, Dadaab, December 2005. Farhiya, a
cousin of Abdisalam's, was raised by the family. She stands in the
doorway of their living room. This is typical Dadaab architecture.

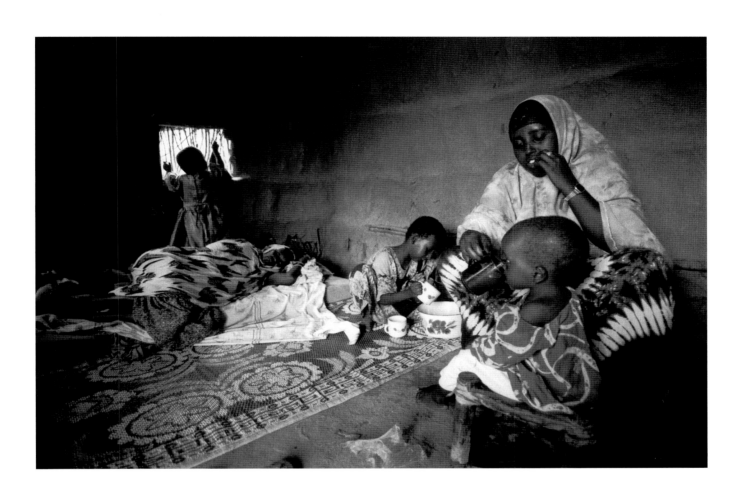

An Aunt's Visit, Dadaab, December 2005. Abdisalam's sister, Sadio
Abdirahman, cares for the children. She has come from Somalia to
visit her brother and his family. She will return when Abdisalam
immigrates to the United States. (Sadio is also the name of the
cousin who accompanied the family to the United States.)

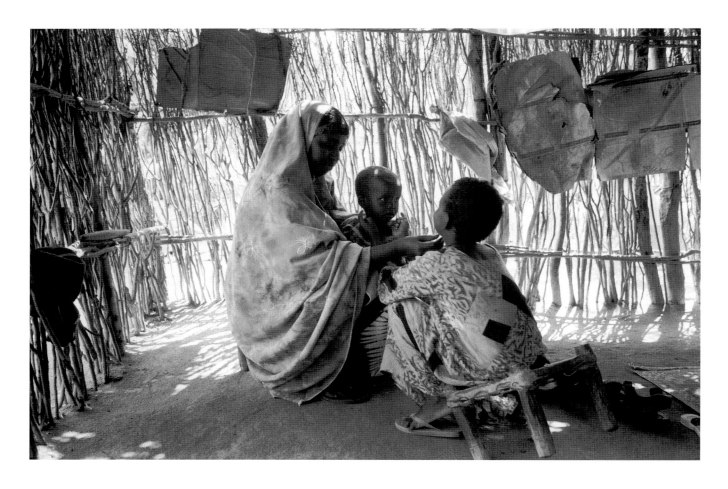

An Aunt's Last Words, Dadaab, December 2005. Sadio speaks
with her nieces before the children leave for America.

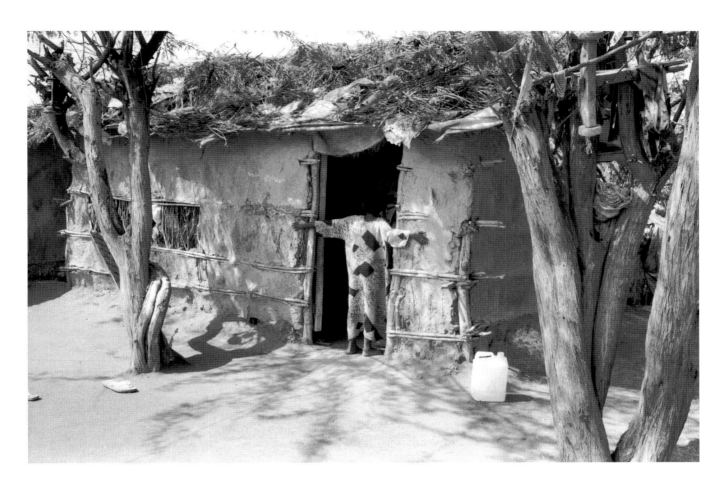

Looking into the House, Dadaab, December 2005.
Cousin Asha looks in on the children of Abdisalam.

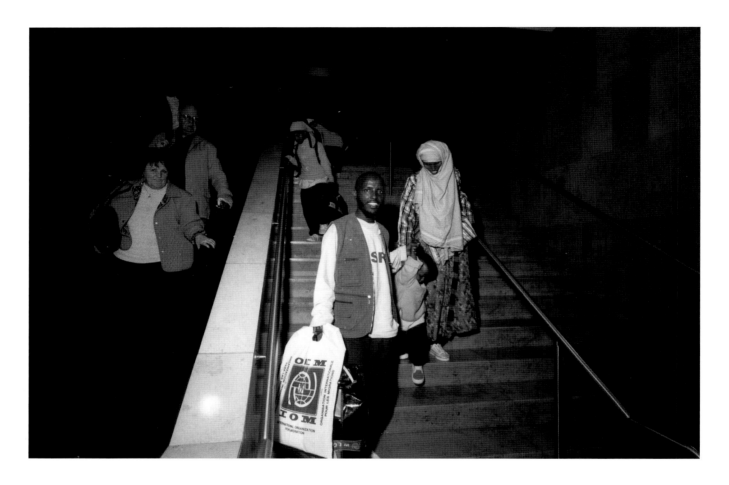

Arriving, Orange County, February 2006. Abdisalam and his
family landed at John Wayne International Airport. The IOM
bag from the International Organization for Migration identifies
the family for the resettlement agents who are picking them up.
We told the family to take the escalator, but they were afraid of a
machine that they did not understand.

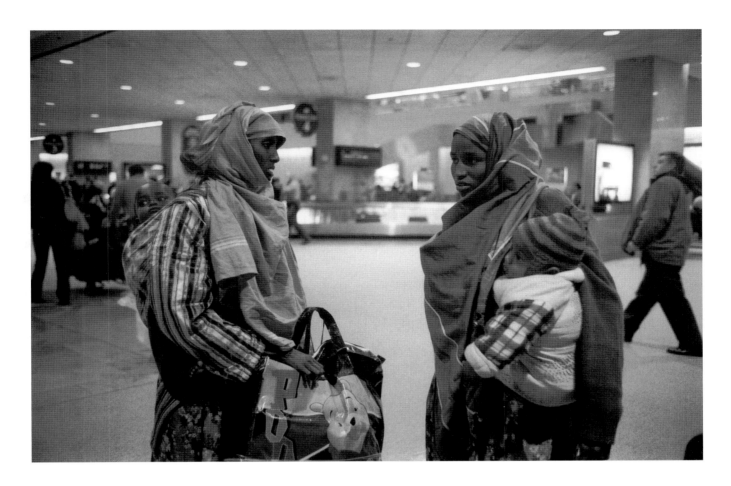

The Airport, Orange County, February 2006. The airport was
as foreign to Ijabo and Sadio as the Winnie the Pooh on their
bag was, but even though they were exhausted, hungry, and
confused, both women were happy to have arrived in America.

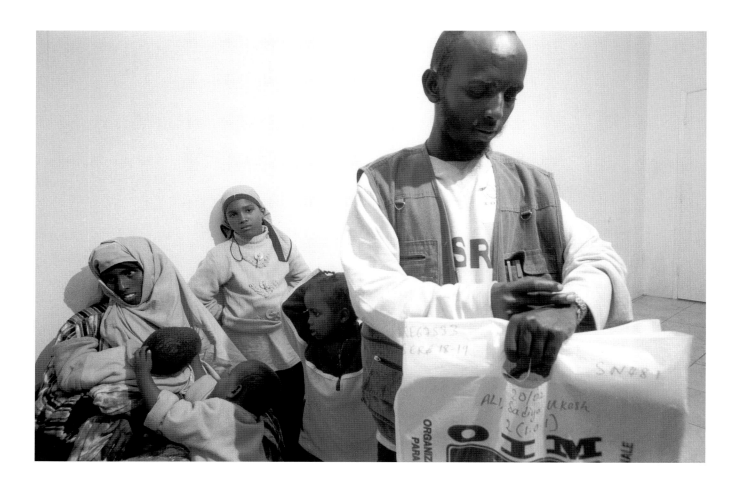

First Evening, Anaheim, February 2006. The family spent their
first night in America at the home of the social worker who met
them at the airport. For the first time since 1998, they partake in
the traditional Somali meal of rice and goat meat. Abdisalam still
carries the IOM bag, and Ijabo's nearly skeletal face is visible here.

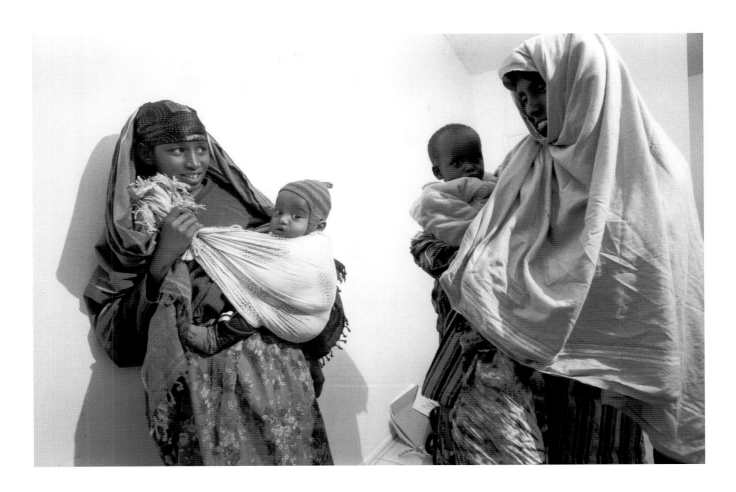

Glad to Have Arrived, Anaheim, February 2006. Both Sadio and
Ijabo are in their twenties, about the same age, but Ijabo looks
much older because her face is so strained by malnutrition.

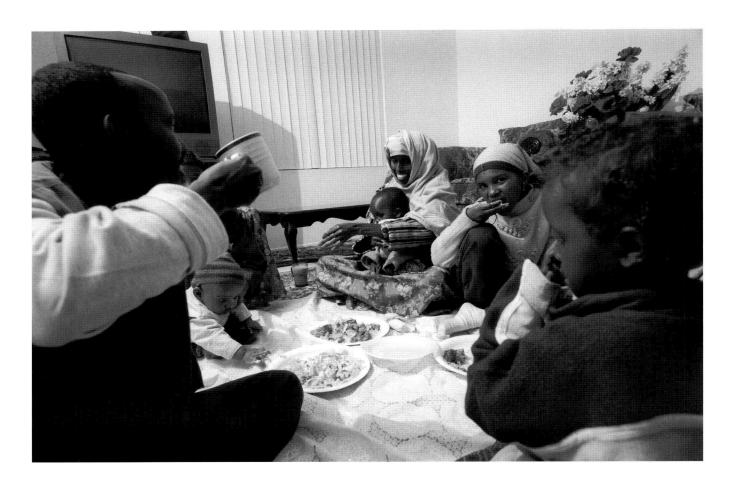

Their First Meal, Anaheim, February 2006. The family's first meal in America was also their first traditional Somali meal in eight years. After they finished eating, they said that the last time their stomachs were full was eight years ago, before they were forced to flee to Dadaab.

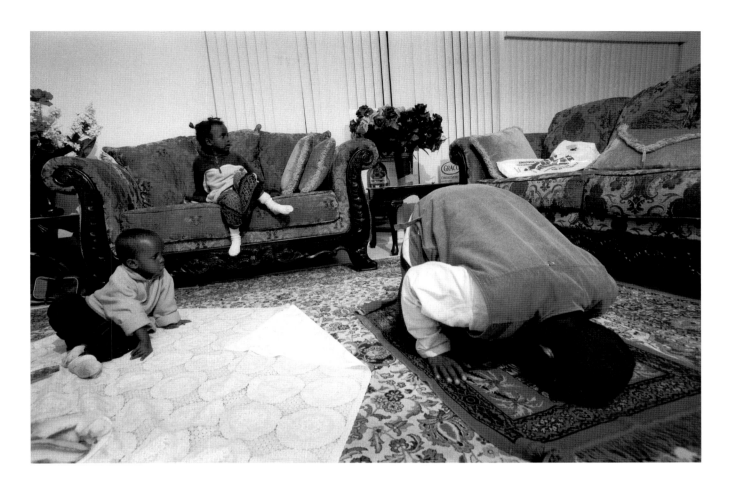

Praying in Ibrahim's House, Anaheim, February 2006. Abdisalam
felt fortunate that Ibrahim, the social worker who picked up the
family at John Wayne International Airport, was also Somali.
Ibrahim invited the family to spend their first night in America
at his house.

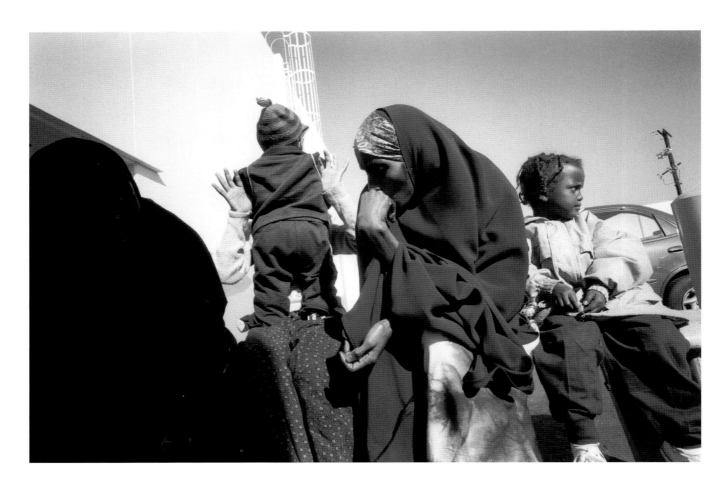

Waiting, Anaheim, February 2006. Ijabo and the family of
Abdisalam experience their first day in America waiting in
the parking lot of the social services office in Anaheim.

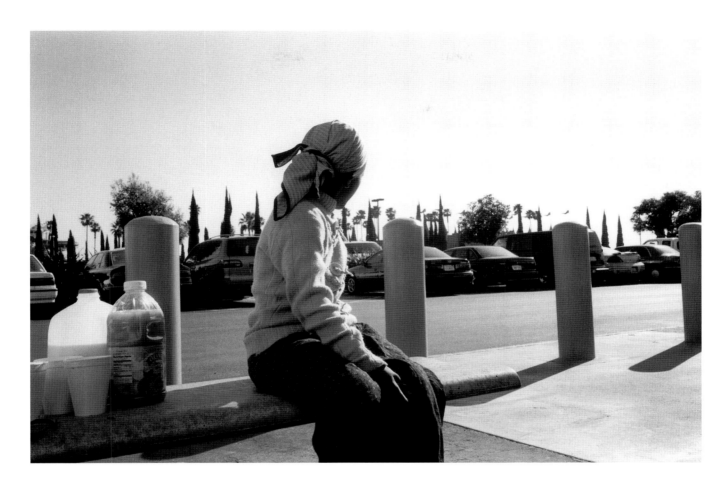

Looking toward Disneyland, Anaheim, February 2006. Farhiya
waited in line for most of the morning to get her Social Security
number, and now she waits with her family at the social services
office. As she looks off into the distance, she sees the turrets of
Disneyland, but she could not have understood that icon of fun
for American children.

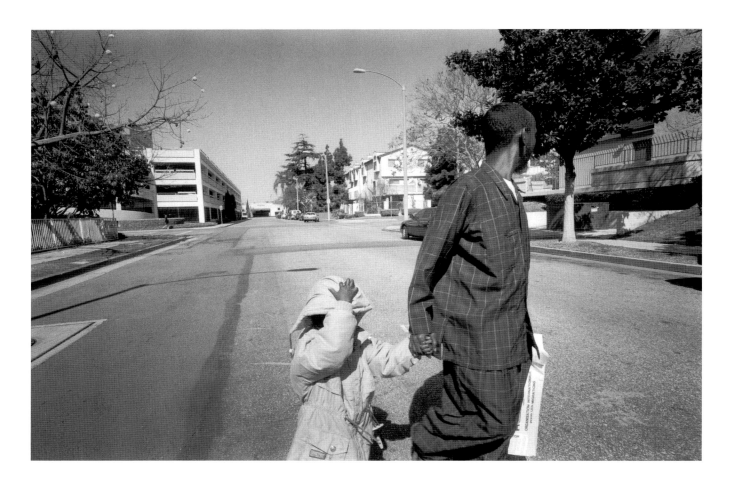

Crossing the Street, Anaheim, February 2006. He has spent most of his life as a subsistence farmer and a refugee, so watching for traffic is a new experience for Abdisalam and his daughter Hofsa.

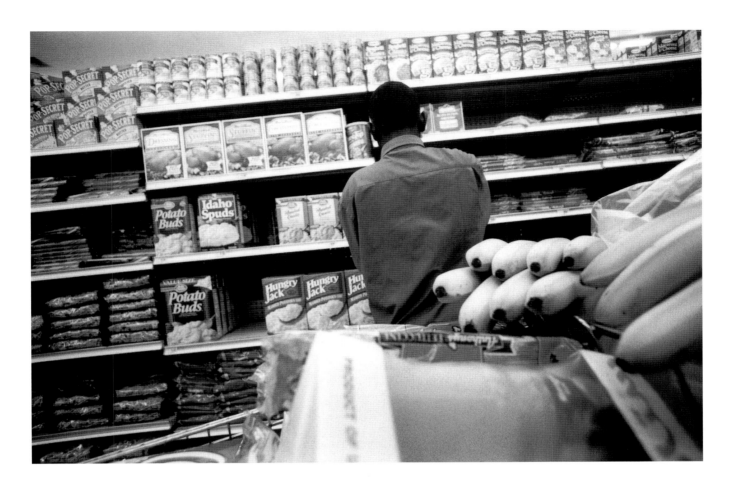

Abdisalam and the Grocery Store, Anaheim, April 2006. When he
first arrived in the United States, we asked Abdisalam when he
had last eaten a banana, a favorite food of Somalis. He had not had
one since 1998. At the grocery store, he had never seen so much
food at one time. It is hard for him to comprehend why the food
does not spoil and why it should all be in one place when so many
people need it.

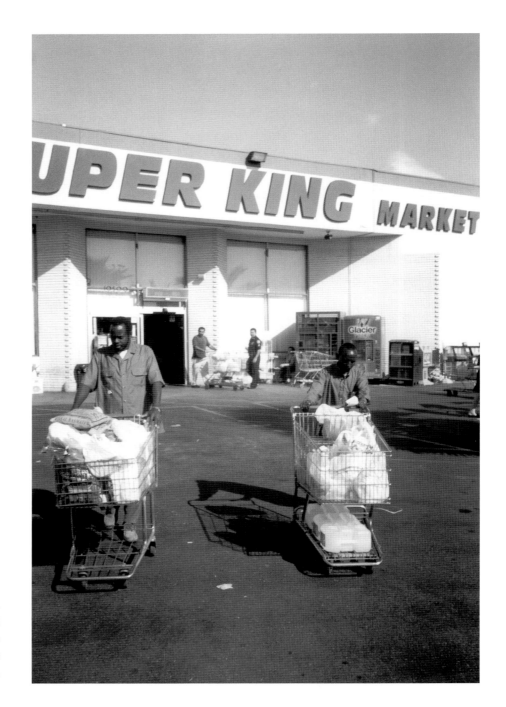

Leaving the Grocery, Anaheim,
April 2006. Abdisalam found a Somali
friend in Anaheim, who shops with
him and helps him negotiate the
difficulties of his new home.

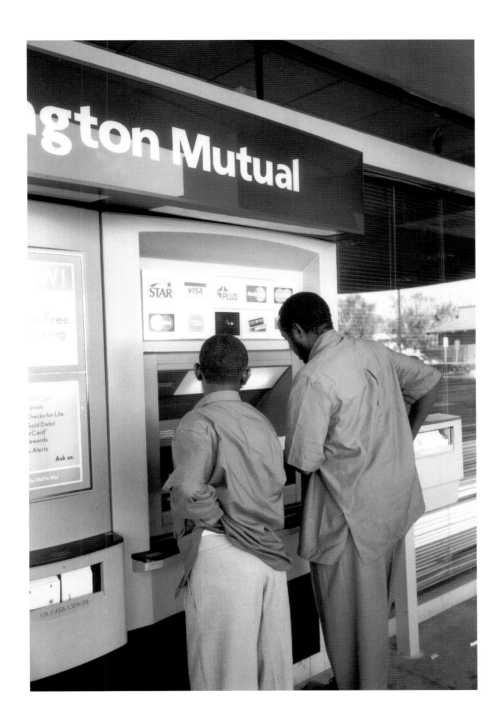

The ATM, Anaheim, April 2006.
To survive in the modern world you
must use modern technology, but it is
a little confusing for Abdisalam and
his friend.

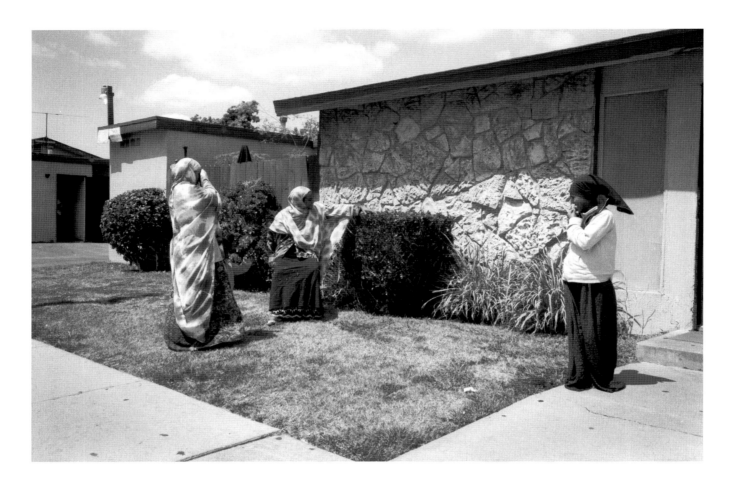

The Ladies Outside, Anaheim, April 2006. Farhiya, Sadio, and a neighbor talk outside the family's new apartment complex. The amount of time Somalis spend outside might seem odd to Americans, but in Africa the appliances that keep American homes comfortable were not readily available, and many immigrants are accustomed to spending most of their days outside socializing with friends. Somalis also feel free when they are outside.

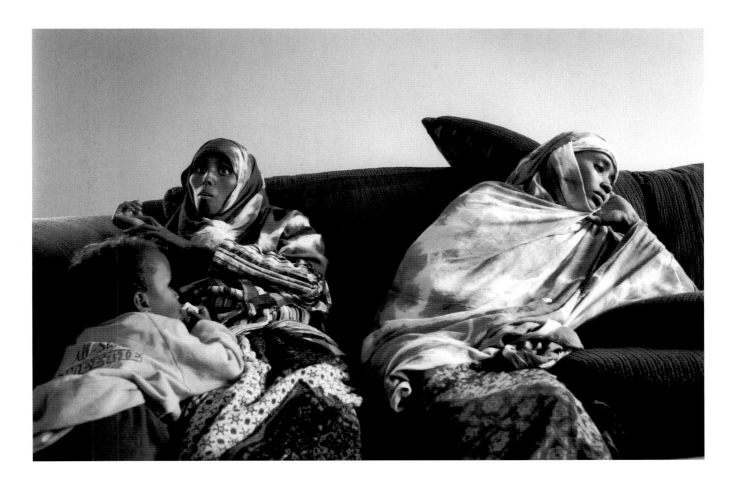

Sitting on the Sofa, Anaheim, April 2006. Ijabo consistently
declares how happy she is to be in the United States, but her
malnourished face exaggerates the anxiety in her eyes.

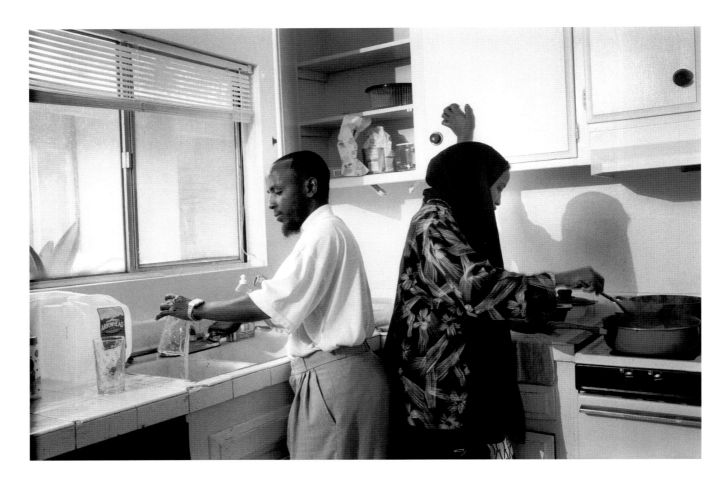

The Kitchen, Anaheim, April 2006. Compared to the stick kitchen in Dadaab, this American kitchen is luxurious. The family of Abdisalam offers traditional Somali hospitality to friends and neighbors.

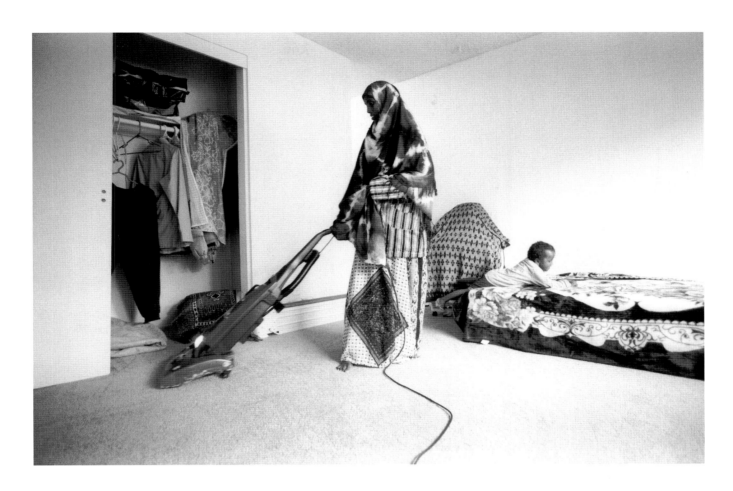

The Vacuum, Anaheim, April 2006. Electrical appliances are a new phenomenon for the family. Ijabo has moved from a home with dirt floors to one in which she relies on mechanical help to remove dirt from the carpet.

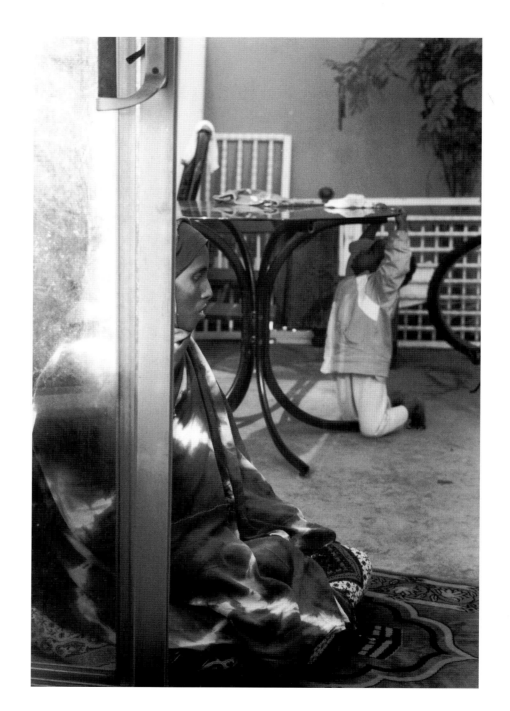

Ijabo on the Porch, Anaheim,
April 2006. Ijabo finishes her
afternoon prayer as Hamdi plays
on the porch of their new home.

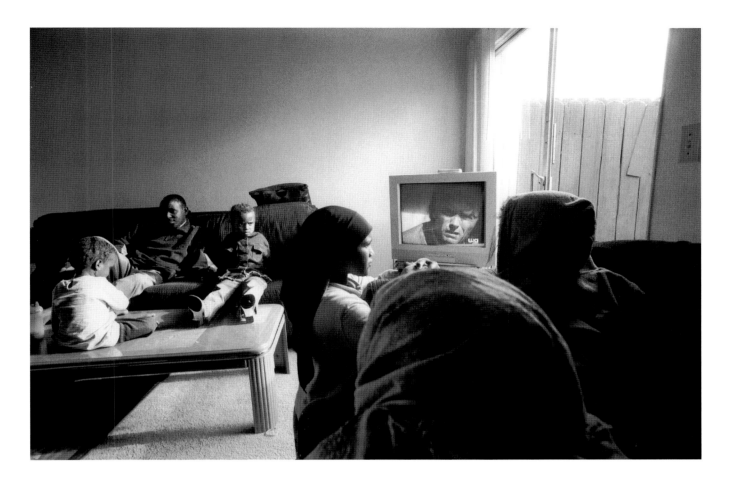

Dirty Harry, Anaheim, April 2006. Farhiya and the children have never seen television before. They have no idea what is going on during this Clint Eastwood cop show, but every time something crashes or explodes they think it is very funny.

Anaheim on a Bike, Anaheim,
April 2006. Abdisalam is discovering
a new land by bicycle with the
unaccustomed luxury of paved roads.

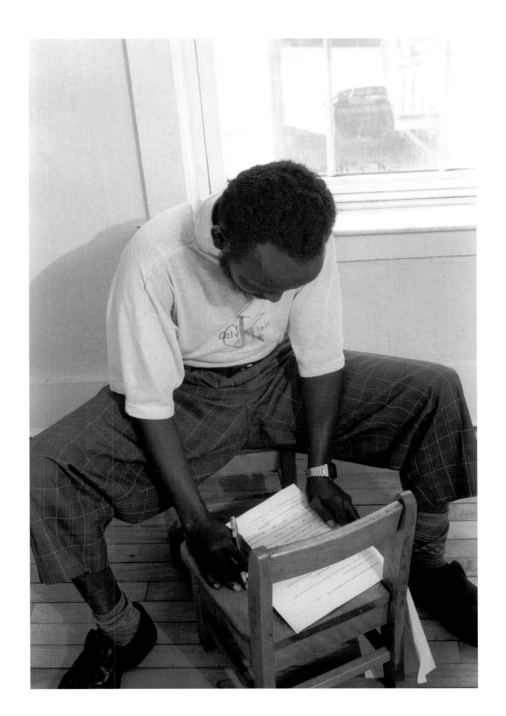

Looking for a Job, Portland, September 2006. Because the job he was promised fell through, Abdisalam struggles to find employment with minimal language and job skills. Before he came to the United States, he could never have understood that access to America's wealth would be so difficult.

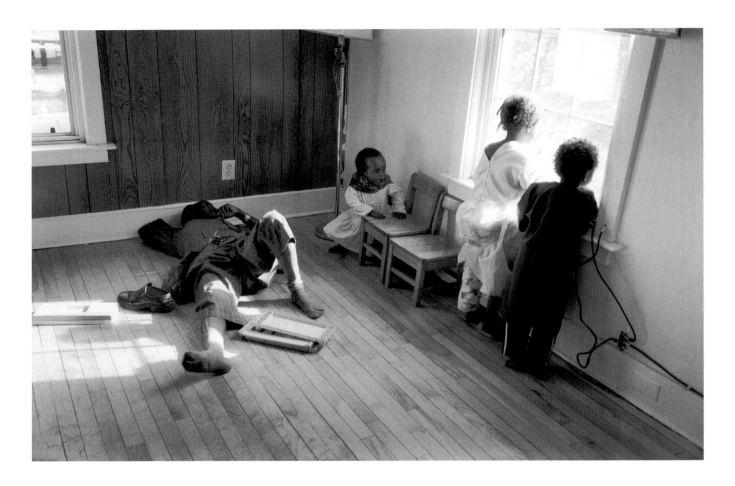

Abdisalam on the Floor, Portland, September 2006. Living conditions for Abdisalam's family in Maine were not as good as they had been in Anaheim. They couldn't afford furniture, so Dad sprawls on the floor while his daughters find amusement in the world outside the window.

Swinging, Portland, September 2006.
The irrepressible Hofsa always finds an
opportunity to play and express her
energy.

The Kids at the Window, Portland, September 2006. The Somali community in Portland is small, but Hofsa and Shukri watch much of it come and go through the windows of this subsidized apartment.

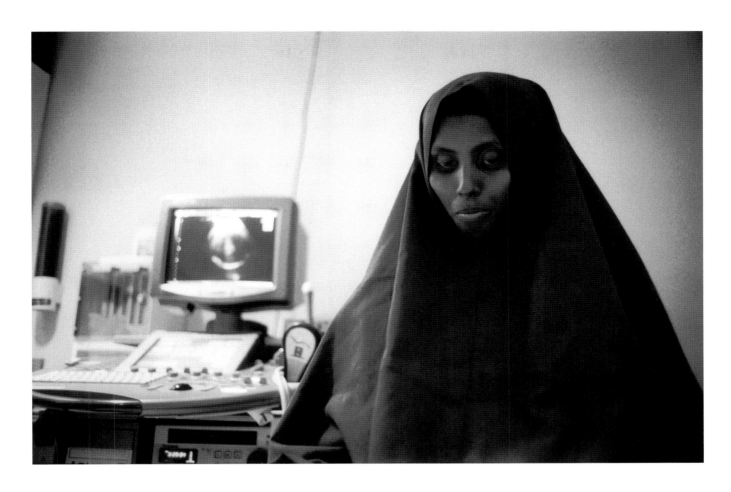

The Ultrasound, Portland, September 2006. Just days before
giving birth, Ijabo has an ultrasound, which tells her that the
baby conceived in the refugee camp will be healthy when born in
the United States. If the delivery had occurred in Dadaab, where
even X-ray machines are unavailable, both mother and baby would
probably have died because of Ijabo's severe malnourishment.

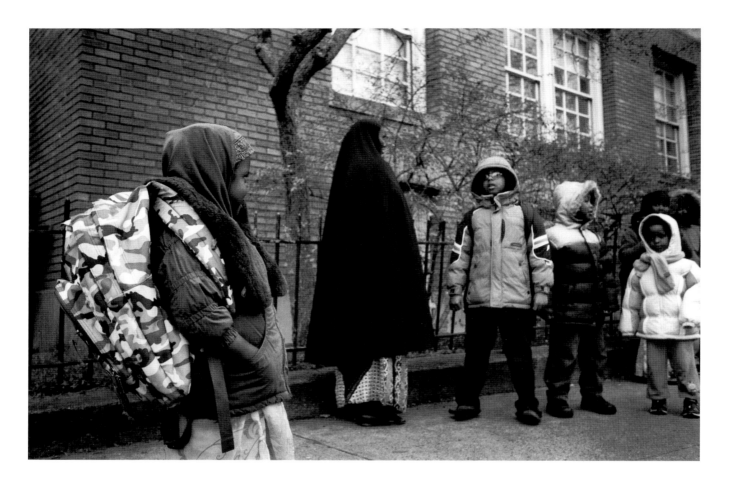

Waiting for the School Bus, Portland, November 2006. When Hofsa started school, she picked up English with amazing rapidity. Her energy and intelligence represent profound hope for her family.

Columbus, Ohio: Preparing for American Life

The rapidity with which the number of Somali people living in central Ohio has grown has surprised most mainstream Ohioans. Indeed, the Somali community in Columbus is thriving. More than 45,000 ethnic Somalis live in central Ohio. There are over 350 Somali-owned businesses in the second-largest Somali community in the United States, businesses that provide jobs for Somalis as well as other Americans. Hundreds of Somali students in Columbus are pursuing undergraduate degrees and many are working hard toward advanced degrees. The Somali community has come together to create several nonprofit organizations that provide after-school programs and ESL classes, as well as help newcomers apply for jobs, find adequate housing, and negotiate the challenges of a new culture.

Despite these advances, most Somali people in Columbus are still preparing to participate in American life. Many of the Somalis living in Columbus were refugees from rural areas or small towns in Somalia. Like Abdisalam, they were either subsistence farmers or nomads who had little experience of urban life, so they have not quite reached the point where they are able to participate in American cultural life as thoroughly as they soon will be. Moreover, the percentage of recent refugees is larger in Columbus than it is in Minneapolis, the biggest Somali community in the country. Finally, most people in Columbus were forced migrants, who fled the violence that accompanied the outbreak of the civil war in 1991, whereas in Minneapolis, a significant number of people are voluntary migrants who left Somalia in pursuit of education or professional positions long before the civil war began. This means that Somali people in Columbus are struggling to learn the language and adjust to the culture of central Ohio, while mainstream Americans are still trying to decide how to respond to their new Somali neighbors.

The fact that the Somali community in Columbus is still largely in the preparation stage of development presents special challenges concerning the exercise of political influence, which has become so crucial to the community's well-being in Minneapolis. During the elections in the fall of 2006, most candidates for local and national office were interviewed by the Somali newspaper, the *Somali Link*. This indicates that politicians

are aware that the Somali community in Columbus is developing a degree of political clout. However, politicians were not making the kinds of specific promises to deal with Somali problems that we will see them make in Minneapolis, because the Columbus community is not as organized or as large as the community in Minneapolis, so Somalis in Columbus are not able to sway elections the way they can in the Twin Cities.

Education presents a significant challenge to the Somali community in Columbus. Both parents in families that recently immigrated to this country are required to take ESL classes in Franklin County or risk losing their benefits. This can be a problem for people with large families, as it often presents difficulties with child care. If the family were lucky enough to immigrate with its elders, then of course grandparents could watch the children, but very often, as was the case with Abdisalam and his mother, families are broken apart during the immigration process, so the kind of familial support that would have been available in Africa does not exist in Columbus. In response, several Somali nonprofit organizations have arisen to teach ESL within the community, while attempting to provide child care as well.

As we noted earlier, the more significant educational problem is that after growing up in a refugee camp for ten or fifteen years, children are placed in American school systems according to age, not educational level, and if they have reached the age of eigh-teen, they are not placed in school at all. This is a serious problem for almost all Somali parents in Columbus, and it means that children often feel alienated from their classmates. In an attempt to address this gap in educational achievement, the community has worked hard to win grants that finance after-school programs, which, in turn, help bring their children up to grade level.

Several organizations, such as the Somali Women and Children's Alliance, HAND (Helping Africans in a New Direction), and the Somali Community Association of Ohio, have garnered the resources to provide ESL classes for newcomers and to create after-school programs that help children who last attended school in the refugee camps catch up with their American counterparts. Moreover, these organizations help people prepare for and apply for employment in central Ohio. The school system itself, however, offers little culturally sensitive education, so clashes still arise. Of course, it takes time for schools to take advantage of the opportunity Somali students present for all students to learn about and become sensitive to another culture.

The effort to become culturally sensitive also needs to occur in the workplace. For example, Somalis consider eye contact to be aggressive and arrogant, so during a job interview a Somali man would be predisposed to look down or away from his potential employer out of respect. For his or her part, the American interviewer would be culturally inclined to think that the job can-

didate who refused to look him or her in the eye was untrustworthy. In this case, neither person would be expressing cultural prejudice. Nevertheless, cultural differences would have prevented each of the people from understanding the other. A similar misunderstanding can occur when it comes to shaking hands. Many Somali women believe that their religion prevents them from shaking hands with or indeed touching men (other than family members) in any manner. Moreover, many Somali men believe that they cannot shake hands with women. Religious restrictions also sometimes prevent Muslim people from shaking hands right before prayer, and Somali people often feel unable to shake hands after they have eaten. Therefore, several scenarios might arise in which a Somali person would decline to shake hands after an interview. Such behavior might seem to the American interviewer to be rude and disrespectful, whereas the Somali interviewee would have been trying to be pious, clean, and polite. In addition, Somali Muslims require time to pray. They also have to clean much of their body before prayer, which can make normal bathroom facilities inadequate.

It is also true that Somali people themselves often have to be trained to cope with the environment of modern American corporations. Mohamed Mohamed, who is pictured at the end of this chapter waiting for the bus after Eid, was mistakenly given the wrong Social Security number when he first arrived in this country, so for nearly a year it was illegal for him to work. When he finally was able to secure employment, he found that for months his paychecks were for far less than he expected. When he asked a friend to look into the matter, his friend discovered that Mohamed didn't know how to punch in. Apparently, his workplace required that the employee dial a number on a phone and then at certain sound cues punch in other numbers to identify the employee and the employee's time of arrival on any given day. Modern technology was simply something Mohamed was not accustomed to, so he was punching in inappropriately and therefore losing money.

Columbus has yet to achieve much of the cultural training that has been reached by the general community in Minneapolis. This means that in addition to businesses, public services still have to prepare themselves for the Somali community, as the Somali community has to prepare itself for Western practices. For example, in Somalia, when you are pulled over by a police officer, you are expected to get out of your vehicle and approach the squad car. Obviously, if one were to try that in Columbus, one might well get shot. Moreover, Somalis have a difficult time availing themselves of even basic services, because those services are not prepared for them. There is a phone line for translators, and the courts have very able translators in Columbus, but the police department still does not have its own translator. Medical clinics are having trouble with translators, and banks pull people out of

line to translate for other customers, an action that obviously violates a customer's privacy.

One wonders if the need to have translators within the police department might not solve some significant problems that the community faces in central Ohio. For example, Nasir Abdi, a young Somali man, had a serious but treatable mental disease. When he stopped taking his medicine for bipolar disorder in the fall of 2006, his mother called Netcare, as she had in the past, so that her son could receive the treatment he required. Netcare routinely dispatches the Franklin County sheriff's office in such cases to pick up and bring psychologically troubled people to the hospital for care. Four deputies were sent out to apprehend Nasir Abdi, but within sixty seconds after the deputies arrived on the scene, Nasir Abdi was shot dead. It is standard practice for law enforcement officials to find a family member or neighbor who can negotiate with the patient, but none of this occurred in the case of Nasir Abdi. The sheriff's office claims that Mr. Abdi was armed with a small knife, but Somali witnesses on the scene insist that there was no weapon. Instead, they say that the deputies sprayed mace in Mr. Abdi's face, and when he swung his arms in response to the spray and the pain, one deputy shot him. When reporters arrived on the scene to investigate, they interviewed English-speaking people, but not the Somali witnesses. Moreover, it seems at least possible that if the sheriff's deputies had some way of engaging with Somali people in their neighborhood, they could have negotiated with Nasir Abdi. Instead, they shot him.

Perhaps one of the most telling and disturbing signs of cultural mistrust and misunderstanding in Columbus occurred when the deputies were brought before the grand jury. The courthouse was surrounded by barricades that said in Somali, Arabic, and English, "Do Not Pass Beyond This Point." These barricades had never been used before in the history of Franklin County jurisprudence. They were created specifically to discourage Somali people from expressing their opinions concerning the hearing.

This is not to say, however, that Columbus is not trying to take advantage of the potential for economic prosperity and cultural diversity that the Somali community offers the city. For example, Mayor Michael Coleman has recently instituted an annual meeting between the Somali community and his office, and he has hired a creative and intelligent man in the person of Abdirizak Farah to be part of the Community Relations Office.

Nevertheless, at the moment, there is little cultural dialogue on the community level. In the Minneapolis neighborhoods that include Somalis, they and other Americans come together to discuss how best to use their resources, learn from each other, and simply enjoy each other's company. The Somali community is much more isolated and segregated in Columbus than it is in Minneapolis. Perhaps this separation will be overcome

in time, but for the moment, it means that Americans remain more unfamiliar with their Somali neighbors than they should be. Moreover, it is more difficult for some Somalis to find jobs and for mainstream Americans to discover the business opportunities that the Somali community offers.

Somali social life, almost unseen by mainstream Americans, is vibrant in central Ohio. One profound way in which that vibrancy is expressed is through Somali weddings. Somali weddings may be conducted with the wedding parties in traditional Somali dress or American style, but no matter how people dress, the event remains Somali in values and in purpose.

Perhaps like any other marriage ceremony, Somali weddings are oriented toward women. This orientation is demonstrated in a very colorful fashion in Somali weddings, for every time a woman moves during the celebration, a great swath of color sweeps across the floor. Many of these ladies wear hijabs and long, flowing traditional gowns of bright and intense colors, and all of the colors are coordinated. How do they do that? Women from the community must be on the phone with each other for weeks, deciding who is going to wear what, so that when the big night finally arrives, none of the colors clash, and no one is wearing exactly the same thing. Instead, the ladies' tables become like intricately designed bouquets, so that each hijab-wearing head is like a flower, thrusting itself up to be noticed.

Many people complain that they cannot under-stand women who wear the hijab, because this clothing conceals too much about the person. However, Muslim women have plenty to say about themselves, their place in the community, and their place in the universe through the clothing they wear. Hijabs can be more or less conservative and even more or less fashionable. If you look into the classes of a charter school designed for Muslim children, you can tell which girl is studious and which is trendy simply by looking at their hijabs. You can also tell who is married, who is single, who is more religious, who is less, who is rich, who is poor, who is celebrating a special occasion, and who is simply getting through her day. If mainstream Americans cannot understand a woman who wears a hijab, it is because they have not learned to speak her language, and this will not change when the woman simply removes a piece of cloth from her face.

Muslim women dress with varying degrees of conservatism, but no one is more conservative than the bride on her wedding night. In Somali weddings, the bride is expected to maintain a grave expression for the entire evening. Otherwise, she will be thought of as anticipating only the pleasures of marriage without giving consideration to the seriousness of the event. How does the bride do it? How can she possibly concentrate on looking morose, while everyone else is dancing, laughing, and making traditional trills of ecstasy? The adults and even the children dancing around the bride and groom are celebrating the event

with every positive emotion they can muster, but the bride must continue to look intense and serious; the look of joy and celebration will have to wait for the next wedding she attends.

In Western weddings all the other ladies attending have to be very careful not to dress better than the bride, but for the other ladies in Somali weddings there are no such barriers. The bride is definitely not the best-dressed woman present. In fact, she dresses rather plainly, whereas all the other women are covered in the most flamboyant of colors. When Western women attend a Somali wedding, nothing they can do can prevent them from appearing rather banal in comparison to the great sashaying of bright, shimmering colors that adorn all the Somali women save the bride. The bride is being initiated into their number, but she has not yet arrived. She must look simple and serious in comparison to the excitement of the women who dance around her.

Somali weddings are unlike American weddings, not only because there is no alcohol, but also because anybody can come. People hear about the wedding through the most powerful means available to Somali people, word of mouth. Word can and does spread from city to city, state to state, and even country to country, and anyone who hears about the event and would like to participate is more than welcome. Indeed, not to welcome everyone would mean that there is someone you do not love, someone you do not consider part of the fam-

ily; more important, it would mean that you were stingy and selfish and that you did not know how to care for guests. No Somali wants to be thought of in such a way, for to be Somali is to be welcoming and kind.

The wedding needs to be large, because this event is more than a celebration of the loving couple; it is a celebration of the community. It is also an initiation of the couple into the adult members of the community. Of course, Western weddings also celebrate the group, but to understand the difference, you must consider the experience of Abdi, who visited his family in Somalia and was told that he had to marry or his family would cast him out. He would no longer be their son. That evening, they introduced him to his bride in what became a formal engagement. The next day the wedding occurred. "Did your family make the right choice for you?" Abdi was asked. "Oh yes, she was wonderful," he replied. Four months later she was pregnant. The point is that Abdi reached a stage that in order to be an adult member of the Somali community, he needed to be married; if the family and the community are to continue, they need children, so Abdi's individual happiness was not as important as the continuation of the group.

Traditional Somali weddings are often divided in time between male and female sections. In the morning, men gather to discuss dry things like the dowry and how the bride will be cared for. In the evening the women gather to dance and chant until the early hours

of the morning. The women dance around the bride often making a long trill in their throats until four in the morning or when the sun comes up. Then the husband comes to have the last dance with his new wife, and he takes her home. But when they leave, it is not to go home alone, for the rest of the wedding party will follow them and the bride and groom are expected to feed them. Moreover, this is simply the beginning, because from now on, whenever any member of the community drops in unannounced, the couple is required to be hospitable and support that person in whatever manner the occasion requires. It will be days before the wedding couple are actually allowed to be alone. They are so surely being initiated into the community that they cannot even separate themselves from it long enough to get to know each other.

In Western weddings, individual happiness is usually paramount, and this remains true through the life of the relationship. Therefore, if a husband or wife decides that he or she is not happy, friends and family will support each of them through the divorce. This is often not true for a Somali couple. The risk of losing your place in the community is great, and that place can be lost when the marriage is terminated. If there is trouble between the couple, the elders of the families counsel each spouse and try to negotiate a suitable solution that will leave the marriage intact. All the members of the community will do what they can to maintain happiness within the marriage.

If the marriage still breaks down, it is entirely possible that the community will decide which partner is at fault and cast that person out. For example, one gentleman, whom we shall call Hassan, left his wife after the community did everything it could to keep the couple together. Hassan was a respected member of the community. He used to come to meetings and offer his opinion on important issues concerning the Somali people, but he no longer comes.

Unfortunately, Hassan is also left out of what might be called the insurance system. Normally, when a Somali person is out of a job, he can count on financial support from the community. If he is sick or hurt, the community will come together to help him. If he goes to the hospital without insurance, the community will collect money to pay the bill. However, for the rest of his life, Hassan will be unable to garner the support of his people. If he gets sick, no one will help him; if he needs money, no one will collect it for him. Now, he is truly alone.

Somali weddings are celebrations of the community, not simply the couple. Love here is love of a family, a village, and a people, for the entire community will raise the children, and the entire community will grow stronger through the love of the couple. To be Somali is to be part of a group. Every decision you make is seen as contributing to or detracting from that group. Even one's most personal and intimate moments are seen as integral to the community; to deny this fact even for a moment would be a sign of selfishness, and

no one dares risk being thought of as selfish in the Somali community, for then he will not receive help when his need arises. You are either a part of the group, or you are alone.

Many of these rituals may seem foreign to Americans, but this sense of strangeness will diminish as Americans become acquainted with their Somali neighbors. One way mainstream Americans can overcome the barrier that separates them from their Somali neighbors is simply to introduce themselves. Somali restaurants offer the perfect opportunity for Somalis and Americans to come together, but Americans must be prepared to encounter some cultural differences. In some Somali restaurants in Columbus, as opposed to Minneapolis, there is a special place for women to eat that is separate from men. Somalis often feel that people of the same gender want to eat together, and they believe that women want to be separate from the heated political conversations men are likely to have. If a family or a group of people come into African Paradise, a Somali restaurant in Columbus, for example, those people may well be shown the women's section in the back. This does not mean that women have to eat in the rear or that Somalis do not respect women. It is simply part of an ancient cultural practice that gives Columbus more of a traditional flavor than the largest of the Somali communities in North America. By the way, *mahadsanid* is the Somali word for "thank you," and it is wonderful to see Somali faces light up when Americans attempt even one word of their native tongue. Attempting to employ Somali phrases is a good way to initiate the transition from neighbor to friend.

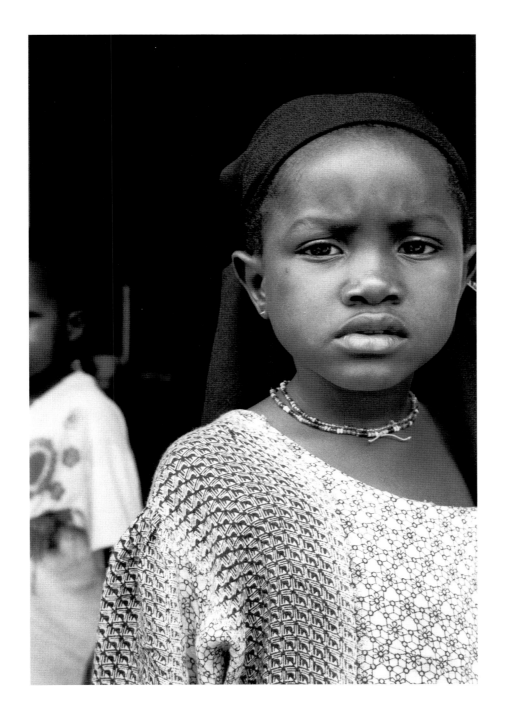

Batula, Columbus, July 2004. Batula
(here with her sister, Chengwa) had
lived only in a refugee camp before
she moved to Ohio.

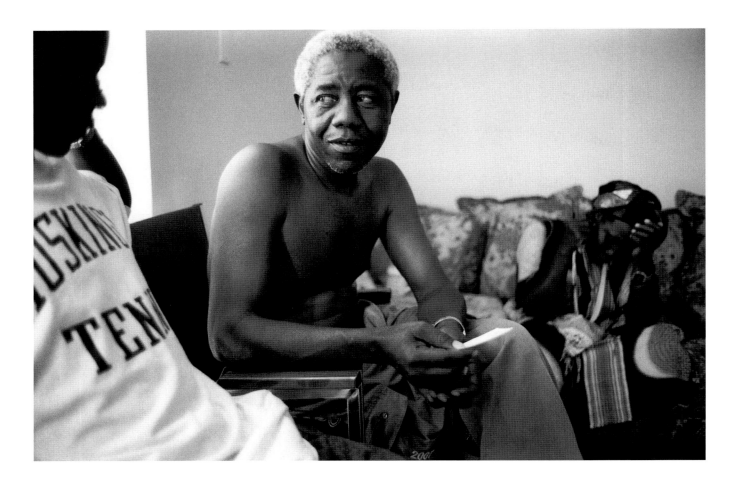

Hassan Ali Kassim, Columbus, July 2004. After Mr. Kassim had been in Columbus a week, trouble arose between the African American and Somali communities in his rent-subsidized complex. The Somalis felt under attack and had to move. On the Fourth of July, Mr. Kassim's belongings were put into this apartment. The heat was stuck on, and it was unbearably hot. The Somali tradition of hospitality is so strong that Mr. Kassim wanted to offer us, his guests, a traditional Somali meal, despite the intolerable heat and the fact that he had just moved.

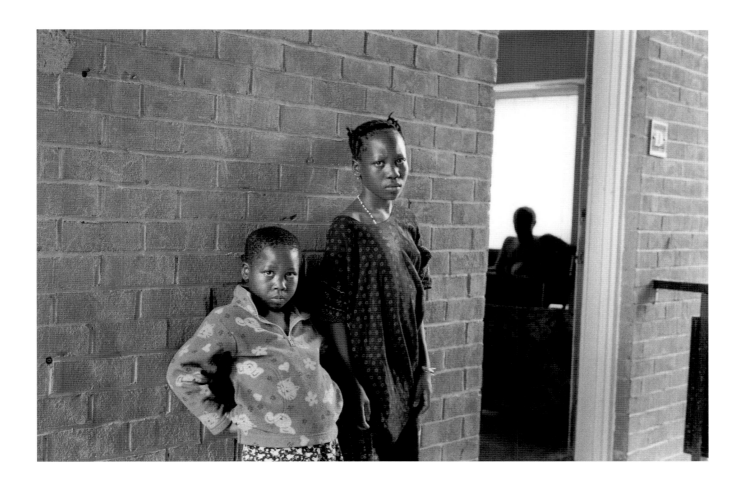

The Children of Mr. Kassim, Columbus, July 2004. Mr. Kassim's daughters, Muslimo and Talafay (the taller, older sister), wait outside their new apartment to keep cool.

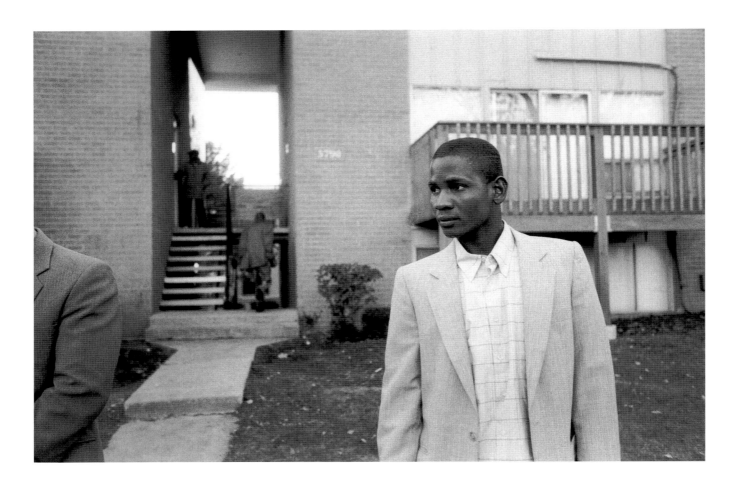

Habib, Columbus, July 2004. Habib had grown up in the refugee camp, but he expressed frustration about talking about the past. His only question was, "Can you help me find a job?" He is now married and working three jobs, for he has family to support in Columbus and family to support in Africa.

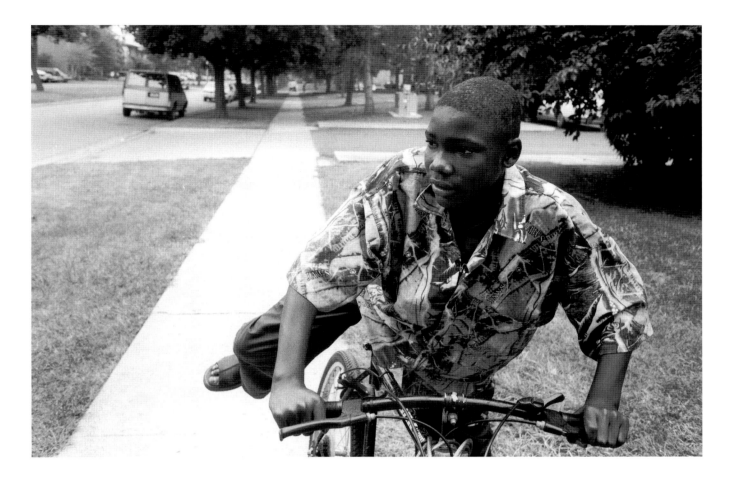

Boy on Bike, Columbus, July 2004. This young man had been out
of the refugee camp only a short time before he was riding his
bike down this tree-lined American street. When he was asked,
"What about the friends you left behind?" his head dropped in
guilt and sadness. To an American, the question seems harsh,
but Somalis believe they have a moral responsibility to an almost
mystical concept of the Somali people. This boy was reminded
that it is fine to enjoy his current pleasant circumstances, but
as he grows up he must remember his duty to help those he left
behind.

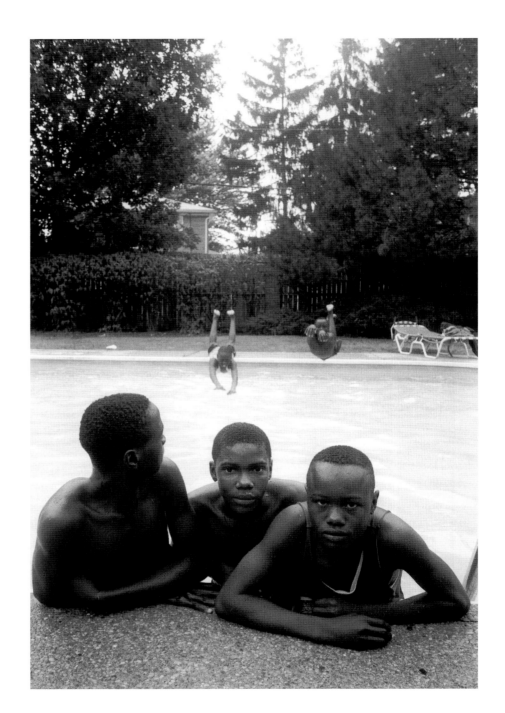

Boys in Pool, Columbus, July 2004.
Teenage boys who grew up in a
refugee camp enjoy a dip in the
pool at their apartment complex.

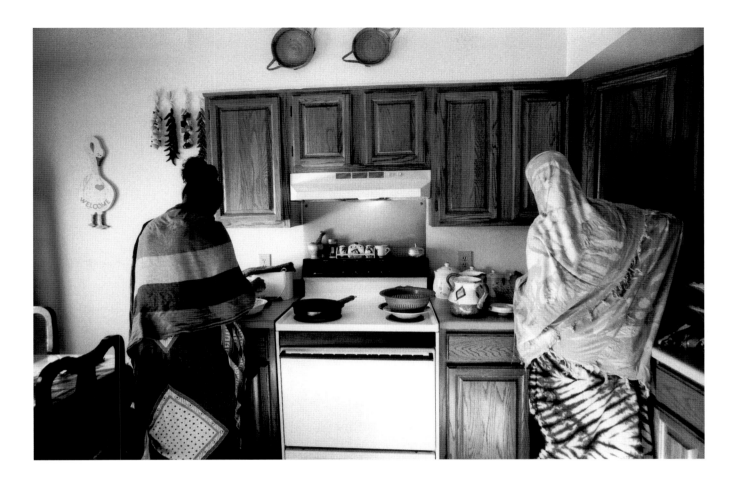

Somali Hospitality, Columbus, May 2004. The kitchen is the
center of Somali social life. Friends drop by Somali households,
unannounced and unexpected. No one asks if the guests are
hungry—the women simply start preparing an elaborate meal
that usually includes rice and goat meat.

Abu Hassan, Columbus, April 2003. Mr. Hassan, a butcher at
Maka Market on Morse Road, cuts up goat meat. Maka Market
serves halal meat, which has been blessed. The blessing requires
that the animals be butchered according to religious restrictions.

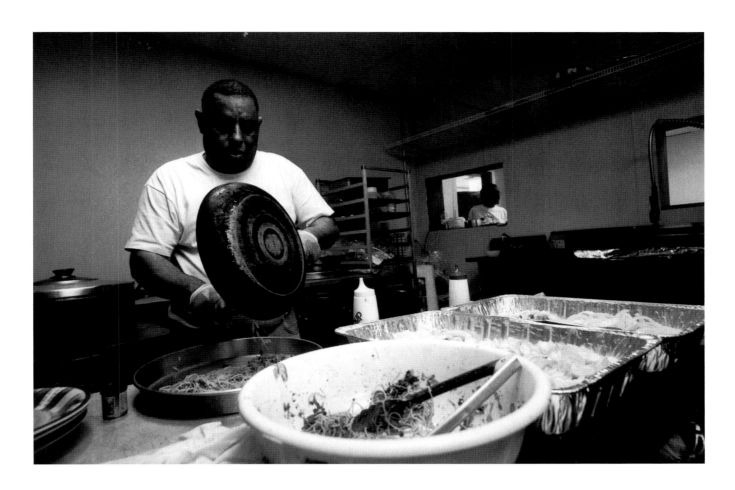

African Restaurant, Columbus, July 2003. Somalis enjoy gathering
at a Somali restaurant as well as at home. Chef Sherif prepares a
traditional Somali meal while a server waits for his order.

Blackie, Columbus, September 2005. Wearing his trademark hat,
Blackie enjoys lunch at a Somali restaurant on Cleveland Avenue.

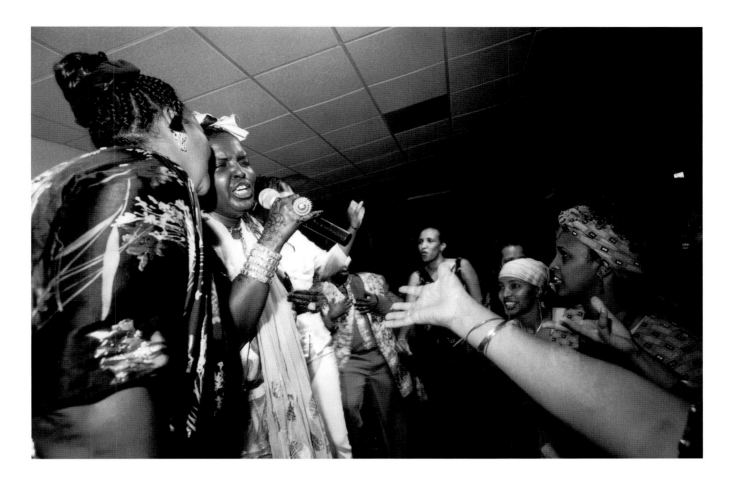

Maryam Mursal, Columbus, November 2003. Maryam Mursal, a
famous Somali singer, was forced to flee Somalia on foot when the
civil war broke out. Now she produces CDs and visits her many
fans on tour. Because Somali is an oral culture, the tradition of
song and poetry is strong, and Somali songs are rhythmic, poetic,
and romantic.

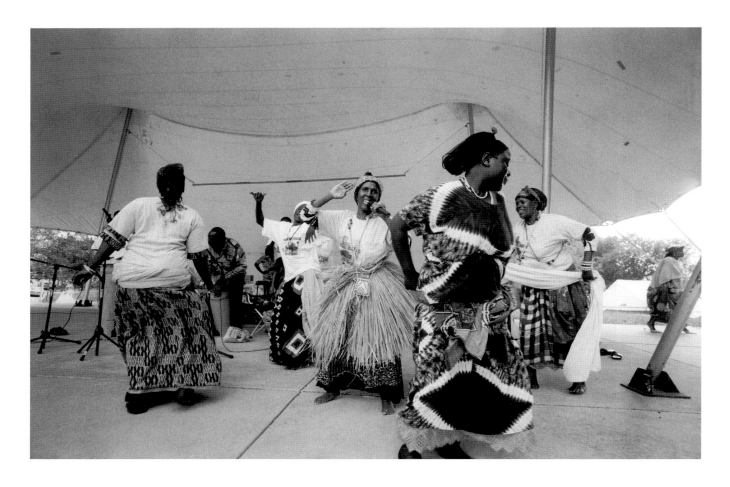

Traditional Somali Dance, Columbus, August 2005. These Somali
women performed at the African Festival in Columbus. Somali
folk dances are complex and vary by region. Sometimes Somalis
dance to encourage rain and fertility.

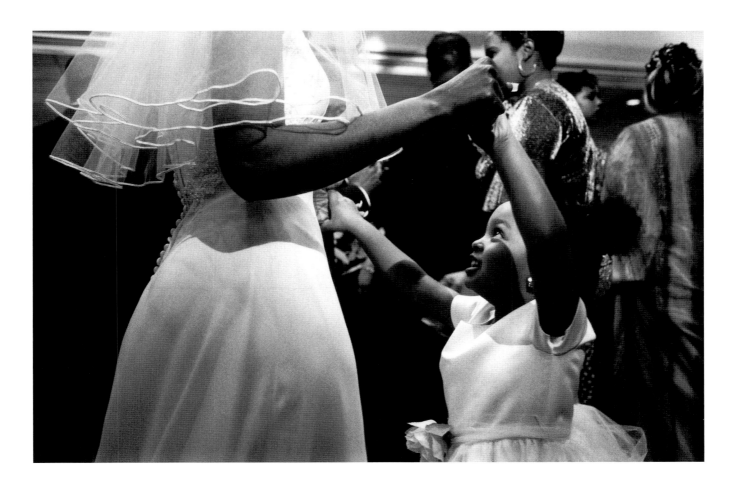

American-Style Wedding Series 1, Columbus, December
2003. Somali women in the United States may choose
whether they dress in traditional Somali wedding clothes
or in an American-style bridal dress. The values and the
schedule of the ceremony remain Somali. Perhaps this girl
imagines when this wondrous ritual will revolve around her.

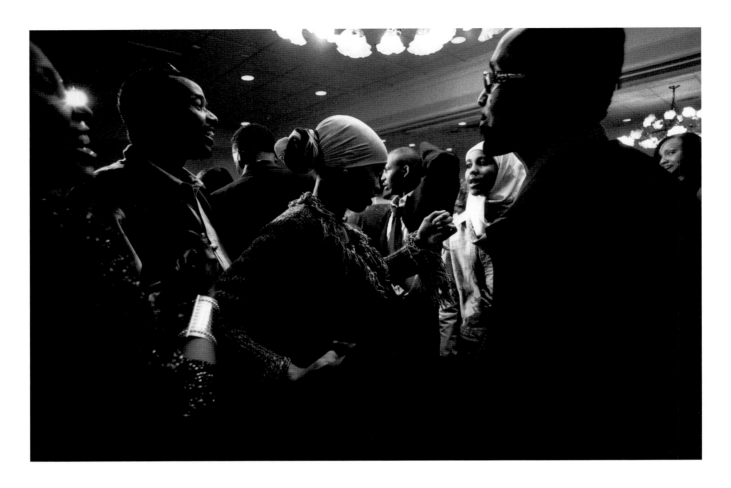

American-Style Wedding Series 2, Columbus, December 2003.
In this American-style wedding, men and women dance together,
though many women wear traditional Somali clothing.

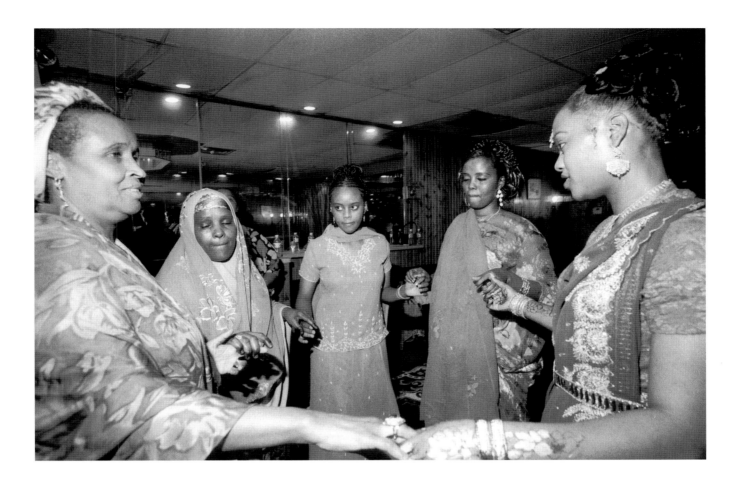

Traditional Somali Wedding Series 1, Columbus, August 2005.
Traditional Somali weddings are divided into two sections:
usually the men meet during the day and the women in the
evening.

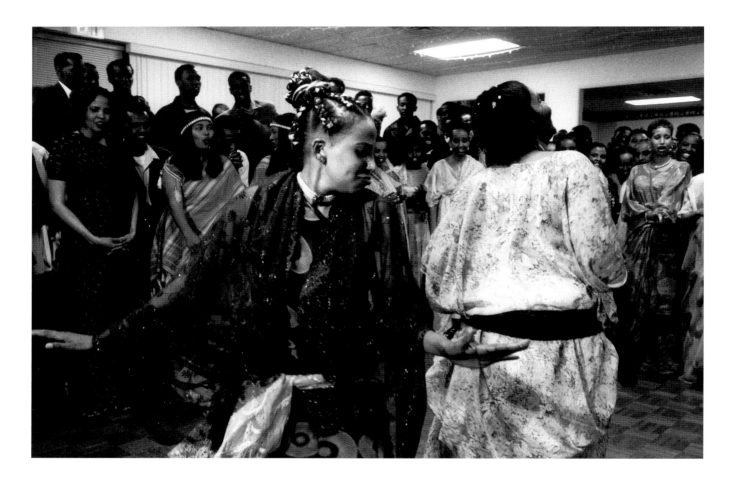

Traditional Somali Wedding Series 2, Columbus, January 2004.
In the women's section of a traditional Somali wedding, Somali
ladies dance late into the night. These women dance and chant,
but the bride must remain serious or she will be considered light
and frivolous. She must wait until the next wedding to express
her delight in dance and song.

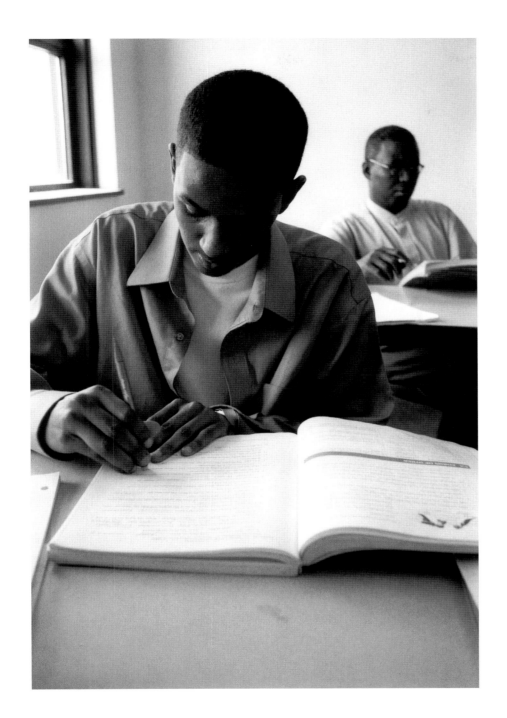

Learning a New Life through a New
Language, Columbus, November 2006.
Columbus State University offers
a program in English as a Second
Language to Somali college students.

After-School Program, Columbus, August 2005. Somali children
have a hard time in American schools, where they are placed
according to age rather than performance level. To help the
children catch up to their American peers, Somalis provide
after-school programs that teach math, English, and science.
Somali children are soon able to perform commensurate with
their American counterparts.

Fatha Hashi, Columbus, February 2004. Fatha, one of the Somali success stories, studies at New Albany High School.

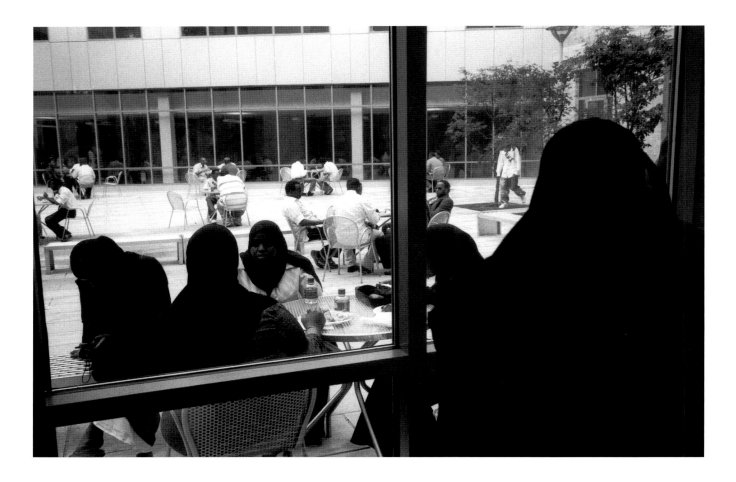

Somali Student Association of North America at Ohio State
University, Columbus, August 2005. This organization
represents thousands of Somali students who are pursuing
advanced degrees. The percentage of African immigrants
currently obtaining college degrees is higher than for
the general American population (Clarence Page, "Black
Immigrants Collect Most Degrees," *Chicago Tribune*,
March 18, 2007).

Huda Qur'an School Series 1, Columbus, February 2004. In addition to attending school and after-school programs, Somali children go to Qur'an school on holidays and weekends. All Muslim children must memorize the entire Qur'an. This boy meditates on the holy book in a sacred space.

Huda Qur'an School Series 2, Columbus, February 2004. Shoes must be taken off before a person enters Somali Muslim space, from mosque to home. At the end of the school day, children locate their shoes before going home.

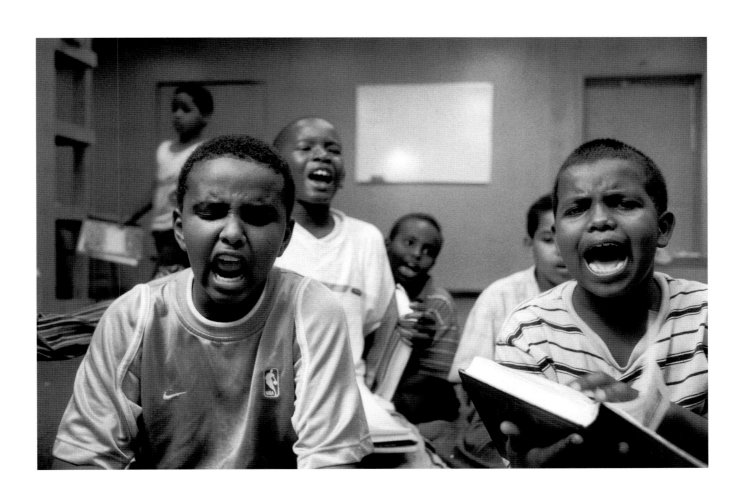

Huda Qur'an School Series 3, Columbus, February 2004.
These boys chant verses *(Ayat)* from the Qur'an in their
effort to memorize the holy book. The teacher calls out
the beginning of a verse, and the children are expected
to complete it.

Bus Trip to Prayer, Columbus, November 2004. These Somalis
are on their way to celebrate Eid ul-Fitr. During Ramadan, in
the ninth month of the Muslim calendar, the faithful fast while
the sun is out. On the day after Ramadan, Somalis celebrate Eid
ul-Fitr: first they attend morning prayer, and then they enjoy
large meals with friends.

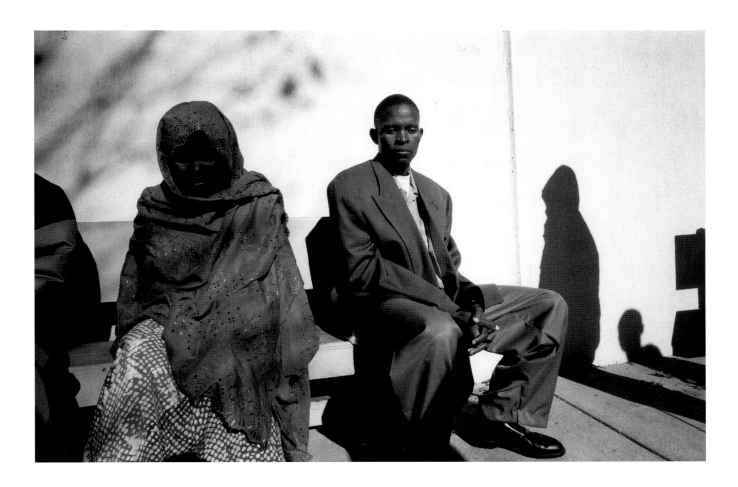

Going Home, Columbus, November 2004. After attending
Eid ul-Fitr prayer, Mohamed Mohamed waits for the bus
to take him home.

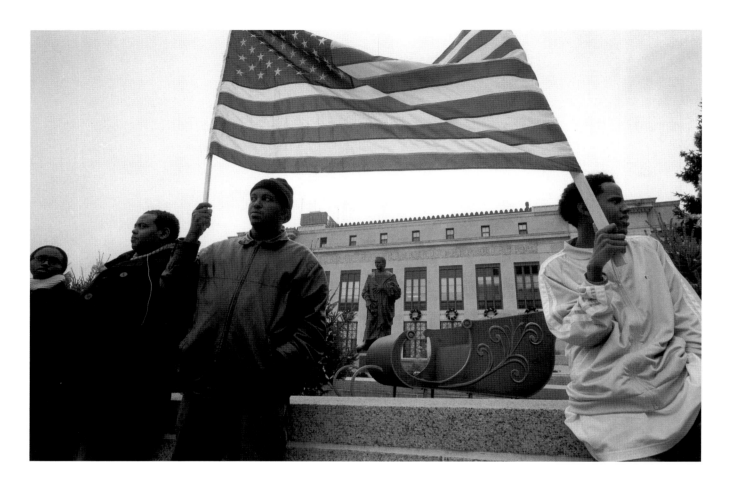

Protesting, Columbus, December 2005. Nasir Abdi, a
mentally ill Somali man, was shot dead by Franklin County
sheriff's deputies sixty seconds after they arrived on the
scene. Mr. Abdi's parents had called Netcare for help when
their son stopped taking his medication; Netcare called the
sheriff's office. The Somali community believed his death to
be unjust and protested in front of City Hall.

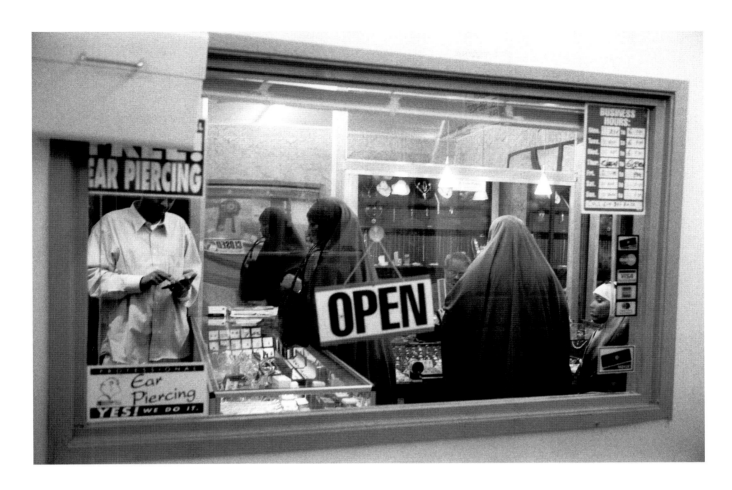

Ear Piercing, Columbus, April 2003. This scene at Kowther Jewelry Store illustrates part of Americans' difficulty in understanding their Somali neighbors: why would women purchase earrings if they then cover their heads? Women throughout the world like to think of themselves as beautiful. The earrings testify to the inner worth of the Somali women, and the men who love them will see the earrings, because the hijabs are removed at home.

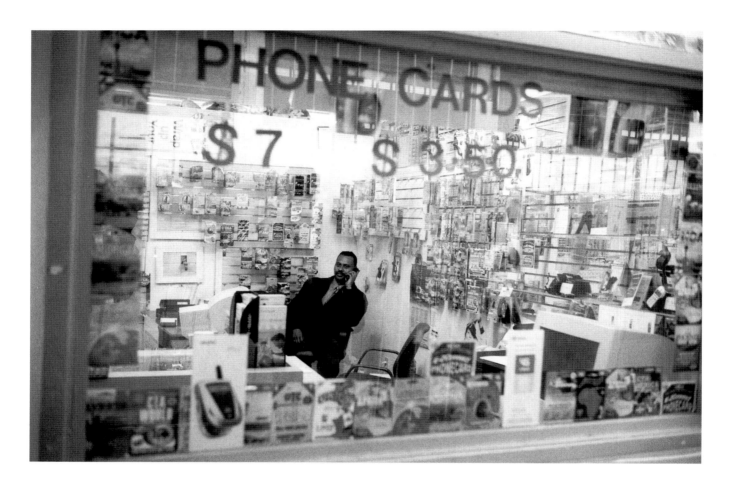

Phone Cards, Columbus, May 2003. Somali immigrants want to
stay in contact with friends and relatives back home. Phone cards
allow them to call Africa for a fixed price, so they don't run up
large phone bills.

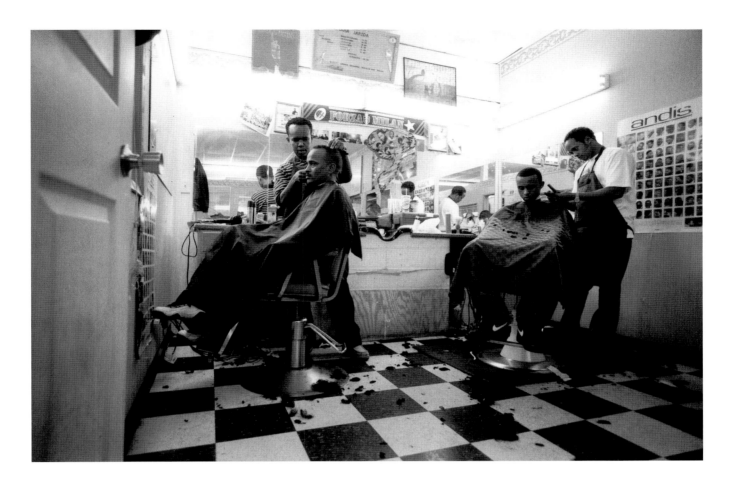

The VIP Barber Shop, Columbus, April 2003. Sade *(right)* runs
an energetic and exciting barber shop: people drop in, no matter
the length of their hair, to talk about what is going on or to
discuss the political situation back home. Abdi Nassir, his fellow
barber *(left),* is glad to live in America but worries that people
accumulate so many bills here that their freedom diminishes.

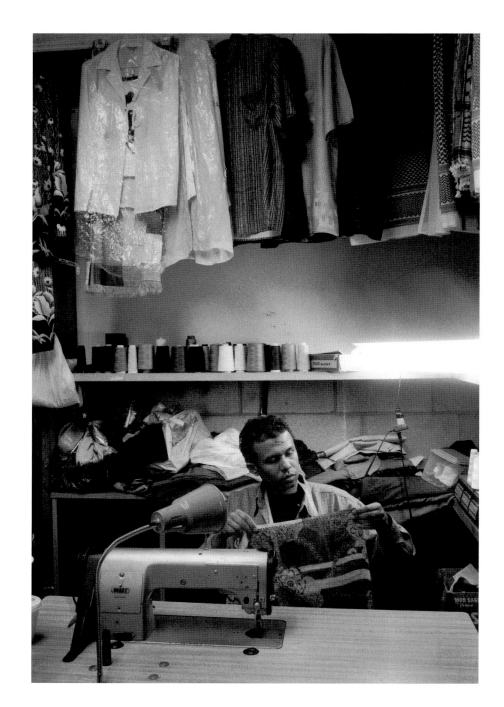

Maki the Tailor, Columbus, September 2003. Maki makes a traditional colorful Somali costume. Examples of his work hang above him, including traditional Somali and American outfits. Many people dress for both American and Somali lives.

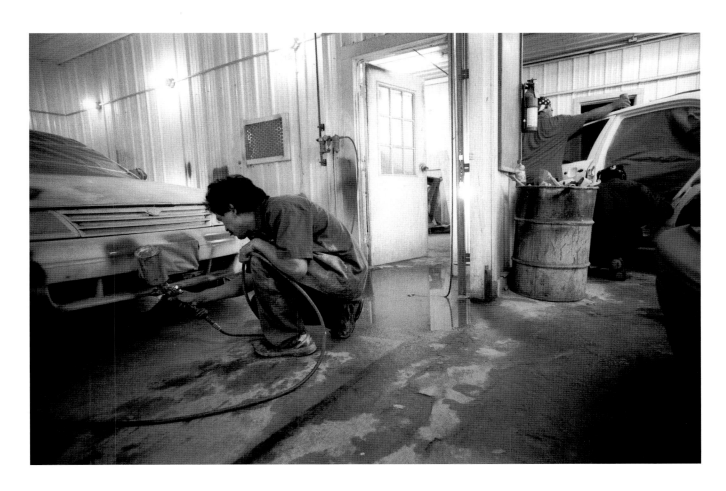

African Auto Sales, Columbus, June 2004. Ali Mohamed, from
Somalia, owns this business; with nearly fifty thousand Somalis
in Columbus, he has a solid customer base. He employs other
Columbus residents, such as Rafael del Cruz, from Mexico,
and *(in the background)* Humberto Lopez, demonstrating how
the Somali entrepreneurial spirit contributes to the economic
prosperity of the city.

Minneapolis: Participation in the Mogadishu on the Mississippi

While most Somali people in Columbus are still preparing to live in the United States, the Somali community in the Twin Cities is fully participating in American life. Nearly 100,000 Somali people live in the Minneapolis–St. Paul area. Approximately 600 Somali businesses hustle and bustle in the two cities. Scores of those businesses are housed in three exciting and busy Somali malls. Many Somali people, especially newcomers, live in the Cedar-Riverside area between downtown Minneapolis and the University of Minnesota, but Somali people live everywhere in the Twin Cities and surrounding towns. Although Cedar-Riverside is the center of the community, Somali professionals often move to the suburbs, where they can raise their children without concern about the crimes that frighten people who live in the inner city. The Somali professional class in Minneapolis is much larger than it is in Columbus. A significant portion of Minneapolis professionals are voluntary migrants, who came to the United States to attend school or start businesses long before the civil war erupted. These people feel an ethical obligation to care for the folks who came as a result of the violence. Indeed, nearly every Somali feels an almost mystical responsibility toward *Dadka Somalida* (the Somali people). This creates a profound support system, which runs from legal advocacy and union organizing to ESL classes and help finding jobs. Also in Minneapolis, there is no separation between the Somali community and the rest of the city. Instead, there is an easy flow between Somali areas and those populated by other ethnic groups, which means that no one is surprised to see women wearing hijabs or a group of Somali men lingering outside a coffee shop.

The Somali community is politically active in Minneapolis. Led by the Somali Action Alliance, Somali people such as Amina Dualle and Nimco Ahmed worked very hard during the 2006 campaigns, and they were extremely proud to have helped elect Keith Ellison, the first Muslim representative to the U.S. Congress. The Somali Action Alliance is the creation of Hashi Abdi, who has struggled for many years to inspire the Somali community to work together to encourage the American government both at the local and national levels to recognize the needs of the Somali people. Mr. Abdi

profoundly believes in civic engagement. He struggles in neighborhood forums and in national elections to get mainstream Americans to engage with the Somali community on issues of mutual concern.

During the 2006 elections, we witnessed a forum held at Augsburg College that had been held since 2002, in which candidates for national and local office were offered the opportunity to address the needs of the community. During this forum, the Somali community asked politicians four direct questions that related to the community's well-being, such as, "Do you support family reunification?" The candidates were required to answer each question either with "yes" or "no." No immediate follow-up was allowed. Afterward, the politicians were given seven minutes to clarify their positions. The final question was, "Will you meet with us within ninety days after you are sworn in to review your progress toward keeping your promises?" That politicians were willing to undergo this rigorous questioning and were prepared to meet with representatives of the Somali community within three months testifies to the growing political strength of the Somali community in the Twin Cities and to the fact that Somali people there are fully participating in American life.

The community is politically active in many other ways. Somali members recently achieved their own table within the Service Employees International Union. This means that the union is now alert to specific Somali concerns. For example, Somali women wish to wear the hijab while they work. Somali people also need time to pray during the appropriate periods of the day, and they need the time and the facilities to prepare themselves for prayer. Of course, like everyone else, they would also like full-time work and benefits. Somali people also came together to protest America's support of Ethiopia's invasion of their homeland on December 30, 2006.

The Somali community in Minneapolis not only has the kind of after-school programs and ESL classes that we saw in Columbus, it also has designed educational programs specifically for Somali children. As we mentioned earlier, the Somali community has built a culturally sensitive school in the Twin Cities International School, Minnesota International Middle School, and Ubah Medical Academy, the elementary, middle, and high schools that educate immigrant children from kindergarten through twelfth grade. The mission of all three schools is to provide an American education in an environment that fosters the East African heritage of its students. By way of this institution, parents are given a sense that they will be able to maintain their culture, while the children are simultaneously able to feel comfortable being who they are. Here, no one stares when young women wear the hijab, nor is there ever any problem when it comes time to pray.

Twin Cities International School, and its sister middle and high schools, represents a special kind of hope

for the Somali Diaspora. Their creator, Abdirashid Warsame, found himself in Otanga refugee camp near Mombasa as a young boy. The fact that he could rise up out of that experience to create a school that would enable the Somali people to take advantage of the educational opportunities that America has to offer, while maintaining their own culture, is something of which he should be very proud. Moreover, his success is also something that represents the range of accomplishment and the potential of the Somali people. Ubah Medical Academy sent its first graduates off to college in 2007, so everyone was very pleased.

In the Twin Cities, people also work tirelessly on a local level to promote understanding and find culturally creative ways to make use of Somali culture in attempting to solve problems that could arise only in America. For example, in Somalia, elders would help bring up everyone's children and would feel free to correct youngsters not their own who were acting in a culturally inappropriate way. In America, of course, if an elder were to pick up a stick and gently tap the back of a child's legs to let him know that school was in the other direction, the elder might well be arrested, but in Somalia, he would be thanked and invited over for dinner. However, in St. Paul, the Somali Action Alliance, in conjunction with the prosecuting attorney and the police department, realized that with minor crimes, elders could often be called upon to help. If children were truant, for example, elders could be employed to speak with them, and in domestic dispute calls in which no one was actually hit, and therefore no crime was committed, elders could be asked to counsel the troubled couple. This would mean that elders, who all too often find themselves in America without their family and with nothing to do, would become useful and contributing members of their community once again. It would also mean that the resources of the police department could be reserved for more serious crimes.

Work is also an area in which Minnesota has become more culturally sensitive than Columbus. The IBM plant at Rochester, for example, has built bathrooms that facilitate the Muslim ritual requirements for cleanliness, and the Jenny-O Turkey plant in Willmar has hired Abulcadir Abucar Gacal (Ga'al), a wonderful Somali man, as a supervisor. Ga'al was a voluntary immigrant who came to California in 1985 and so is more than aware of the culture of American industry. Ga'al not only speaks both English and Somali, he also speaks Dutch, Arabic, and Spanish. His language skills enable Jenny-O Turkey to hire recent Somali immigrants without requiring them to speak English. As starting positions at the plant pay eight to ten dollars an hour, this means that Somalis new to this country can achieve a middle-class lifestyle while they are still learning English.

Moreover, the community is appreciated in Willmar for more than its economic contribution. Somali boys recently helped the high school track team win the state championship, so Somalis have become an integral and welcome part of the community. Indeed, during the Martin Luther King Day celebration of 2007 in this small midwestern town, Mayor Lester J. Heitke told his fellow citizens how much the Somali population contributed to the economic prosperity and cultural diversity of Willmar. Compare this to Lewiston, Maine, where the mayor wrote a public letter telling the Somali people that they were no longer welcome in his town! In this regard, the small town of Willmar, Minnesota, may have something to teach the rest of the country.

While Somalis are entrepreneurs everywhere, they may find it easier to start businesses in Minneapolis than in any other place in America. This is partially true because of the economic base such a large population of Somalis provides, but it is also true because of the various organizations Somalis have created to help their countrymen start and maintain new businesses in the Twin Cities. For example, Abdulkadir Hashi heads the Somali Business Association of North America from here, which gives aid and advice to Somali businesses all over the country. Hussein Samatar created and is the executive director of the African Development Center. This organization is able to offer start-up loans to new businesses without violating the Islamic injunction against paying or collecting interest. Moreover, Mr. Samatar and his staff offer help creating business plans and developing organizational skills, which ensure that new Somali businesses will prosper. Clearly, these are services that would not be available at ordinary banks.

Mr. Samatar also contributes a Somali language program to KFAI, one of two radio stations that make time available for Somali programming. Somalis also have their own television program in the Twin Cities. These services are wonderful for newcomers as well as established Somali people in that they discuss issues and announce events of concern to the community. They also explain how to get basic services, where to apply for jobs, and how to get medical care. Of course, these programs also discuss political issues concerning Somalia itself, and they air Somali songs and poetry.

The Somali people may not have assimilated in Minneapolis and St. Paul, but they certainly are participating in American political and economic life in a way that contributes to the diversity and the vibrancy of an already bustling urban area. Somali culture has become an important color in the fabric of the Twin Cites. Somali businesses pay taxes, provide jobs, and contribute to the economic activity of the area. Finally, Somali people are contributing to and are re-creating the political landscape. When they help elect a Muslim to the U.S. House of Representatives, they are adding an important cultural insight to the national scene at a time when

American power is profoundly changing in the Islamic world. When Somali people contribute to the authority of the Service Employees International Union, they are helping to improve the working conditions of everyone in the city. Perhaps most important, both mainstream Americans and Somali people have demonstrated the ways in which there is room for Somali people to remain themselves while simultaneously forming a community with other residents in the Twin Cities. Somali people have proved to be good neighbors in the welcoming community of immigrants who already made their home on the banks of the Mississippi.

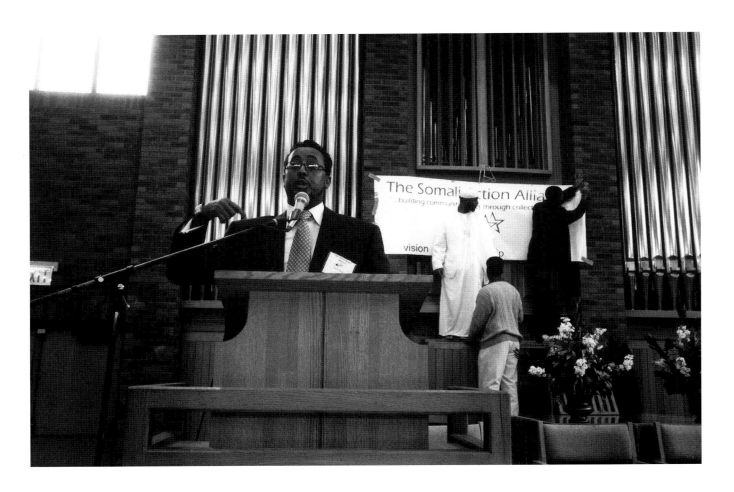

Hashi Abdi, Minneapolis, Forum at Augsburg College, October
2006. Mr. Abdi, director of the Somali Action Alliance, introduces
candidates for national office and explains that the candidates must
answer the community's questions with either "yes" or "no."

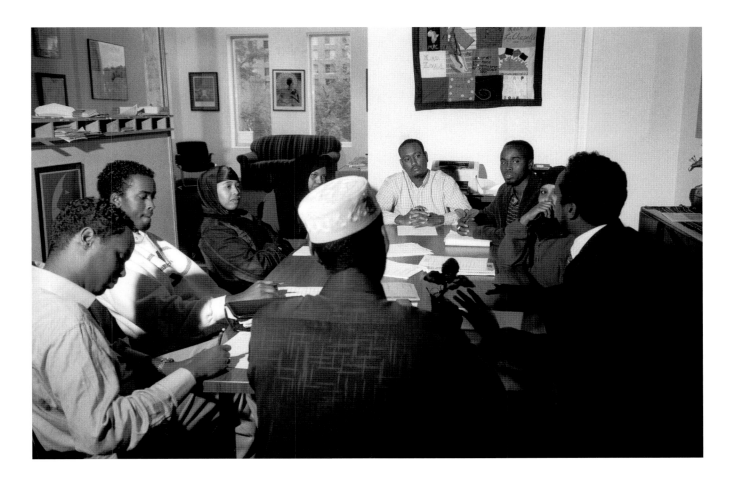

The Somali Action Alliance, Minneapolis, November 2006. After
the politicians answered the questions of the Somali community,
members of the alliance met to debrief and to plan the get-out-
the-vote campaign.

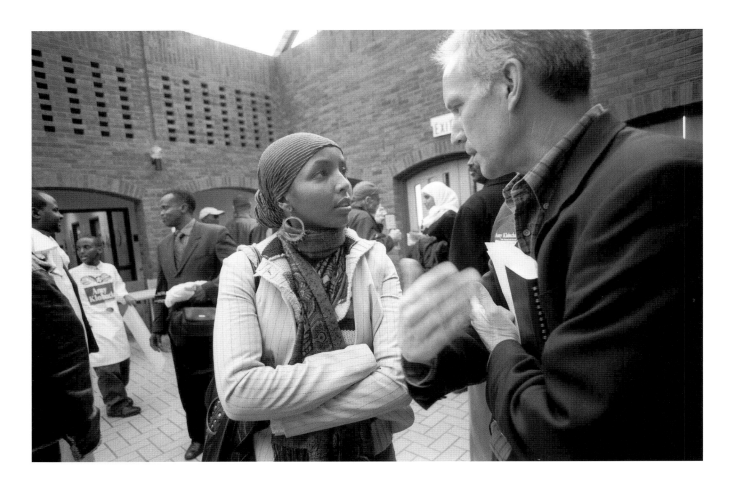

The Future of Somali Politics, Minneapolis, November 2006.
Nimco Ahmed, a supporter of Keith Ellison's campaign for
U.S. Congress, speaks to Jeff Blodgett, director of Wellstone
Action. Many people in Minneapolis believe that Nimco has
a bright political future.

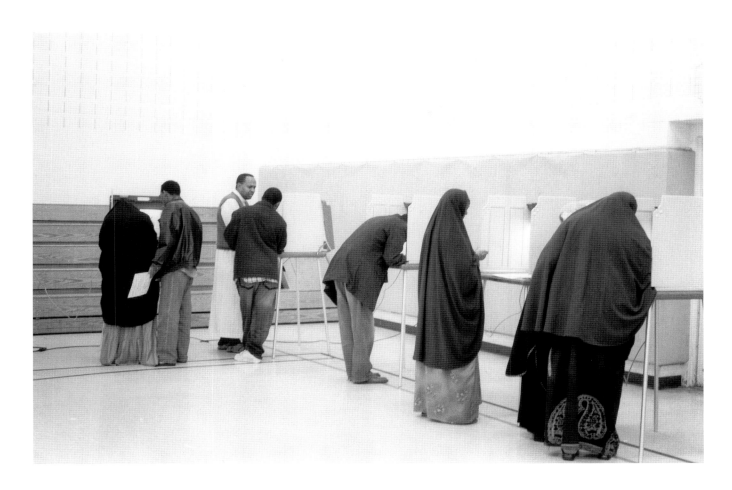

Voting, Brian Coyle Community Center, Minneapolis, November 2006.
This community center is in Cedar-Riverside, the heart of the Somali
community in Minneapolis. The get-out-the-vote campaign obviously
worked: Somali voters turned out in great numbers.

Relaxing after the Election, Minneapolis, November 2006.
Amina Dualle (who works for the Somali Action Alliance)
and Mohamed Abdi vigorously encouraged Somali people
to vote. Mohamed, once a member of the U.S. Marine Corps,
is now running for Parliament in Kenya.

The Former Prime Minister, Minneapolis, December 2006.
Minneapolis is the focus of Somali politics in more complicated
ways than local or national elections. Ali Khalif Galaydh was
prime minister of Somalia from 2000 to 2001; he is now professor
of public policy at the Hubert H. Humphrey Institute of Public
Affairs at the University of Minnesota. He is regularly consulted
about public policy throughout the world, including the current
struggle to bring peace to Somalia.

Hussein Samatar, Minneapolis, December 2006. Mr. Samatar founded and is executive director of the African Development Center. He is the only Somali who has been elected to an American political office: he is a member of the Minneapolis Library Board, an elected position.

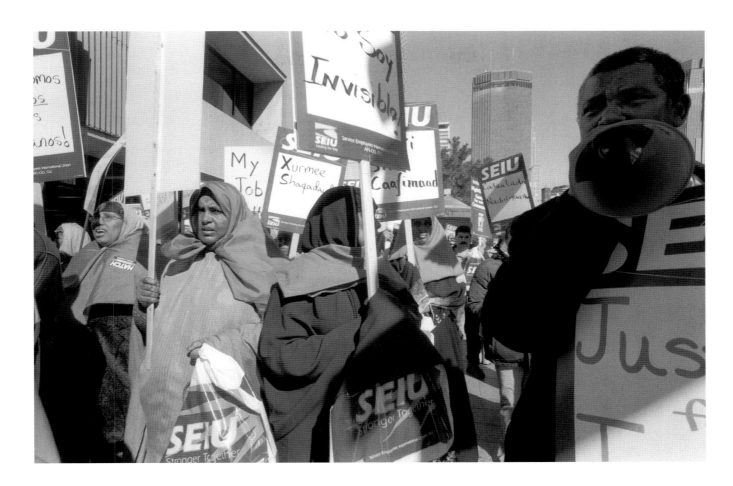

SEIU Rally, Minneapolis, October 2006. Somali politics in
Minneapolis do not stop at the election booth. These Somalis
are members of the Service Employees International Union,
which represents janitors and other service employees. The
women wear special hijabs that are the color of their union.
Many American women see the hijab as a sign of weakness,
but for these Muslim women their hijabs represent their
strength.

Muna Noor, Northfield, Minnesota, December 2007. Muna is a
stellar student at Carleton College as well as a union organizer
for SEIU. She became involved in the union because her mother
was given only part-time work so that she would be ineligible for
benefits and she was not allowed to pray at the times required by
Islam. Muna, a devout Muslim, believes that her hijab is an aspect
of her strength.

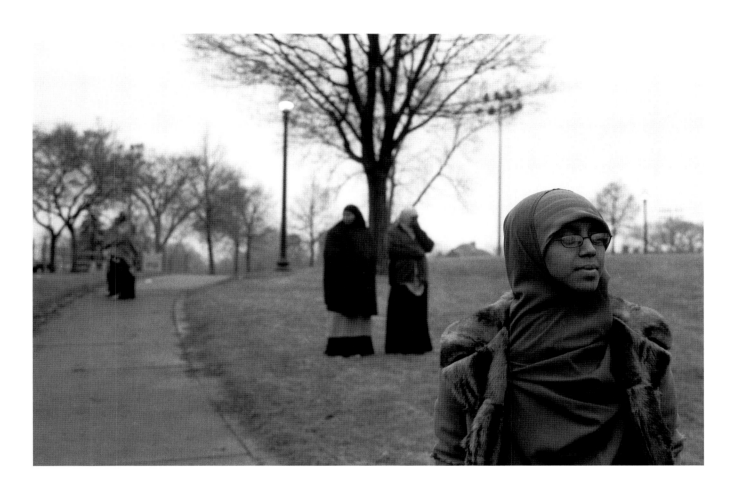

Protesting the Ethiopian Invasion, Minneapolis, December 2006.
As immigrants, Somalis live international lives; their political
concerns stretch across the globe. Here Ikram, a high school
student at Ubah Medical Academy, approaches a Somali protest
against the American-supported Ethiopian invasion of her
homeland.

Somali Diversity Radio, Minneapolis, November 2006. The Somali community shares concerns through the media so that it can remain politically active. Here Ali Musa uses Somali Diversity Radio to inform his community about news of the day.

Hassan Mohamud Jamici, Minneapolis, January 2007. Hassan Jamici *(right)* offers a transition between politics and religion for the Somali community, reminding us that religion and government are not separate in the Muslim world. His real name is Hassan Mohamud; Jamici is a nickname that means scholar. He is an Imam and a lawyer—the lawyer who struggled to work out a compromise on behalf of Somali cabdrivers who refused to take passengers carrying alcohol. He teaches at William Mitchell Law School in St. Paul and volunteers for legal aid. Here he addresses the congregation after conducting a service. Hassan Mohamud Jamici works tirelessly to resolve Somali legal and political conflicts in the Twin Cities.

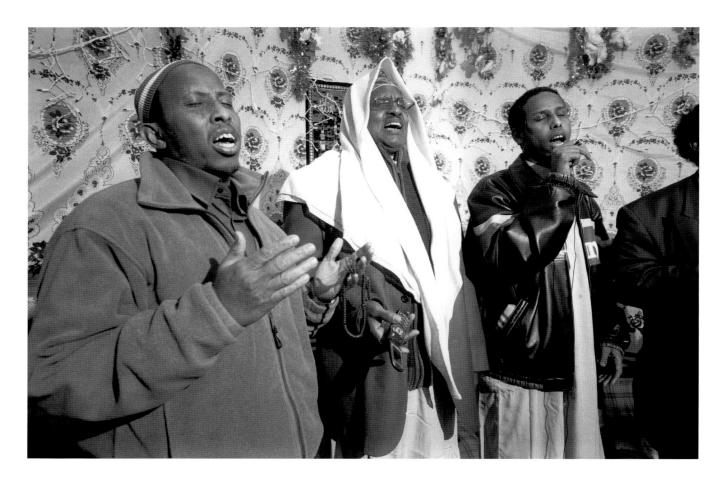

Sufi Ceremony, Minneapolis, January 2007. Sufism is a mystical
branch of Islam. These worshippers chant and dance in a
ritualistic attempt to become one with Allah.

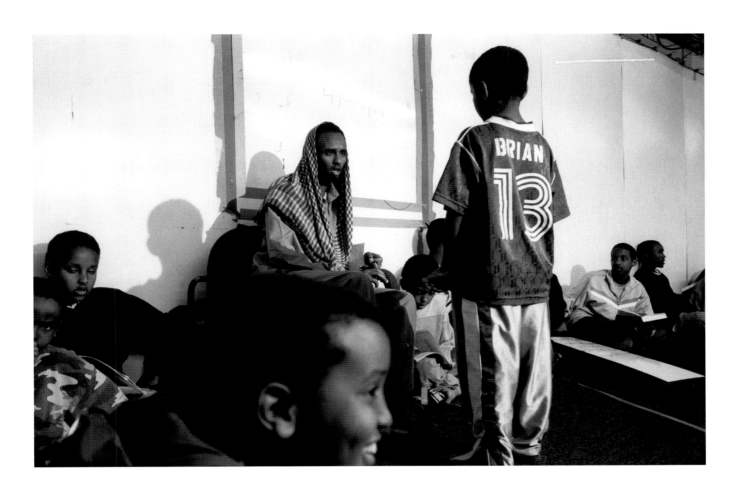

Qur'an School, Minneapolis, October 2006. These young people are learning how to be good Muslims in Minneapolis. They also study Somali history and culture.

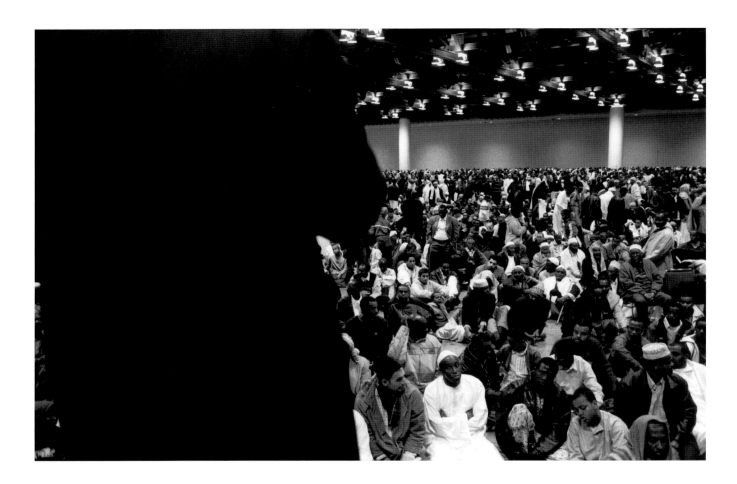

Eid ul-Fitr Prayer, Minneapolis, October 2006. Somali Muslims
feel that prayer becomes more efficacious when people pray
together. On a special holiday like Eid, the convention center in
downtown Minneapolis becomes a mosque where thousands of
people gather to offer the holiday prayer before spending the day
celebrating with family and friends.

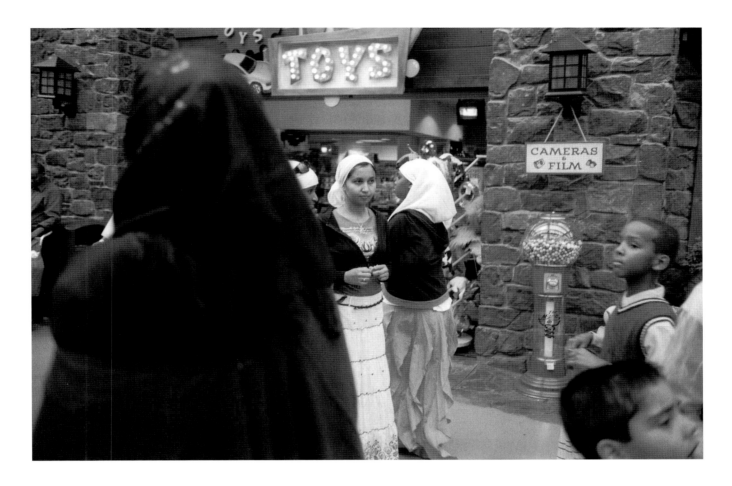

Eid ul-Fitr at the Mall of America, Bloomington, Minnesota,
October 2006. When the monthlong fast of Ramadan is complete,
Muslims celebrate Eid in Minneapolis by taking their children to
the amusement park at the mall. Approximately thirty thousand
Somalis gathered there in 2006 to cherish this Islamic holiday.

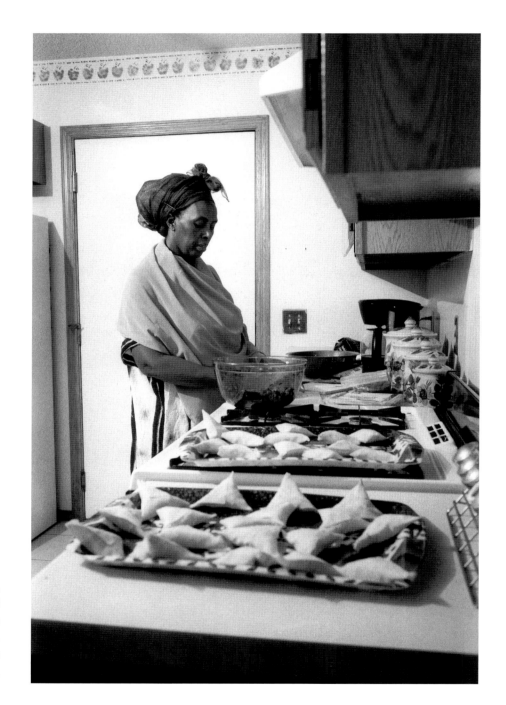

The Eid ul-Fitr Feast, Minneapolis, October 2006. After a month of fasting, Somalis celebrate with a huge feast. Here Kadra prepares *sambusa*, a traditional Somali pastry, for the Warsame family's holiday meal.

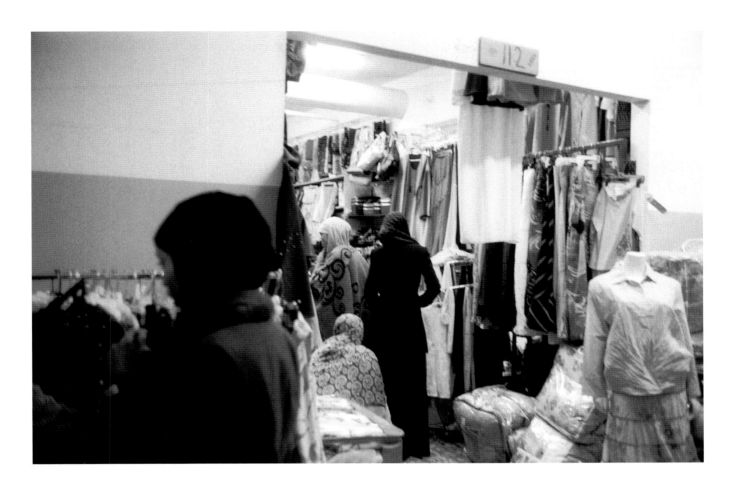

Shopping for the Holiday, Minneapolis, October 2006.
Eid ul-Fitr, like many holidays the world over, is a time
for women to dress beautifully. Somali women often
shop at Karmel Mall, a Somali mall in Minneapolis near
Pillsbury Avenue and Twenty-ninth Street.

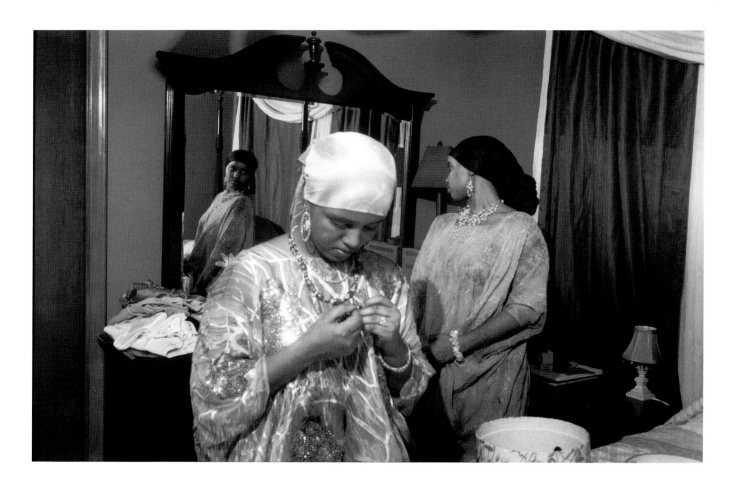

Shugri and Friend, Minneapolis, December 2007. Once you finally
select the proper dress, it has to be worn with just the right
accessories in just the right way.

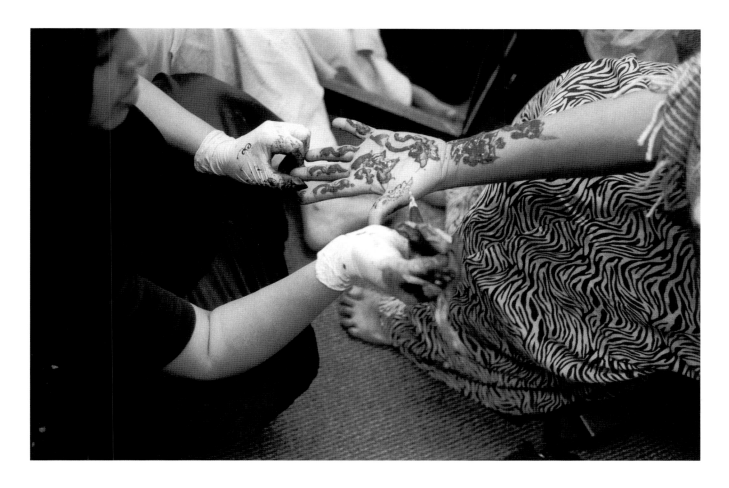

Beautified for the Holiday, Minneapolis, October 2006. The right
dress demands the right adornments—including, for Somali
women, decorating your body with henna in complex patterns.

Qamar Driving, Minneapolis, November 2006. After she had completed the training necessary to be a city bus driver, and after having worked as a school bus driver for several years, Qamar was told that she could not wear her hijab while driving the bus. As the hijab represents her Iman, or faith, Qamar refused to remove it in public, but she also refused to give up her job. After protesting and hard negotiations, the city of Minneapolis finally agreed to see things her way.

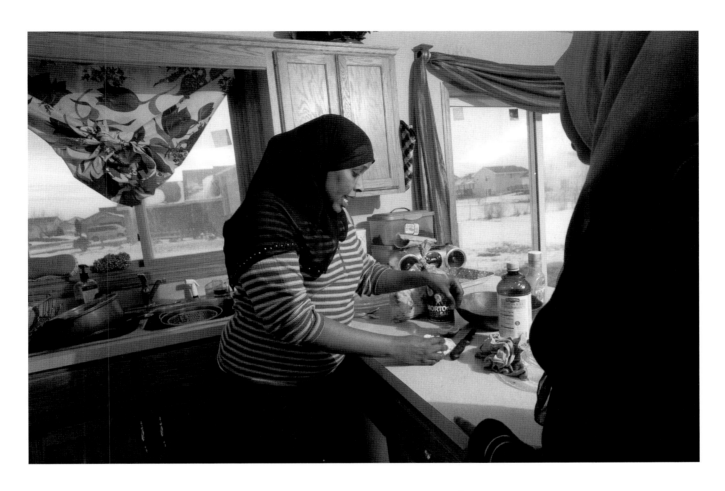

Hodan in the Kitchen, Minneapolis, January 2007. Hodan Hassan
works for the Somali Action Alliance on political issues for Somalis.
She lives in the suburbs of Minneapolis, and her children attend
the local public school.

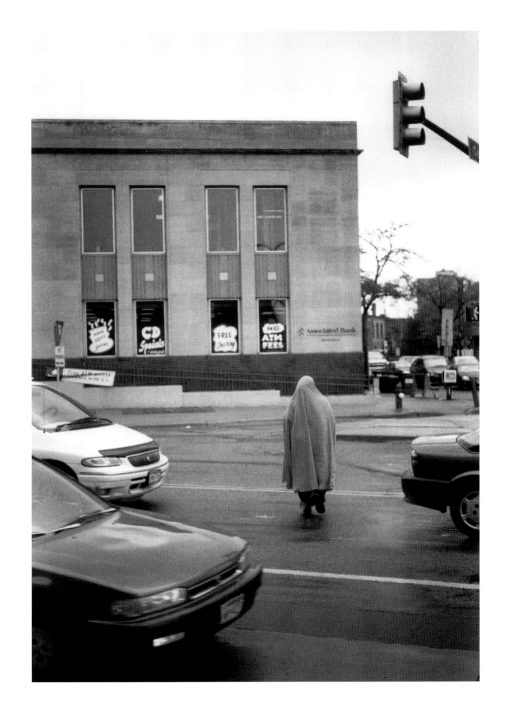

Cedar and Riverside, Minneapolis, December 2006. This is the center of the Somali neighborhood in Minneapolis. Somali people are proud that this neighborhood, once troubled, became safe and peaceful when many Somalis made it their home.

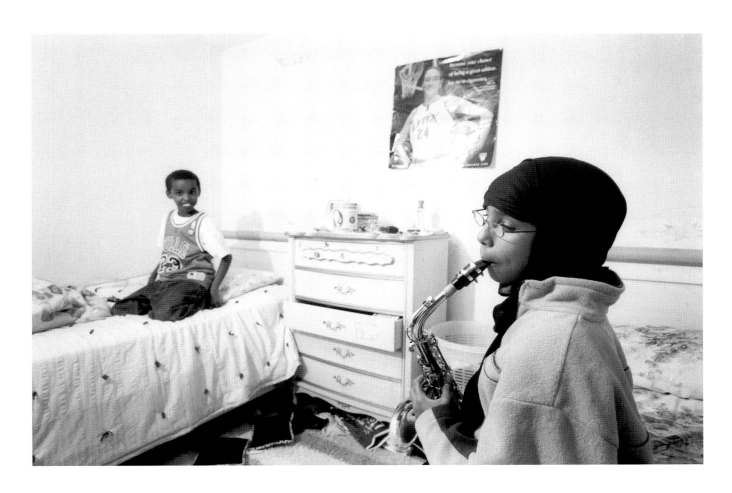

Somali Jazz, Minneapolis, October 2006. Ismahan (Amina Dualle's
daughter) entertains her brother, Fuad, with her developing
musical skills.

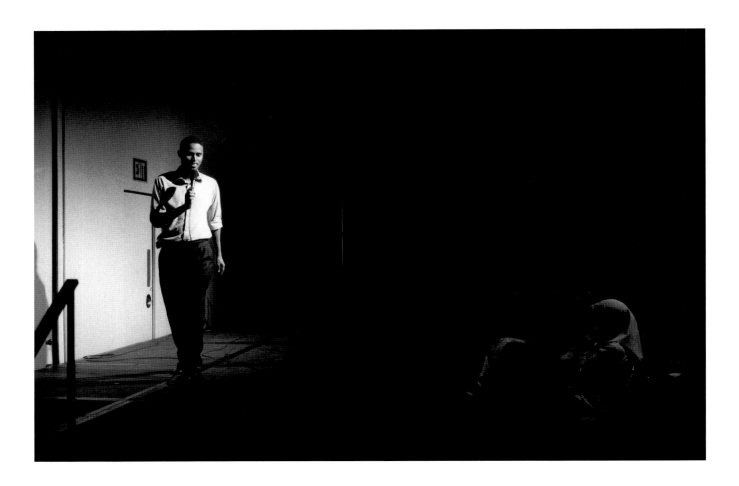

Somali Comedian, Minneapolis, October 2006. Omar Abdulle
finds that humor helps mitigate the frustrations of a community
trying to adjust to a foreign culture.

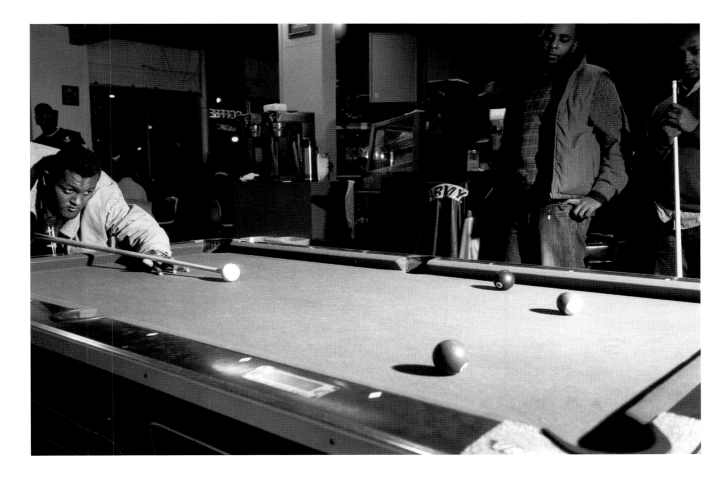

Shooting Pool in Minneapolis, Minneapolis, December 2006.
Somali coffee shops and community centers often feature pool
tables and card games to encourage Somali people to hang out
with each other.

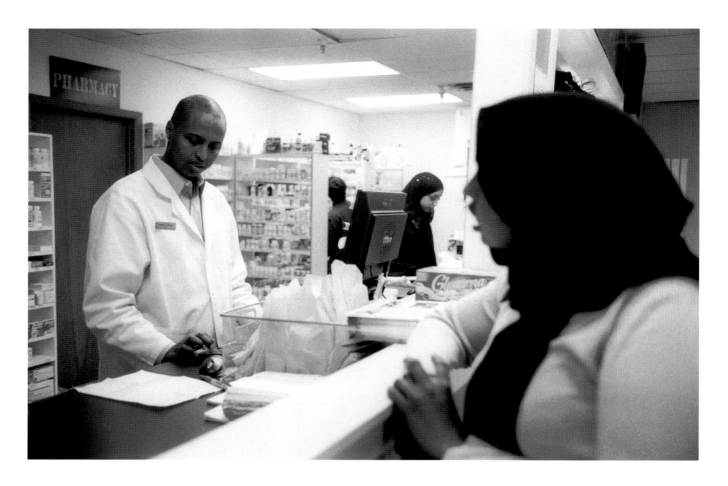

First Somali Pharmacy, Minneapolis, October 2006. Ahmed Osman
is proud to have opened the first Somali pharmacy in Minneapolis.
He helps doctors explain medical conditions to Somali patients,
and he helps doctors understand Somali culture. Here Amina
Dualle from the Somali Action Alliance has her prescriptions filled.

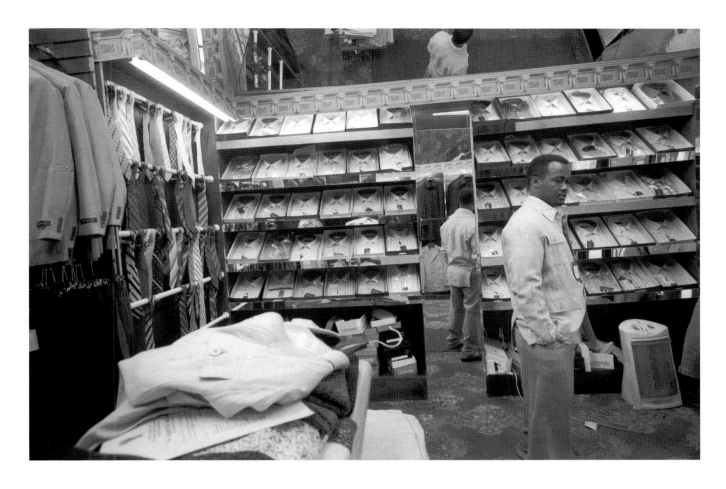

Men's Store in Karmel Mall, Minneapolis, December 2006.
Somali men's fashion is inspired by the country's Italian
colonizers, and Italian styles as well as traditional Somali
clothes are available at the Somali mall. Entering the mall is
like going to a foreign country while still in Minneapolis.

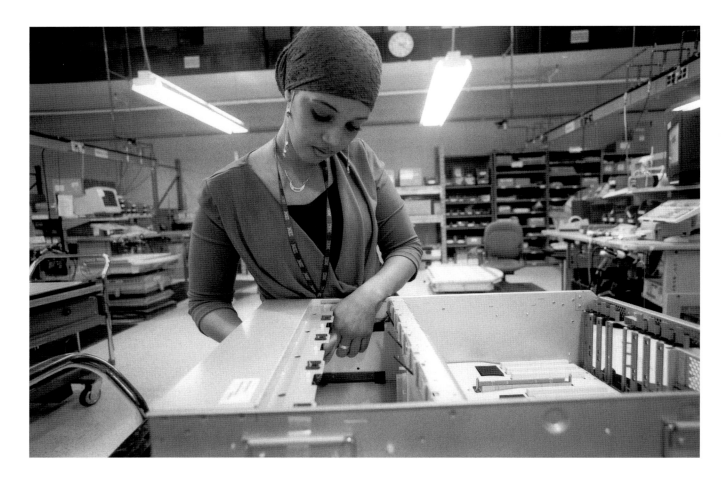

Building Computers, Rochester, Minnesota, January 2007.
Somalis are often employed in the computer industry
by IBM in Rochester, Minnesota. They usually work
as contractors and are laid off when work is slow.

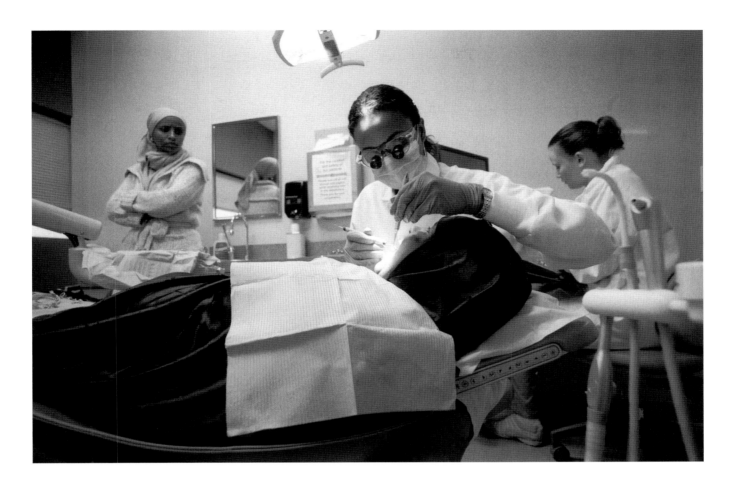

Cleaning Teeth, St. Paul, November 2006. Dr. Saharla Jama, a
voluntary immigrant, came to America to attend high school
long before Somalia's civil war. Like most Somali professionals,
she believes in helping her people, so she works in a clinic where
she can serve a Somali population who otherwise would have
difficulty explaining their troubles to a typical American dentist.

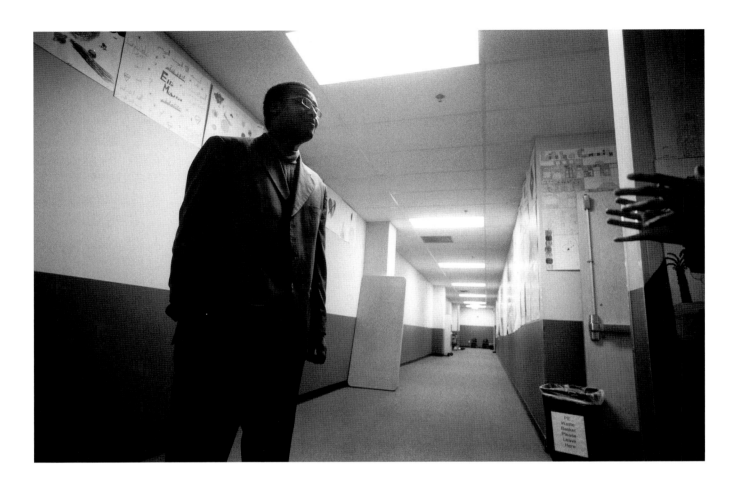

Twin Cities International School, Minneapolis, October 2006.
Abdirashid Warsame, once a resident of Otanga refugee camp
near Mombasa, Kenya, is founder and director of this charter
school that serves East African immigrants. The school offers
these children a culturally sensitive environment while
providing an American education with American standards.

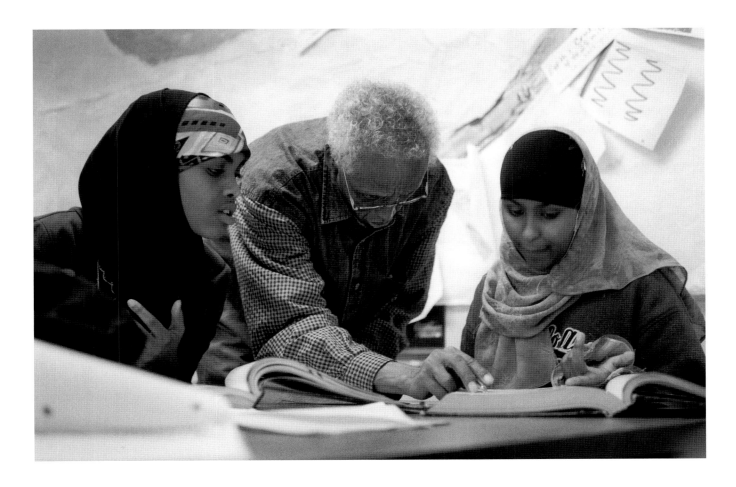

Teaching Science, Minneapolis, October 2006. Dr. Ali Jama is
a respected Somali science teacher at Ubah Medical Academy,
the high school component of Twin Cities International School.
He has a Ph.D. and was a teacher in Somalia before coming to
the United States. In Somali, the word *ubah* means "flower."
Macalim, the Somali word for "teacher," carries a good deal
of respect.

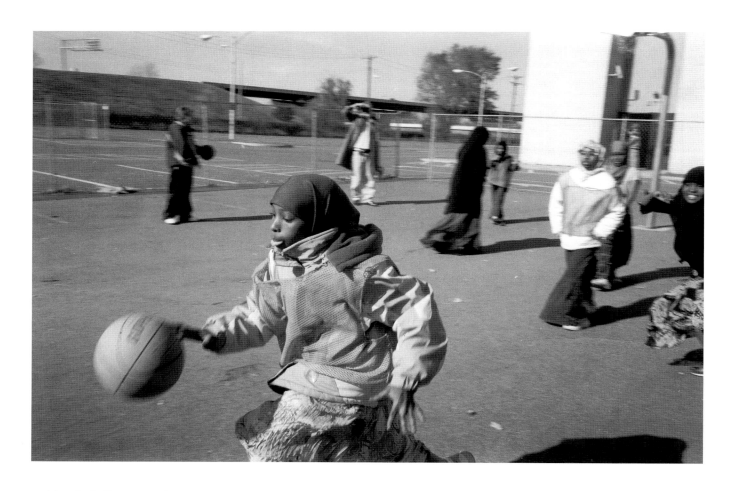

Girls' Basketball, Minneapolis, January 2007. These girls attend
Minnesota International Middle School, part of the school started
by Abdirashid Warsame. At this largely Somali school, boys and
girls must exercise separately, but both get an intensive workout.

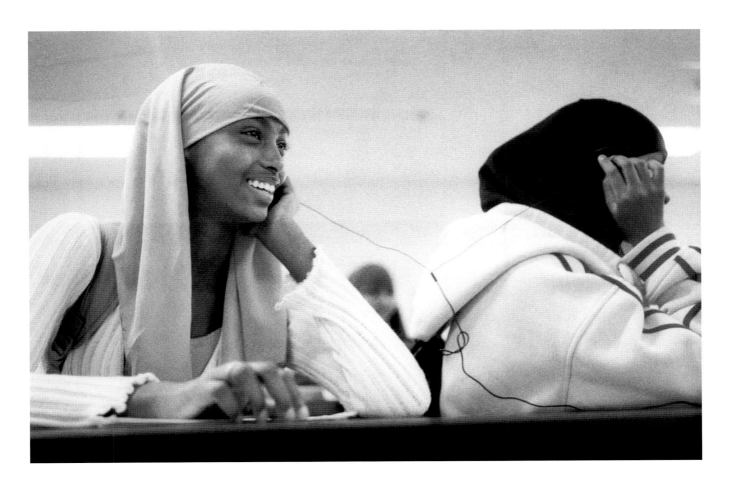

Sharing a Song before Class, Minneapolis, October 2006. These girls at Ubah Medical Academy (the high school component of Twin Cities International School) are not quite ready to settle down for the day's lessons.

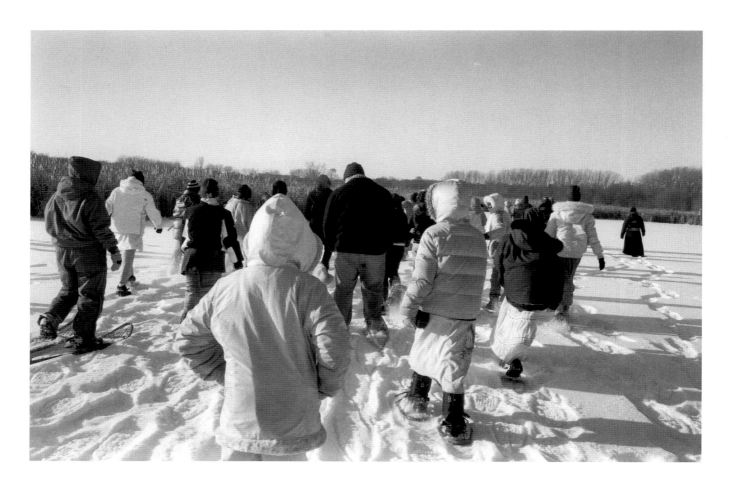

Snowshoeing, Minneapolis, January 2007. Somali girls from
Minnesota International School receive a snowshoeing lesson.
Many of these children have grown up in Minnesota, so snow is
not new to them, and now their parents have become accustomed
to it as well, even though it is far from the equatorial climate of
Somalia.

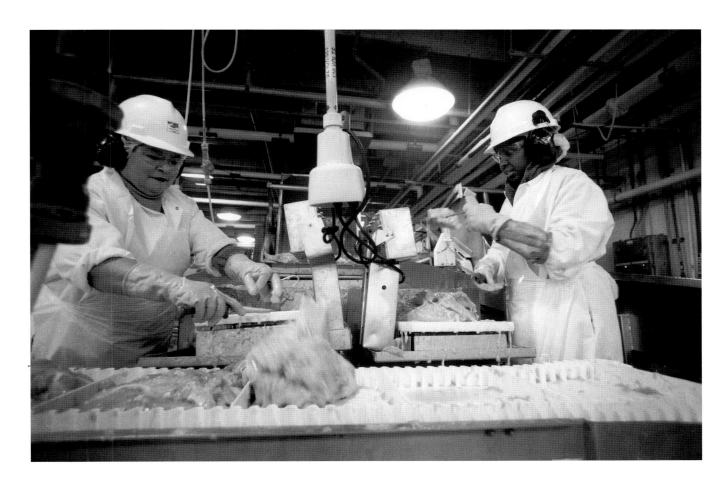

Jennie-O Turkey, Willmar, Minnesota, December 2006. Jennie-O Turkey does not insist that its employees speak English, so recent immigrants can find employment in this small town and receive good wages.

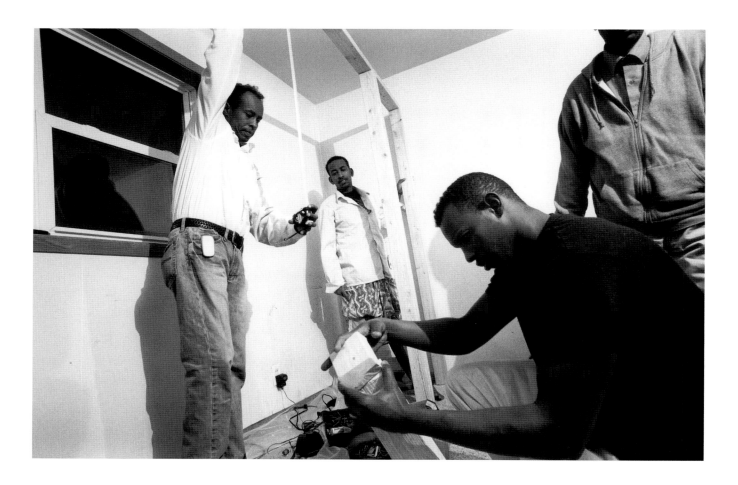

Building a House in Pelican Rapids, Pelican Rapids, Minnesota,
January 2007. Pelican Rapids is another small town with a turkey-
processing plant where Somalis can work without speaking
English. A Lutheran organization helped these men purchase a
house on a land contract, so they would not violate the Islamic
prohibition against paying interest.

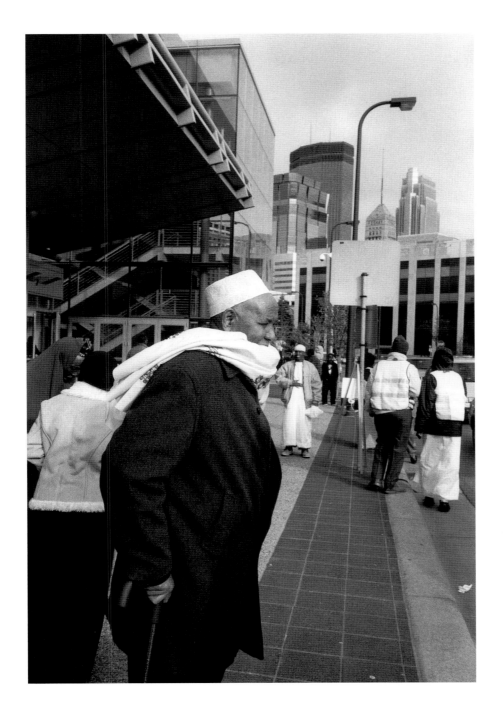

Leaving Eid ul-Fitr Service, Minneapolis, October 2006. Somali elders are still respected when they come to the United States, but it is hard for them to find a place. They often leave their homeland without their families, and American laws prevent them from raising the community's children the way they would have in Somalia. Many older Americans remember a time when adult members of the community had the authority to discipline other people's children.

Making Coffee, Minneapolis, November 2006. Issa is a Somali elder who lives alone. He tried to remain in Somalia with his family, but he could not tolerate the escalating violence any longer. After a harrowing and expensive bus ride through the civil war, he reached Kenya and after many years made his way to the United States. His wife remains in Africa.

Community Meeting, St. Paul, October 2006. The men and women
praying here are involved in a meeting that represents hope for
Somali elders. It is a creative interaction between American law
enforcement and traditional Somali culture. After advice from
the Somali Action Alliance, law enforcement officials recognized
that sometimes police were called in response to events that were
not actually illegal. If elders consulted on these borderline cases,
older people in the Somali community would be given meaningful
work, and police officers could use their time more efficiently.

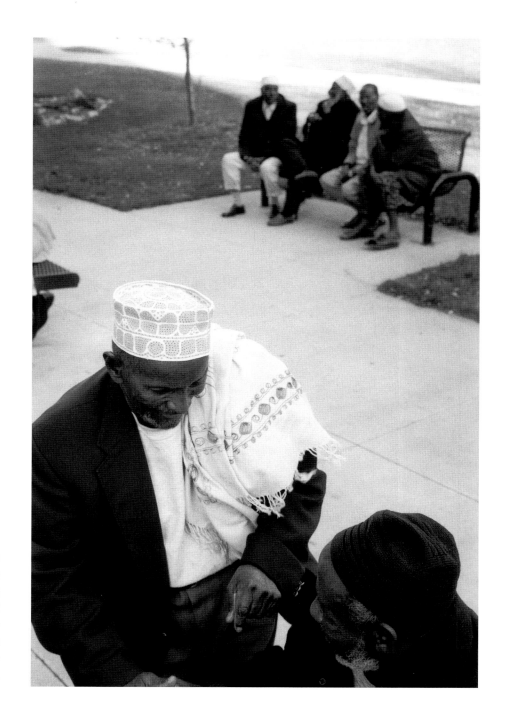

Somali Elders, Minneapolis, October 2006. The hat, or *koofi*, denotes that a man has contributed to the well-being of his community and is worthy of respect as an elder. Somali elders endeavor to be a meaningful part of the Somali community in America despite the many challenges they face.

The Future: Hope for the Somali Diaspora

Many of the images in this book represent hope for the Somali Diaspora in America and, in fact, hope for the Somali Diaspora around the world. Perhaps the distance between the photograph of Farhiya staring off toward Disneyland and the images of children celebrating Eid ul-Fitr at the Mall of America in Minneapolis most profoundly represent the extent to which that hope can grow and be realized in the United States. When we were in Dadaab, people kept expressing concern for their youngsters, saying, "The children are our hope." They dreamed that their children would learn the economic and political solutions that would finally bring peace to their homeland. "But," they would inevitably go on to say, "it is hard for them to learn when their stomachs are not full."

When Abdisalam brought his family to California, the lives of his children were certainly more secure. Their stomachs would surely be full enough to learn, as Hofsa so quickly demonstrated. Nevertheless, poverty would make their life spartan for quite some time, and it would prevent Abdisalam as well as his children from realizing his dream of helping Somali refu-gees in the near future. The economic challenges this family faced were ironically symbolized as they sat in the parking lot of the social services offices in Ana-heim, California. When she first arrived in America, Abdisalam's cousin Farhiya could not have understood, as she sat on the edge of that unpleasantly hot asphalt square, that the turrets in the distance represented the children's paradise of Disneyland, and Abdisalam could not have afforded to take her there to enjoy that land of childhood dreams even if she had. Neverthe-less, when Hafsa began going to school in Portland, Maine, and learning English, her education came to represent a profound hope for her, her family, and her community. Moreover, many Somali people who have been in the United States ten years or even less take their children to the Mall of America on Eid. Many of those folks have achieved the middle-class lifestyle that lets them afford this luxury in a very short period. They have struggled and they have worked two and often three jobs, but they can afford to give their chil-dren a kind of joy that they once could never even have imagined. And just as those children have been

introduced to the pleasures of childhood, so they have been introduced to its education. Somali children are graduating from college in record numbers, and in those numbers, there is hope. Maybe, just maybe, one or two or three of these graduates may go on to solve the problems of their homeland and realize the dreams of their parents.

When the violence ends in Somalia, some people will return to their country and help to rebuild it. Indeed, when six months of peace developed in 2006, many members of the Diaspora returned to their homeland to restart businesses and reunite with their families. Since war broke out again, with the Ethiopian invasion, the return to Somalia has slowed to a halt, but many people are anxiously awaiting the next outbreak of peace. In Columbus, for example, our friends Abdiqani Farah and his wife, Amina, want very much to go back to Somalia to raise their three sons as soon as it is safe enough. Abdiqani has a master's degree in economics, and Amina is a professional nurse. Both were trained in the United States. America has been good to the Farah family, but they want to raise their children in a Muslim country, and they are anxious to help rebuild Mogadishu when the fighting stops.

Of course, other families will see that their children have started school or have established a business and that it will simply be too difficult to leave them behind. Abdirashid Warsame, for example, is doing too much good for the American Diaspora to return to Somalia.

Indeed, his home city of Hargaisa in northern Somalia is peaceful now. He could return if he wanted, but his future and his duty remain with the Somali children of the Twin Cities.

Still other people will follow the opportunities with which the global economy presents them. Abdi Roble's cousin Jamal, for example, travels to the Far East to purchase goods inexpensively and sell them to merchants in the United States and around the world. He is one of a growing number of Somali merchants who take advantage of the fact that Somali entrepreneurs are now a worldwide phenomenon. That means they can have business partners in several hubs around the world, allowing them to exploit the variations in the currency markets across the globe. Fatuma Bihi, the former ambassador to the United Nations in Geneva from Somalia, tells the story of a Somali woman who hides thousands of dollars inside her clothing. Then she travels to China, with no knowledge of the language, equipped only with money and a scrap of paper on which is written a Beijing address. When she lands in the capital, she will show the cabdriver the address, go to the district where the Somali merchants operate, buy all the goods she can afford, and arrange to have them shipped to America. Here, she will sell them at great profit in the Somali mall, and then her trip will begin again.

Somali members of the Diaspora are far from home, but they have learned to participate in the economic and cultural environments in whatever country they

find themselves. They are caring for themselves and their families, and they are hoping that the peace they have found in America will finally find its way to the land of their home. But for them the journey continues. These traditionally nomadic people are no longer leading herds of camels and goats as they seek the most recent rain, but they are following economic and cultural opportunities across the globe. However, no matter what happens in Somalia, Somali grace and hospitality are a worldwide phenomenon now, and people in the rest of the world have only to learn to appreciate this gift.

Acknowledgments

We could never have gotten as far as we have with this project without the support and assistance of many wonderful people. First, we thank the children at Twin Cities International School, Minnesota International Middle School, and Ubah Medical Academy, and their founder and director, Abdirashid Warsame, who offered us the financial and emotional support we so desperately needed to go to Dadaab. We also acknowledge the deep debt of gratitude we owe to the United Nations High Commission for Refugees as an institution for allowing us to go to the Dadaab refugee camp in Kenya. Perhaps even more than the institution, the individual people who took time out of their tireless efforts to aid the refugees to look after us deserve a profound amount of thanks. Thanks to Toshiro Odashima, head of the suboffice in Dadaab, for believing that our project was worth the time and effort his staff had to put into our presence. Thanks also to Kevin Allen, director in charge of resettlement when we were in Dadaab, for introducing us to so many people, especially to the victims of violence and torture in Dadaab, which built the project and built our characters. We thank Susana Martinez Schmickrath, who lost her heart to every refugee and fought hard for refugees' rights. Susana's assistant, Nathalie Massenbach (Nina), kindly accompanied us to many neighborhoods in Dadaab. We thank Abdikadir Haji Muktar, who bought us clothes when ours were lost in the airport and who made sure that we always had a driver. And, of course, we have to thank Mude Bare Tifow, our driver, who violated many rules so that Abdi could get just the right shot. Many thanks to Mr. Dixon, director of the Friends International School in Ifo, for showing us around and allowing us to attend the graduation ceremony. We thank Pindie Stephen, the regional cultural orientation coordinator of the International Organization for Migration, who gave us permission to follow the family of Abdisalam, and Mohamed Abdullahi, who introduced us to the family. It goes without saying that we owe a deep debt of gratitude to Abdisalam, his wife, Ijabo, and his daughters Hofsa, Shukri, and Hamdi and his cousins Sadio and Farhiya; they never stopped treating us like family even when the constant presence of a photographer and a writer must have been awkward. We thank

the East African Community of Orange County, ably directed by Ibrahim Sheikh Hussein. Ibrahim showed us around Anaheim and introduced us to the challenges of resettling Somali refugees. We also thank Mohamed Ali, who offered a tremendous amount of information and support—and bought us a lovely dinner when we needed his company. And thanks to Ali Mohamed for always making himself available to answer our unending flow of questions.

In Maine, thanks to Mohamed Awale, president of the African Culture and Learning Center, who answered many questions about the plight of Somali refugees in Maine. Thanks also go out to Ahmed (Gam Gam), an elder in the community who took us in so that everyone else would accept us.

In Columbus, many thanks go to Hassan Omar, president of the Somali Community Association of Ohio, who let us observe the workings of his institution. Thanks also to Abdirizak Farah, who introduced us to many of the trying issues in Columbus and offered an avuncular guidance that has proved invaluable as we struggled to establish our organization. We are deeply indebted to Hawa Siad and the organization she runs, the Somali Women and Children's Alliance; she offered much-needed support when we raised money for people in Dadaab. Many thanks to all the people who are the Friends of Dadaab: because of you, the children of Dadaab will have a new educational facility and youth center. Thanks to Reghe Egal, a fine

teacher, who let us invade his after-school class, where we interviewed and photographed people in a way that would have disrupted anyone else's class, but Reghe took it all in stride. Thanks also to Mahadi Taakilo, who runs the *Somali Link,* for helping us get key interviews with city officials. We deeply appreciate the assistance of Ahmed Mohamed and Hassan Kafi, who run the Global Mall in Columbus; their intelligence and insight helped us through several projects. Deep appreciation also goes to Dr. Mohamad Mohamud Diriye (Diriyos), who has given us guidance and insight since the first days of the project. We appreciate the support of Sarah Kriska (Sally) and Doreen Uhas-Sauer, who helped us develop an educational project in Columbus that we later took to Minneapolis. We thank William Lane of Lane, Alton, and Horst, who helped us put the Somali Documentary Project together and has been consistently both supportive and patient. Thanks to Mary Gray of the Ohio Arts Council, without whose joyful and kind support the Riffe Gallery show would never have happened. Mary's support didn't stop: when we ran out of funds, she lent us her credit card so that we could go to Maine to follow the family there. A tremendous amount of respect and gratitude goes to Dr. Wayne Lawson, executive director of the Ohio Arts Council; Wayne was the visionary who could see what we wanted to do at the very beginning, when we had done so very little. Thanks also to Dr. Frank Goza, who was willing to share his hard work on develop-

ing demographic statistics of Somali migration. Thanks to Gerald and Marjorie, the first donors to the Somali Documentary Project. Many, many thanks go to Rainer Zehiem of Left Channel, who kindly helped with our Web site and our graphic design needs. We owe a profound dept of gratitude to Alicia Oddi, Ariane Bolduc, and Bryan Knicely of the Greater Columbus Arts Council, who have given us great support and kind guidance in developing our project.

In Minneapolis, we could never have done our work without the support of Amina Dualle (Sparkin' Eyes), who let us live in her basement for several months. Thanks to Amina and Nimco Ahmed for introducing us to nearly everyone in Minneapolis; without their help we would have taken several months longer to do our work in the Twin Cities. Thanks to Zainab Hassan for helping us organize a fund-raiser in Minneapolis and to Mariam Mohamed of the McKnight Foundation, who helped with the fund-raiser and fed us, directing us through our trials and tribulations in Minneapolis. We sincerely appreciate the support of Saeed Fahia of the Confederation of the Somali Community in Minnesota. We also enjoyed the jovial insights of Hashi Abdi of the Somali Action Alliance, who introduced us to many people and ideas in Minneapolis and showed us the dynamics of Somali politics in the Twin Cities. We carry a special place in our hearts for Susannah Bielak of Arts Midwest: Suzy was assigned to us, but the care and energy she devoted to helping us with the shows in Minneapolis and with developing our project have been profound. We also thank David Fraher, executive director of Arts Midwest; David became excited about the Somali Documentary Project in its early days and helped us find the support to go to Dadaab. He also helped us follow the family of Abdisalam, and he found the support to bring us to Minneapolis. David took the first show around the Midwest and was instrumental in taking the second show to the Columbus Museum of Art and the Weisman Art Museum in Minneapolis. We owe a sincere debt of gratitude to Sandi Augustine, the artistic director of Intermedia Arts in Minneapolis, whose energy and insight were helpful, not simply for our show there, but for many things that have happened since. Thanks to Anne Waltner of the University of Minnesota for allowing us to speak there more than once and for helping us find venues in the university. We are grateful to Abulcadir Abucar Ga'al, who not only welcomed us into his home in Willmar but was essential to getting us into Jennie-O Turkey. The fact that MSNBC's request to document the turkey-processing plant run by Jennie-O Turkey was rejected just weeks before we were allowed in indicates how much we owe the friendly hospitality of Ga'al. Thanks to Patricia A. Solheid and Steven C. Williams of Jennie-O Turkey for allowing us into the Willmar plant and tolerating our need to document people while they were working. Thanks to Jacqueline Brown for helping us document the Somali employees at the IBM plant in Rochester,

Minnesota. A special thanks to Catherine Evans for hosting our first museum exhibition. Thanks to Neal I. Cuthbert, vice president of the McKnight Foundation, for seeing the value of providing the Somali Diaspora in Minneapolis with a history.

Thanks to Rachel McIntosh, who has guided us through many troubled waters, and to Laura Joseph, who has helped with the efforts of the Somali Documentary Project and with the Friends of Dadaab. We are deeply grateful to Bill Neiberding, the fine printer who prepared Abdi's work for the museum; Bill was always generous with his time and patient with his bills. Thanks to Mark Fohl, who printed thousands of contact sheets. Thanks to Rebecca Rutledge for letting Doug travel around the world and for tirelessly proofreading the writing involved in the project: without your support, I could never have done this work. Thanks to Lisa Clulas for letting Tariq work with us in Columbus.

We will never be able to thank Tariq Tarey adequately for his work on this project. He is an essential member of the Somali Documentary Project, and if he had not processed film, taken negatives to the printer, and delivered final prints to the museum, this project would have fumbled many times over. Another special thanks goes to Stanley Kayne, who edited the photographs in this book and all the images that were in the exhibitions. We miss you, Stanley, and we know that we could never have gotten where we are without you. A profound debt of gratitude also goes out to Sahal Abdulle. Sahal, at great risk to his life, has been doing for the people in Somalia what we have been doing for the Diaspora. Sahal is a true hero of the Somali people and an inspiration to us. Together we are building a history of a people who have little else.

We thank the following organizations, without whose support this project would not have been possible: the Ohio Arts Council, Arts Midwest, the Greater Columbus Arts Council, the Columbus Museum of Art, the McKnight Foundation, St. Paul Travelers Foundation, Thrivent Financial for Lutherans, Twin Cities International School, Ubah Medical Academy, Best Buy, the University of Minnesota Press, Riffe Gallery, Friends of Dadaab, Somali Community Association of Ohio, Somali Women and Children's Alliance, Leftchannel, and African Paradise restaurant in Columbus.

Finally, our thanks to all the people who let us into their lives, who embraced us as family, and who were willing to put up with us as we asked them deeply personal questions and followed them around their homes and their workplaces with a camera. Without each and every one of those persons in Africa and in the United States, this book could never have been published.

About the Somali Documentary Project

The mission of the Somali Documentary Project is to use photography and writing to record the worldwide Somali Diaspora while Somali people are still in the process of migration. In the history of human movement, no other migration has ever been documented while still in progress. The reasons to record the glory and the pain of Somali migration are, first, to provide the Somali people with a record of this crucial moment in their history; second, to educate hosting cultures throughout the world; and third, to draw the world's attention to the horrible plight of Somalia and the fate of the people who are forced to leave their homeland.

People who are at home in the countries of Europe, the Americas, Asia, and Africa are finding that their new neighbors are Somali. Citizens of these dominant cultures need to be introduced to their new neighbors so that they will feel comfortable within their own homes and so that they will treat the people who now live beside them with respect. We believe that understanding promotes respect, which in turn promotes justice, and we hope that the words and photographs we produce through this project will move people closer to understanding and to justice.

For more information visit www.somaliproject.org.

SOMALI DOCUMENTARY PROJECT

ABDI ROBLE is an award-winning documentary photographer from Columbus, Ohio. He immigrated to the United States from Somalia in 1989. He is the founder of two photography groups, Focus Group and African American Photographers of North America, and the founder of the Somali Documentary Project. His photographic exhibitions include One Month in Europe with Leica, Leica Portrait of Cuba, Japan: A Leica Perspective, and, most recently, The Somali Diaspora and Against Forgetting: Beyond Genocide and Civil War.

DOUG RUTLEDGE has taught English and English literature for twenty years. He is the author of numerous plays, poems, and essays, and his writing has appeared in *Somali Link* and Hiran Online.